The Awakening Artist

Madness and Spiritual Awakening in Art

The Awakening Artist

Madness and Spiritual Awakening
in Art

Patrick Howe

BOOKS

Winchester, UK
Washington, USA

First published by O-Books, 2013
O-Books is an imprint of John Hunt Publishing Ltd., Laurel House, Station Approach,
Alresford, Hants, SO24 9JH, UK
office1@jhpbooks.net
www.johnhuntpublishing.com

For distributor details and how to order please visit the 'Ordering' section on our website.

Text copyright: Patrick Howe 2012

ISBN: 978 1 78099 645 5

A CIP catalogue record for this book is available from the British Library.

Design: Stuart Davies

Printed and bound by CPI Group (UK) Ltd, Croydon, CR0 4YY

We operate a distinctive and ethical publishing philosophy in all
areas of our business, from our global network of authors to
production and worldwide distribution.

CONTENTS

Acknowledgements

I would like to acknowledge these individuals for offering their suggestions to the manuscript of this book, and for their enthusiastic support of the creative vision that the book presents: Chris Bevington, Sandra Brown Jensen, Alex Lavilla, Tad Leflar, Cheryl Renee Long, Sheryl Newland, Thomas Orton, Victoria Palmen, and Paul Petrucci. I would like to acknowledge artist Mitch Albala for his excellent editorial suggestions and our long conversations about The Awakening Artist. I would like to acknowledge Steve Taylor for generously offering to write the foreword to this book. I would like to particularly acknowledge Kathy Kimball who patiently helped me transform my earliest ideas into coherent written concepts.

Foreword

by Steve Taylor

There has always been a very close connection between poetry and spirituality. Many poets have been very spiritually developed individuals, living in a heightened state of consciousness – for example, Wordsworth, Shelley, Whitman, Emily Dickinson, D.H. Lawrence, Ted Hughes and Mary Oliver. And many mystics, gurus and spiritual teachers have also been great poets, such as At. John of the Cross, Sri Aurobindo, Vivekananda and Thomas Merton. Poetry is the natural expression of spiritual experience, which transcends the limits of ordinary language.

In this enlightening – in both intellectual and spiritual senses of the term – book, Patrick Howe shows that the same is true of art. He describes how many of the greatest artists in history were spiritually 'awake', and how their 'wakefulness' was the source of their art. Artists like Constable, Turner, Caspar David Friedrich, Thomas Cole and George Inness perceived the natural world with a heightened intensity. Whereas most human beings perceive their surroundings through a veil of familiarity, with a functional automatic perception, they saw it with the freshness and first-time vision of children. Rather than experiencing a sense of duality and separateness, they felt a powerful sense of connection to the world. And just as Wordsworth and Whitman had the literary skill to convey their spiritual visions and insights through poetry, these artists had the ability to convey the wonder and intensity they experienced through their paintings.

Arguably, this applied to most of the great painters up to the 20th century. It is certainly true of impressionists like Monet, Pissaro, Renoir and Van Gogh. To look at some of Van Gogh's paintings is to see the world in a mystical state of consciousness,

with spirit-force pervading the sky, the stars and the whole of the natural world. It's true of Patrick Howe's own artwork too. As he writes of his own perception, 'All I have to do is look out any window, walk in any park, study the cooking utensils on any kitchen counter top, or look in almost any direction and I see the beauty and peace of the world.'

One of the great pleasures I've had while reading this book is to break off periodically to look up the paintings of some of the artists. As a European who isn't particularly well-versed in the history of art, I wasn't familiar with some of the American painters Howe discusses. I had never heard of George Inness, for example, and looking up his paintings was a delight. He's become my new favourite painter, alongside my old favourites, Van Gogh, Monet and Turner. I love the way Inness paints the sky, with just as much as emphasis as the landscape, with the clouds as prominent and beautiful as rocks and trees. It resonates so much with me, because I often see the sky that way too. (I wrote a poem called 'A world that moves too fast to map' about the sky in my book *The Meaning*.)

Throughout this book, Howe shows how the artwork of individuals relates to the culture they are a part of. For example, he suggests that the Romantic movement – in poetry, art and music – was part of what I call the 'trans-Fall' movement. (In my book *The Fall*, I describe this as a movement beyond ego-separateness towards re-connection to nature and the human body, a movement beyond egocentricism towards empathy and compassion.) Howe also makes the important point that, until this time, artists had been in the service of kings, emperors, aristocrats and the church. Their subject matter was always circumscribed by the demands of their benefactors and employers. But in the 19th century, artists became independent for the first time, free to express their emotions, to explore their imagination and perception.

In many ways, the 'trans-Fall' movement of reconnection has

continued through the 20th century and into the 21st, leading to the environmental movement, increased equality and women's rights, a spread of democracy, an increased sexual openness, an explosion of interest in spirituality and self-development and so forth. But particularly in the last few decades, much European and American artwork has turned against this trend. Modern art is in a very strange position. At least amongst art critics, artists who attempt to convey beauty or a sense of awe or transcendence are seen as redundant. In a climate of post-modern self-consciousness, it has become unfashionable to express any genuine emotion – to do so is to be accused of 'romantic sentimentality.' Art has become divorced from reality, and overtaken by the intellect. The word 'conceptual' – as in conceptual art – is very apposite. As Partick Howe puts it, 'Much of art today has lost its "mythic power"... Most art is made for the market and the critics and makes no effort whatsoever at being transformative.'

Rather than a creative 'right-brain' pursuit, art has become an intellectual 'left-brain' one. In spiritual development, the conceptual mind is seen as a hindrance to overcome. Concepts are the conditioned ideas and cognitive habits we have developed through our upbringing and experience. Through meditation and other forms of spiritual practice, we attempt to quieten the conceptual mind, to weaken its structures, and gain access to a pure, unconditioned consciousness, which it can obscure. So in this sense modern art is *anti*-spiritual. It reinforces the dominance of the conceptual mind. It's designed to make us think, to shock and provoke, rather than to transform our consciousness and our relationship to the world.

In many ways, then, the sad state of modern art mirrors the worst aspects of our culture, and of ego-consciousness itself – divorced from nature, narcissistic, entangled in theories and concepts, rather than in connection with the present, and the world itself.

But true art is always bigger than the intellect. It always stems from a mysterious transcendent source, rather than from the puny thinking mind. As Patrick Howe points out of his own work, sometimes paintings seem to flow through him without conscious control, so that he doesn't know what he'll end up with. Artists in other fields have made the same point. Musicians and poets usually don't think songs or poems into existence; they come *into* their minds. They hear the music in their head and transcribe it. In the same way, lines or phrases come to poets in moments of inspiration. Once the kernel of a piece of music or poem is there, *then* the artist can use his or her intellect, to chisel it into a rounded and finished piece. But without the initial non-rational inspiration, there is nothing to work on. (Interestingly, this applies to science too. Many famous scientific discoveries have arisen from unconscious inspiration rather than logical thinking. For example, Niels Bohr won the Nobel Prize after 'seeing' the structure of an atom in a dream. One of the triggers of the industrial revolution was the idea of a separate condenser for the steam engine (to stop it from losing heat), an idea which spontaneously formed in James Watts' mind while he was walking across a green in Glasgow.)

In the *Awakened Artist*, Patrick Howe attempts to re-connect art to this transcendent source. Even without realising, spiritual artists have been part of what he calls 'the one art movement', whose role is to encourage the flowering of human consciousness. The artist is both a channel of heightened spirituality, and an 'agent' of evolution, helping the rest of the human race to develop the same awareness.

For me, another great thing about this book is how it reminds us that you can't separate spirituality from other aspects of life. Spirituality isn't a separate category, it's a potential quality of *every* category of life. 'Spiritually awakened' individuals aren't just – or even primarily – monks, gurus or spiritual teachers, they may be painters, poets, musicians, athletes, and so on. They may

not even be anyone or anything – just 'ordinary' people living in obscurity, doing nothing of any note. They may not even know that they are 'spiritually awakened.'

So if you are interested in either art or spirituality, this book will be wonderfully inspiring reading. But it will also make you aware that in reality there is no either/or. You can't separate art and spirituality, in the same way that you can't separate waves from the sea, or my essential self from yours.

Steve Taylor is the author of several books on psychology and spirituality, including *The Fall, Waking From Sleep, Back to Sanity* and *The Meaning*. His website is www.stevenmtaylor.co.uk

Introduction

As an adolescent artist I painted on my bedroom floor. Tubes of paint and brushes were scattered among socks, jeans and baseball gear. I painted pirate ships and the faces of old craggy men that I cut out of National Geographic Magazine. Or I would invent a wild abstract thing that would make my eyes sizzle. Time would vanish, hours would fly, and a wonderful world would emerge from my brush.

I often felt, as many artists have, that whenever I painted, there was something transcendent about what I was doing. Somehow, when painting, I felt I was touching the divine, or it was mysteriously touching me. I had this feeling not because I was religious, but because I often felt, paradoxically, that I was accomplishing something I did not know how to do: I was creating something I did not know how to create on my own. My creations seemed to swirl out by themselves. It was not a mysterious or supernatural experience, as if I held my brush out and watched in detached amazement as the brush jerked my arm around on the canvas. That would have been cool, but that wasn't it. More precisely, I would paint for an hour, nose to the canvas, with complete attention only on the areas I was painting. Eventually, I would stand back and look at the painting from a distance, and from that new point of view I would see an unexpected order and a coherent relationship among all the parts that I had not seen (or intended to create) while working up close. So the question is, how did that order get there if I had no intention of putting it there?

Any good art instructor has occasionally observed this, when a student's painting is temporarily in a state of perfect harmony and balance, and yet the student is unaware of it. That harmony, it seems to me, was being expressed *through* the student, independent of the student's conscious awareness. In my own

I

example, if you were to see those long-ago paintings today, you would most certainly think they looked quite amateurish, as would I. But the point is, this was my first realization that I was participating in a level of creativity that was beyond my mental awareness. I was creating something beyond what my mind alone could create. This realization came with a feeling of profound joy and respect for whatever it was that allowed this to happen, and for the artistic forms that were created as a result.

Eventually I went through art school, became absorbed in the art world, and showed my work in museums and galleries. By then I had long forgotten that original, innocent magic and wonder that I had known making art as an adolescent. It wasn't until many years later that I allowed that original joy and innocence to re-enter my life and I began awakening to the infinite creative source that was beyond my awareness, yet flowed through me. It is the same creative energy, I realized, that has created all forms of life, and the universe. That is the subject of this book: awakening to the infinite creative energy that is beyond the artist, yet flows through the artist, and through all art movements the world has known. The artist who becomes aware of this magnificent creative source moving into his or her creative forms is the awakening artist.

I titled this book *The Awakening Artist* because the word "awakening" describes a gradual movement out of an unconscious state and into a conscious state. The particular kind of awakening I am referring to is spiritual awakening: the emergence out of the condition of psychic disharmony that all humans share to varying degrees, and into a potential state of beauty, love, inner peace, and tremendous artistic creativity. As we shall see, this awakening is easily visible in many works of art throughout the ages, if we only look at them from the perspective of spiritual awakening. However, our primary goal is not an intellectual analysis of this subject; rather, it is to learn from other artists in order to further our own artistic awakening. In that

sense this book is also a learning tool.

I have always considered myself a spiritual person, but like many others I have never felt at home within religious structures, although I have always respected their core truths. We will use some of those core truths, particularly those of Eastern spirituality, to help us explore the ultimate source of true creativity that is available to each of us now. Furthermore, as an artist, I have never felt particularly at home within the structure of today's art world, though there are surely many people doing wonderful work there. I have, however, felt a strong kinship with many artists throughout history. This kinship that I, and no doubt many other artists sense, is what I believe American artist Robert Henri referred to in his book *The Art Spirit*[1] as a brotherhood of artists whose relationship transcends time and space. It is through art, past and present, that we recognize a shared, common spirit, and we will explore this timeless kinship that all artists may share in. By contrast we will also examine why most contemporary art today appears to be excessively intellectual, and divorced from spirituality and beauty, and I will present the "awakening" alternative.

Artistic creativity is expressed in many ways other than visual art; there are also the literary arts and performing arts. However, for the sake of simplicity, I am using the painter in this book as a symbol for all artistically creative people and because I am a visual artist. And though I will use the history of art to illustrate the theme of awakening, the same theme can also be seen in the history of the literary and performing arts because it is a universal theme. The creativity of all artists originates from the same creative source.

We will also learn about the transformational power of art and how, on the negative side, it has been used to manipulate societies, and on the positive side, provide a portal to the vast beauty of the world in which we live and enable us to touch the mystery of Life. Furthermore, we will learn how to bring this

same transformational power into our own art.

Ultimately, it is the purpose of this book to introduce you to the greatest source of artistic creativity there is, which originates from beyond the artist's imagination, intellect, knowledge of art, and the art world itself—and yet is inseparable from the artist.

Definition of Terms

The following are terms and phrases that I use throughout this book. I will elaborate on each of them later, however an overview of them presently would be helpful.

Play of Form

The phrase "play of form" describes the interaction of all forms in the cosmos: galaxies, stars, solar systems, forests, birds, insects and humans. The concept of the "play of form" portrays these interactions through the lens of playfulness. The phrase comes from the Hindu term "Lila" which means "cosmic play". Playfulness is common in artistic creativity. Some artists would say it is essential. The way I use the phrase indicates the experience that artists derive from manipulating materials, mediums and concepts. I also suggest that artistic playfulness is a natural extension of cosmic playfulness.

Awareness

The words awareness and knowledge are often thought of as interchangeable. We might say: "I am aware that you called" or "I know that you called." However, in this book awareness and knowledge are different. Knowledge is information. Awareness is the space within us that contains knowledge. For example, when we say we know something, that knowing is happening within our awareness. It is evident that knowledge could not exist were there no conscious awareness of it. Therefore awareness must exist for knowledge and experiences to be known.

Having abundant knowledge is to be knowledgeable. To have

lots of awareness is to have a sense of inner spaciousness. This spaciousness gives a person room to breath, as they say. It enables a person to observe the world without the necessity of conceptual knowledge. The more aware a person is, the more empathetic and compassionate they become toward themselves, others and the environment.

The Mystery of Life

Why do we exist, and why are we here? The mystery of life is a way of describing the unanswerable questions of human existence, life and death. From a merely physical point of view, humans seem to exist as a matter of evolutionary happenstance. From a more open-ended point of view there is a sensing of something beyond what the human mind alone can know about life. From this point of view, life remains a mystery.

Normal Consciousness and Higher Consciousness

Normal consciousness is the state of being awake and aware of our surroundings. Higher consciousness is often thought of as a mystical realm reserved for saints and sages. However, the way this book uses the term higher consciousness is more practical: It is a state of being more awake and more aware than normal consciousness. To be conscious in the normal sense is to be aware of oneself, others and one's surroundings. However, higher consciousness also includes the experience of being empathetic and respectful towards oneself, others and the environment without personal gain. To be empathetic is to sense the aliveness of others as if it were your own.

Unconsciousness, and Gross Unconsciousness

Physically speaking, to be unconscious is to be asleep. However, some people seem to be unconscious even when they are awake. They seemed to be absorbed in themselves. They are unaware of others around them and have little regard for the environment.

Gross unconsciousness is extremely unaware and calloused. It can justify human cruelty and blatant destruction of the environment.

The Evolution of Consciousness

The evolution of consciousness is not the same as the evolution of knowledge. The evolution of knowledge is about an increase of information and abilities. The evolution of consciousness is about an increase of awareness. The evolution of knowledge is dependent on the evolution of consciousness because the accumulation of knowledge is not possible without conscious awareness.

You could say that on the level of the individual, a person who becomes more compassionate throughout their life is evolving in consciousness. A society that emphasizes respect and compassion as core social principles has evolved in consciousness. As the human species becomes more compassionate, it is evolving in consciousness.

Universal Intelligence

The marvelous complexity of the universe and the extraordinary evolution of living organisms on our planet suggest to some that the universe is inherently intelligent. A simple daffodil is an example of a highly complex form. Yet, not even the greatest intellects in the world put together could ever hope to create a single daffodil from scratch, and yet the universe produces countless numbers of them every spring with apparently no effort whatsoever. This implies to some, including me, that there is something highly intelligent about the universe.

The Infinite Creative Source

This is a phrase I have coined and use frequently throughout this book. It is similar to the concept of universal intelligence mentioned above but with an emphasis on creativity. The

universe is not only intelligent, according to this concept, but the forms it has created—solar systems, galaxies, plants and animals, make it also appear creative. The infinite creative source is a metaphor for universal creativity. Literally speaking, there is no source, or place somewhere *way* out there that is beaming creativity to us *way* over here. Through metaphor I am communicating that the creative energy that has created all of life is the same creative energy that is the artist.

Oneness

Oneness is the concept that there is an intrinsically shared harmonious relationship between people and with the natural world. It is easy to look at the chaos in the world and see little harmony so the concept of oneness could seem doubtful. Plus, one may wonder, how could there possibly be oneness when we are obviously separate individuals? There is me here, you there, and them over there—all separate. For those questions, consider this analogy: if the fingers of a hand were humans, they could easily believe they were separate fingers from all the other fingers. In fact, each finger's existence is completely dependent on the unity that all fingers share in the hand, and the hand is dependent on the arm, and so forth. The fingers, in this analogy, are unified at a deeper level than where they appear separate. However, because most humans are unaware of their unity, their oneness, they are unable to comprehend their inseparable and mutually purposeful relationship with each other. They are unaware of the 'hand' to which they are connected. A similar analogy could be applied between humans and plants, and humans and solar systems; at a level below surface appearances everything is interrelated. If we accept this possibility then we are beginning to sense the oneness of life.

The One Life

This phrase embodies the notion that all forms of life are

evidence of a single collective expression of life. In this concept, the One Life is the ultimate source from which all forms or life spring. When we look at nature we can see apparently separate life forms such as birds, trees and flowers. However, from the point of view of the One Life, they arise from a common source of Life.

Mental Disharmony (Psychic Disharmony)

Mental disharmony and psychic disharmony are ways of describing a psychotic state of mind. We experience mental harmony when our minds are joyful, peaceful and content. Mental disharmony is the psychological suffering that humans experience. Mental disharmony can be mild or acute. Mild mental disharmony is a moment of anger and frustration. An acute form of mental disharmony is cruelty and violence. The word "psychic" is synonymous with mental. Therefore I often use the phrase "psychic disharmony" to signify a psychotic state of mind.

Awakening

Awakening is the process of emerging out of psychic disharmony. All people do not experience an equal amount of awakening and psychic disharmony. Some people are more awakened than others. Some societies have been more awakened than others. Some civilizations have been more awakened than others. In this respect I portray some artists and art movements in this book as more awakened than others. Not because I am biased toward them but because it appears to be the case. However, the fact that any artist or art movement may express more awakening does not, in my opinion, make them special or better than artists or art movements that seem to carry more psychic disharmony. All are included in the One Art Movement.

The One Art Movement

The One Art Movement is the concept that the entire scope of human artistic creativity is a single art movement with a single underling theme, instead of a fragmentation of hundreds of art movements, which is the traditional view. That single underlying theme is the compulsion to awaken.

A New Kind of Sacred

The word 'sacred' makes some people uncomfortable, as if the word suggests they tiptoe, whisper, and feel 'churchy'. Traditionally, religions have used sacred objects and sacred rituals that require a demeanor appropriate to the situation. A sacred ritual for the Buddhist, for example, would be meditation. Prayer is considered a sacred act to the Native American Indian. The Hindu practices a sacred ritual of bathing before entering a temple. For Christians the crucifix is a sacred symbol representing the suffering of Christ. However, the way I am using the word sacred would best be described as a profound sense of respect. With this kind of sacredness, petting a dog could be a sacred act. Listening to someone with your whole attention could be sacred. Dancing to joyful music, love making, or gardening, could be sacred. With this kind of sacredness a solemn ritual might be included, but it is not necessary. As long as the activity is done with a sense of respect for oneself, others and ones environment, it is sacred.

Part 1

Awakening

"My first interest is in Being—along the way I am a painter."
Morris Graves

Chapter 1

The Awakening Artist

What I wish to convey to you is that your artistic creativity is an expression of the same creative force that created the universe. The ideas that I am about to present are not based upon intellectual conjecture. Nor are they based on New Age 'woo-woo' ideas about some alien force from outer space that is trying to get inside of you to control you and your creativity. On the other hand, if Buddhist concepts, Zen, modern psychology, common sense, and the word 'spiritual' are 'woo-woo' to you, then this book may offer you the opportunity to examine those assumptions, and to discover a new way of understanding human creativity.

Simply put, spiritual terminology has been used by art historians and scholars to describe and explain art for centuries because so much of the world's art has been influenced by the world's religions. I use spiritual terminology throughout this book, too, but not in a narrowly religious or extremist way. I use it metaphorically. As mythologist Joseph Campbell noted, when words are understood metaphorically, they may evoke deep meanings. However, when they are merely perceived literally, they block and flatten the deeper meanings. For example, take Shakespeare's metaphor "All the world's a stage". A literal, 'flattened', interpretation of the phrase would be that the earth is a theatrical platform because that is what the phrase literally states. On the other hand, if we understand Shakespeare's phrase metaphorically, it invites us to see those around us as actors performing on the stage of their lives. We are invited to observe them 'performing' their lives with all the joys and sorrows they bring. To witness humanity around us in such a way is a tremendous thing because it may inspire empathy within us. A

literal interpretation cannot do that.

I am using the word spiritual as a metaphor to signify the creative force that animates life. The Taoists use the work "chi" to mean the same thing. If a reader would prefer a more secular metaphor, simply think of 'spiritual' as the evolutionary impulse, for it too describes an energy that animates life.

Spiritual vs. Religious

Until the mid nineteenth century the history of art was filled more with religious themes than anything else. This book is not an examination of religious art, nor of a 'religious' experience while making art, though a religious person might describe it that way. Instead, we are exploring a knowing of the spiritual in the creative act. This goes beyond the traditional structures of any of the world's religions.

Being religious has to do with belonging to an organized institution that holds as true certain theological concepts about spirituality that members of the institution are expected to believe. Therefore, religious art would promote those concepts. Spirituality on the other hand, describes an individual's own inner, intuitive experience of the transcendent without needing to belong to an organized religious institution, or hold and believe in set theological concepts. This is why a religious person may not be spiritual, and a spiritual person may not be religious. Also, I am using the word "transcendent" as another word to indicate that the spiritual experience is beyond mental comprehension and categorization. After all, if the spiritual dimension could be described, measured, weighed, and analyzed there would be nothing transcendent about it. It would be just another mental structure. The spiritual dimension is beyond mental comprehension, so we have to accept it as an unknowable, mysterious, incomprehensible something that is beyond us. It is transcendent. All religions—Christianity, Judaism, Islam, Buddhism, Taoism, Vedanta (Hinduism) and so forth—are

religious because they offer theological systems of concepts to believe in. The spiritual, on the other hand, describes a personal relationship with the something-or-other about which religions have formed concepts. Zen Buddhism, interestingly, is sometimes considered spiritual, but not religious because it de-emphasizes a belief in theological systems, and emphasizes personal experience of the transcendent. It is in this sense that the awakening artist explores the relationship between the inner spiritual dimension and creativity. He allows the spiritual dimension, that can only be sensed but not known directly, to flow into creative expression, into form.

Creativity

Creativity is always neutral; it is neither a good thing nor a bad thing, though humans have used their creativity to do both harm and good. Creativity has been used to make weapons to harm people, and creativity has been used to make medicines to heal people. Is creativity spiritual? Yes, it can be, when a spiritual person is being creative. Creative action is neutral, but it always reflects the state of consciousness of the person expressing creatively.

Many artists throughout history have recognized a relationship between their creativity and what they believed was a transcendent source of their creativity. Michelangelo, for example, believed that God was working through him. In recent centuries many artists have sensed a creative source that was beyond them that is also within them, and have desired to allow it expression through them. Artist Wassily Kandinsky sought to fill his art with 'spiritual resonance'. And artist Jackson Pollack claimed that his inspiration did not come *from* nature because he *was* nature. Whether or not artists label that sensing as 'spiritual' or 'nature' matters little. What matters is the realization of a creative source that is beyond the artist's mind.

The following are comments by several artists, and others,

suggesting this. Artist Keith Harding said:

> When I paint, it ... is transcending reality. When it is working, *you* completely go into another place, *you're* tapping into things that are *totally* universal.[1]

Author Lewis Hyde commented that many artists "sense that some element of their work comes to them from a source they do not control".[2]

Composer Igor Stravinsky said he did not write *The Rite of Spring*; he transcribed it.

Artist Mark Tobey wished to "express higher states of consciousness" in his artwork.[3]

Artist, Morris Graves stated: "My first interest is in Being — along the way I am a painter."[4]

Sculptor Isamu Noguchi noted that " . . . art comes from the awakening person. Awakening is what you might call the spiritual . . . Everything tends toward awakening."[5]

Art Historian Roger Lipsey (1988) stated in *An Art of Our Own*, "The artist leads us to sense our own stillness between activities, and beyond that an abiding stillness."[6]

Mythologist Joseph Campbell observed: "The way of the mystic and the way of the artist are related, except the mystic doesn't have a craft."[7]

George Rowely, (1959) author of *Principles of Chinese Painting* pointed out that the Chinese artist "had to experience a communion with the mystery of the universe akin to that enjoyed by the Taoist 'mystics'."[8]

Artist and Zen master Hakuin stated that, "If you forget yourself you become the universe"[9]

Albert Einstein said: "The finest emotion of which we are capable is the mystic emotion. Herein lies the germ of art and all true science."[10]

Artist Andre' Enard expressed it this way: "Isn't the ultimate desire of human beings to perceive an order that surpasses us yet is within us, to participate in that order?"[11] Enard's statement hints at a higher form of creativity that the artist is part of, and potentially one with.

Isn't the ultimate desire of all artists to participate in a universal expression of creativity that is beyond them, and yet flows through them? Christians and Jews have called it God, Allah by Muslims, the Tao by Taoist, the Unmanifest by Buddhists. Various spiritual teachers and scientists sometimes call it the One Life, or the Universal Intelligence of Life. Astrophysicist Carl Sagan proclaimed: "We are a way for the Cosmos to know itself."[12] Meaning, it seems to me, there is the potential for an inseparable knowing of creative oneness shared between oneself and the Cosmos. Sagan also said "If you want to make an apple pie from scratch, you must first invent a universe."

Each quotation above points to something transcendent. They are metaphors that indicate something beyond mental comprehension. If it is beyond our mental comprehension then how can we know this universal creativity? Just look around at the infinite variety of life forms. Evidence of the universe's creative expression abound. The artist who is becoming aware of the infinite creativity that is beyond him, that flows through him, and that he is ultimately one with, is the awakening artist.

The fact is, understanding art is not difficult, but the intellect, disconnected from anything deeper, likes to imagine that it knows something mysterious and special that others do not. But the awakening artist understands that there are no objects of art that are particularly difficult to grasp mentally. Some art is predominantly intellectual because the artist, and many viewers, believe that the intellect is superior to any other way of creating and viewing art. But from the view of the awakening artist, great art goes much deeper than the intellect, much deeper than clever

ideas. Truly great art touches the depths of a person's whole being, not just their thinking. When we look at a Monet painting, for example, we usually do not expect to acquire intellectual information from the experience. Rather we are moved at a deeper, non-verbal, non-intellectual level within ourselves. To perceive with one's whole being in this way goes beyond intellectual analysis. As we shall see later, the intellect has its place in making art. However, we are not fooled into believing that the intellect is supreme when it comes to creativity, because creativity, when expressed from the transcendent level, is beyond the intellect. As Joseph Campbell suggested, the function of mythology and the artist is to spiritualize the place as well as the conditions in which we live.[13] The intellect alone cannot do this.

The awakening artist allows space for this universal creative energy to flow through him or her, and this flow includes the interaction of perceptions, ideas, and feelings. There is nothing serious or heavy about it; yet creating with this awareness is always profound because it connects the artist to the universal creative intelligence of life, and that is the source of true intelligence and beauty in art. What beauty is, however, is a matter of opinion, so now we will look at the meaning of beauty from the awakening artist perspective.

Chapter 2

Seeing Beauty and Telling the Truth

There is an expectation held by many viewers that art should be beautiful. After all, when we see something beautiful it brings us pleasure, satisfaction, and delights our senses. It would seem only reasonable, to many viewers, that a work of art should do that. At the very least viewers expect it to offer them a good reason to look at the art—because it presents an interesting idea, or encourages them to look at the world in a new way. So let's look at some of the assumptions we have about art, what art is, what it should look like, and what is should mean.

What is Art?

Today art can mean just about anything. A person merely has to declare that something is art to them, and if that is his or her opinion then who is to argue? If art world scholars, historians, critics, dealers, and curators insist that something is art, and the rest of the world doesn't think so, who is to argue? It's their opinion. This lack of a concrete definition of art is a relatively recent phenomenon. This ambiguity, which is not necessarily a bad thing, started with the deconstruction of the meaning of art by Picasso and the other modern artists of the early twentieth century and continued into the 1970s.

In earlier times, such as during the era of the French Academy of Fine Arts in the early seventeenth century, the definition of art was very precise. If a painting or sculpture did not fit the strict guidelines of the Academy, it was not art. It is unknown when the term 'art' and 'artist' came into use. During the Middle Ages the word 'artist' existed in some countries and referred to individuals whose craft and skills were exceptional. During the High Renaissance in the fifteenth century, those who participated in

making works of art were usually considered skilled laborers, unless they were extraordinary individuals such as Da Vinci, Michelangelo, or Raphael. Going back to the 'art' of early humans, such as the Chauvet cave paintings in southern France from 35,000 years ago, it is impossible to know what they called these cave paintings, if anything. And as we shall see in Chapter 4, some modern scholars theorize that the cave painters were actually shamans, or holy men, who recorded their visits to a spirit world on the walls of the caves. The artist-shamans provided an important link between their societies and the spirit world.

In this book I use the term "art" and "artist" loosely to describe the many objects we will be discussing and the individuals who created them. Therefore "art" for our purposes is defined as objects created to inspire a specific aesthetic, spiritual, political, social, or psychological effect on viewers.

Conditioned and Unconditioned Beauty

Most of us view art through a lens I call 'conditioned' beauty. Based in human conditioning, which is naturally biased, conditioned beauty compares one thing to another. A chrysanthemum is beautiful, but a bat is creepy. Conditioned beauty can also be culturally specific. What is pleasing in one culture may be displeasing in another. Chinese opera may sound lovely to Chinese listeners but may sound like fingernails on a chalkboard to the ears of Western listeners. Between cultures, conditioned beauty can always be challenged and debated.

In Western civilization, conditioned beauty in art changes over time. In the nineteenth century, some critics initially considered Van Gogh's art garish and childish. But now in the twenty-first century most find it beautiful, spontaneous, and alive. For thousands of years, scholars and philosophers have written about conditioned beauty, though they did not call it that, they just called it beauty. The art world has been a main

stage for the debate over conditioned beauty for centuries. When beauty is being challenged in art, what is really being challenged are the assumptions and cultural conditionings of viewers, which are always conditioned and relative. Conditioned beauty is therefore temporary, contextual, and always changing in the next moment.

Conditioned beauty is a matter of opinion and point of view. The observer always projects the state of his or her own consciousness upon what he or she sees. In other words what is observed will always be a reflection of the observer's inner state. For example, an artist friend of mine and I once walked through an art exhibition wearing our audio guides, listening to the recorded voice of a prestigious museum curator explain the artwork. We came upon a large photograph of a dark forest with fallen and rotting trees, dripping moss, and black puddles of earthy goo full of bugs leaping about. The curator's recorded voice explained how this picture represented the darkness and uncertainty of the human condition. It symbolized the gloom that resides in the human subconscious. My friend and I looked at each other and burst into laughter. He, besides being an awakened artist, is also a horticulturalist and I knew that he saw the large photograph as teaming with life, complex beauty, and as a marvel of transformation. His response to the curator's comment was that a photograph of a clear-cut forest would better represent the gloom in humanity's subconscious. In this example, the audio guide curator was projecting his inner state of consciousness upon the photograph, and my friend was projecting his inner state, too.

Conditioned beauty always has at least two points of view, but it is important to know that some conditioned points of view align more naturally with life than others, and I believe this was the case with my friend's point of view. To say that an old growth forest is an intricate and wondrous expression of life is a statement that is truer of the nature of an old growth forest than

to say it is gloomy, and depressing like the human psyche.

Here is another example: One person might say, "The night sky is beautiful." Another might say, "The night sky is eerie because the darkness seems sinister." Both are merely points of view and may be true for each person. However, it seems to me that it is truer to say that the night sky is beautiful because the statement connects the person to the world of which they are a part, whereas to say that the night sky seems sinister only separates the person from the world. Perhaps truer is not the best word to use. To say that it is psychologically healthier to enjoy the beauty of the night sky than to think of it as sinister is certainly true.

Unconditioned Beauty

Artist Morris Graves spoke of unconditional beauty this way: "I, in my nonintellectual way, have determined that beauty is all pervasive and has no opposite."[1] Likewise, from the standpoint of the awakening artist, unconditioned beauty is a quality of being that shines through form. A scene in the movie Forrest Gump illustrates this well. Forrest meets for the first time a young boy who he has just learned that he has fathered. His first response was an amazed and speechless wonder as he looked at the boy. Then he uttered, "He is so beautiful". He did not say: "Well now, let's compare the young lad to all the other young lads to see how well he stacks up". The young boy could have been cute, or not, naughty or nice, but all outer appearances were eclipsed by the unconditioned, unqualified realization of the inner beauty of his son. Unconditioned beauty shines through the form regardless of outer appearances, but it takes an open and available consciousness to see it, as Forrest Gump demonstrated. Unconditioned beauty is like unconditional love, in that it looks at a truth that is deeper than outer appearances.

I sometimes ask my students to recall the first time they were moved deeply by something they saw. They describe it by using

a variety of words such as beautiful, awesome, or sublime. Others say that it is beyond words, indescribable. To one student it is the sight of a yellow rose. I asked her if when she first saw the yellow rose she thought it was beautiful. Almost breathless she said, "No—there were no thoughts. It's difficult to describe. It was a feeling of deep connection; it was so wonderful." For her it was an indescribable and deep connection for which not even the word beautiful was sufficient. In this example the student's experience describes unconditioned beauty which arises from beyond the form but shines through the form. When we are able to sense that shining, we are sensing unconditioned beauty.

Ironically, the more we try to explain unconditioned beauty, the quicker it turns into conditioned beauty, because the nature of explanations made by the mind is to compare and quantify things, making them conditional. On the other hand, unconditioned beauty comes with sudden realization, not explanation. There is a saying, "Who you are speaks so loudly I can hardly hear what you are saying." If we changed that saying to relate to the act of seeing beauty, we could say: "Who you are shines so brightly I can hardly see what you look like."

When we look upon a newborn child, a flower, or sunset we might describe these forms as beautiful. However, the word beautiful alone merely attempts to encapsulate a wonderful feeling-sensation that is far larger and more profound than the word itself. As Cubist artist George Braque said, "To define a thing is to substitute the definition for the thing itself." We should never be fooled into thinking that the word beauty, could possibly define the reality of unconditioned beauty. Not everyone is aware of unconditional beauty because they habitually conceptualize their visual experiences. When a glorious sunset is pointed out to them, for example, instead of allowing it to flood their entire being with beauty, space and awe, a switch flips in their minds and they immediately launch into a story from their past. Like the time they saw a sunset in Bali, but it wasn't easy

22

getting there because their luggage got lost at the airport, and uncle Bob couldn't find his ticket . . . the unconditional beauty of the sunset before them in the present is completely extinguished.

When that mental switch is flipped; whatever was seen automatically becomes conditional because it is then compared, measured and weighed against other things that have been conceptualized. To experience unconditioned beauty is to perceive without defining. In other words you are completely and fully *aware* of what you are seeing, but you are not *thinking* about what you are seeing.

As an exercise in awakening artistic perception, practice looking at forms that are commonly considered beautiful, like a colorful sunset or a flower, and hold it in your awareness and enjoy it, without forming an opinion or thoughts about it. Then notice the feeling sensations in your physical body. You will notice, with practice, that your body will feel good, happy, or contented when beauty is given space within you. This may seem like an odd artistic practice, but this practice is intended to allow you to begin seeing with your whole body and whole being, not with just your eyes and mind. It is the only way unconditioned beauty can be seen.

Finding beauty in the ordinary and unexpected

Art historian Roger Lipsey said:

> One of the great and sad secrets of art is that the ordinary reality goes largely unobserved. The artist who truly sees a flower, a dingy street, a face, or a hillside is already beyond most of us. He or she is turned in the direction of epiphany.[2]

Who would argue that a rose or a sunset is not beautiful? These expressions of nature are easy and familiar forms that connect us to unconditioned beauty. They are obvious to us and it is difficult to not notice them. And yet the world is full of other ordinary

forms that may turn our attention in the direction of epiphany. Gnarled tree roots, for example, or fracture patterns in a stone, or the approach of black rain clouds. In their own way these forms are also beautiful. For example, consider a boulder in the forest splayed with cracks and fissures, moss growing on it, with a surface texture aged over thousands of years. Few people walking by the boulder may notice that it is visually extraordinary. Most likely, they will not notice the boulder at all. They will be looking down the path, talking, or thinking about something. But to the awakening artist, or anyone who is perceptually receptive and sees with innocent and open eyes—with complete awareness—the beauty of the boulder is as obvious as that of a yellow rose or grand sunset. Some forms of nature are stereotyped as unpleasant, like rotting leaves, patterns carved into the earth by a mud slide, the after effects of a forest fire, or the path of destruction left by a tornado. Violent natural forces can cause hellish situations for humans, but from a purely visual point of view, without labeling or judging, they might also be awe inspiring and wondrous to behold.

To see beauty in the human-made world can be a little more challenging, but it is there too. Experiencing the awe-inspiring beauty of a volcanic explosion from a safe distance is much easier than experiencing the visual beauty of, say, a parking lot. In the movie *American Beauty*, there is a scene in which a discarded plastic bag is blowing in the wind. Who would consider trash blowing on the street to be beautiful? But if you watch with openness, the plastic bag, gliding gracefully and lyrically in the wind, becomes beautiful. In this example, the movie director, Samuel Mendes, artfully lures us out of our established assumptions about beauty and exposes us to a broader, deeper awareness of beauty.

Why do we so often miss the beauty that is all around us? Usually the mind's attention is focused on the words and images inside our heads, not on the world out there where beauty is

hiding in the open. You would think that to suddenly come upon something of extraordinary beauty, it would stand out boldly compared to all the normal things we see everyday. But in fact, the human mind is so conditioned to applying the concept of 'normal' to everything it sees that beauty is rarely recognized, no matter how boldly it may stand out. It is often right before our eyes, yet invisible. We briefly notice a colorful sunset, or flower, but that's about it. We see it just long enough to mentally categorize it as beautiful, file it away in the brain's image reservoir, and then quickly return our attention to normal. Even if you point out something beautiful, the conditioned mind will still see it as normal. It cannot be otherwise. And no matter how much explaining and enthusiasm you express to help a person with a conditioned mind see the beauty that you see, they will not. What will they see? Only a clump of trees you are pointing at, the back of someone's head you seem fascinated with, the wet moss you are poking your finger into, the broken fence you must stop and look at, or the clods of soil that you are excited about. English landscape painter, John Constable (1776-1837) said this:

> The sound of water escaping from mill dams, willows, old rotten planks, slimy posts and brickwork, I love such things. These scenes made me a painter.[3]

American painter Georgia O'Keeffe (1887-1986) once stated:

> When you take a flower in your hand and really look at it, it's your entire world in the moment. Most people in the city rush around so, they have no time to look at a flower. I want them to see it whether they want to or not.

Our journey is to move beyond the conditioning of our own minds. In other words, the journey allows us to begin seeing the deeper beauty of the world around us. Then we can begin

exploring that deeper beauty through our creativity, and finally to make it available to others. People sometimes come into my gallery and express sincere appreciation for the artwork on the walls, and feel moved in some way by what they see. I am always delighted and grateful to share a few moments with them. As they walk around the gallery and are busy looking at the artwork, I will sometimes look out the window at the green everywhere, the trees swaying gently, the afternoon lighting glinting and the shadows growing, the cars and bicyclists at the stop light, or the rain tapping the street. Not even the greatest artist in the world could even begin to adequately capture the complexity of that beauty in a work of art. But as an artist, you try anyway, not because you imagine you could possibly portray the infinite beauty of the world through an art medium, but because it's pleasurable to be in the world, and to enjoy embracing it. And apparently, that is sufficient because others are sometimes touched by what you create and for a brief moment they see the beauty of the world through your creation, which they are apparently unable to see as easily by looking at the world for themselves. As Modern photographer Paul Strand put it:

> . . . the artist's world is limitless. It can be found anywhere far from where he lives or a few feet away. It is always on his doorstep.[4]

Truth-Telling Art

Some artists are not interested in beauty or ugliness. Their only mission is to tell the truth, as they believe it to be. They want to portray injustice, insanity, or what they believe are the skewed perceptions of others. There is value in this kind of truth telling when it exposes a cultural shadow. It can teach us a thing or two about ourselves.

Take the famous example of Dada artist, Marcel Duchamp's Fountain sculpture, a porcelain urinal that he attempted to enter

into a prestigious art exhibition in New York, in 1917. It was not accepted but it ignited a debate in the art world about the nature of beauty and the meaning of art. Anyone can look at Duchamp's urinal and see that it is not beautiful and say that it is not art. But it is that very presumption that prompted its 'creation'. Not all art is destined to be beautiful when its task is to expose our assumptions, and the awakening artist always welcomes the examination of assumptions.

However, a problem with art that is designed only to challenge human assumptions is that once you get it, once you have examined your assumption, the art has served its purpose and is no longer needed unless the artist has also brought something transcendent into it. The artist may be given a line in art history books or he may become a legend. But the art ends up as just another material object for investment by collectors and speculators. It has no more transformative power, and therefore no spiritual value. Its transformative power has been spent, we've learned our lesson and we have moved on. This is the limitation of art that is designed to merely teach. Take, for example, a painting that communicates the inhumanity of slavery. Once a culture, or any individual gets the core message that slavery is inhumane, the painting is of no use anymore, *unless* it has other properties of concept, style, design, or historical significance that sustains the artwork's existence and carries it beyond its core message.

On the other hand, take the example of Picasso's *Guernica*, which painfully portrays the horrors of the Spanish Civil War of 1937. Today the Spanish Civil War is just a part of history, so our awareness does not need to be transformed in relation to it. However, the truth-telling potency of *Guernica* has become a universal symbol of the horrors of *all* war. It is such a powerful reminder of human insanity that when *Guernica* is displayed today, in the form of a tapestry at the United Nations building in New York City, thousands of visitors can be reminded of the

insanity of all war.

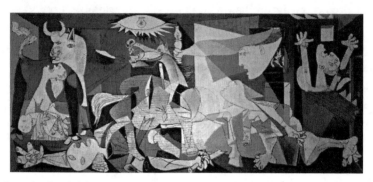

Guernica by Pablo Picasso. A universal symbol of the horror of all war.

"Shock art" is a style of art and it is hard to pull off well. Shocking art plays a part in awakening, too, when it shocks us out of spiritual unconsciousness, such as when images of war depict human insanity. In 2011, there was a photography exhibition of children who were affected by the Chernobyl nuclear disaster twenty years earlier. Their bodies were deformed beyond recognition. Does that not evoke our compassion? Does it tell us something about human madness?

Some shock art is intentionally grotesque and disturbing, to elicit a negative emotional reaction in the viewer. I recall an art performance work at an art opening in which the artist defecated in a bucket and then covered himself in his own excrement. That might tell us that artists can do almost anything they wish in the name of art, but it neither evokes our compassion for humanity nor takes us deeper into the reality of Being.

The First Recognition of Beauty

Most likely the first glimpse of beauty by humans millions of years ago occurred long before the mind could call it anything; before humans developed the word "beautiful." A sunset, a waterfall, a flower, an animal, when viewed, evoked pleasant feelings, a sense of connection, and delighted the eyes, and yet

served no particular survival, utilitarian, or procreation purpose. The first recognition of beauty was one of the first indications of the "flowering of human consciousness", as Eckhart Tolle describes the spiritual awakening of humanity in his book, A *New Earth: Awakening to Your Life's Purpose*. When I have shared this concept with others, that the earliest recognition of beauty is a sign of an emerging higher consciousness, some have challenged me to prove it by citing anthropologists and scientists. To me, however, the idea is self-evident: It is a fact that if you go back far enough in time there was no beauty in the world because there was no world. It is also a fact that at some point during the course of evolution, a life form emerged (humans) that was able to recognize beauty. Because these two facts are obviously true, it proves that something happened that enabled beauty to be recognized. It is also a fact that whatever it was that enabled that recognition to occur required consciousness, otherwise it could not have been recognized. Therefore an emergent consciousness was necessary for the first recognition of beauty.

Furthermore, prior to the advent of language, humans or subhumans, were unable to debate, or have philosophical arguments about a concept of beauty. To formulate a concept of beauty requires a relatively advanced mental capacity, which sub-humans did not yet have. However, at some point humans recognized beauty for the first time and that was all there was to it. That was a moment of awakening.

When humans first looked out upon the world and saw something that evoked a pleasant feeling, they were becoming aware of something within themselves but projecting it out into the world, into the flower, the sunset, the waterfall, or animal. A beautiful scene by itself cannot cause a response in a human, but there is something within the human that recognizes it. How is this so? Of itself, any scene is merely an arrangement of atoms. However, something within the person interprets the

arrangement of atoms as beautiful. Therefore beauty arises from within the person, not only from the scene. Consequently, when a beautiful scene is looked upon, the viewer is seeing a reflection of his or her own inner state.

Seeing with Your Whole Being

Both Monet's painting and Beethoven's music, just to use two examples, often reflect a beauty that endures, though both were considered crude, childish and ugly by many in their own time. How can you know enduring beauty when you encounter it? When you experience any form of art with openness, in stillness, without mental commentary, opinions, or preconditioning, you become aware of how your physical body reacts to the art. How does your physical body mirror what you see? What is your 'gut response' to the art? How does experiencing the art affect your whole being, not just your thinking? When we perceive with openness, without preconditions, it becomes clear very quickly how something resonates within us. If we are open and still inside, those things with which we find harmony, will feel compatible within us. This is an experience that you can test for yourself. When you live in your whole being, and not just in your mind, works of art that are experienced as repulsive will feel disharmonious. They might be called ugly but the label makes little difference. What is important is that we notice the disharmony they produce within us.

What does disharmony feel like? Have you ever watched a movie when suddenly something shocking, or disturbing is projected onto the screen? Your eyes close, you wince, you groan, your chest tightens, you want to cover your eyes with your hands, your stomach muscles tense up. These are all the body's reactions to exposure to disharmonious visual imagery. The inner intelligence of your body believes something is wrong and takes action to protect itself.

Here is a story related to this: In the late 1950s, when I was

about six years old, my older brothers were occasionally burdened with the unhappy task of having to babysit me. Sometimes they would take me cruising with them in my brother's metallic green 1948 Oldsmobile hot rod. We would drive down Foster Boulevard, in Portland, and circle around and around a drive-in restaurant where all the kids hung out, and sometimes we went to movies. One night we saw a double feature showing the science fiction horror movies *The Fly* (1958), in which a scientist accidentally turns himself into a human-size fly when his transporter invention malfunctions. And another was *The Blob* (1958), in which a massive pink goo goes around swallowing people. There wasn't a movie rating system in those days like there is today to help guide parents, or teenage brothers, in selecting appropriate movies for children. At any rate, after seeing *The Fly* and *The Blob* I was horrified for months. At that early age I was unable to distinguish reality from fantasy. The Fly and the Blob were real. They were always under my bed, in the closet, or lurking in the dark. Some people are more affected by disharmonious imagery than others. Michelangelo, in order to study anatomy, dissected hundreds of corpses with no problem. But eventually he came to the point where he could no longer do dissections. According to Michelangelo, the sight of dismembered bodies began causing him to feel sick and vomit.

If nothing else, ugly art and ugly things in general, remind us of the absence of beauty, and beauty is only a word that attempts to describe a quality of Being. But the experience of it, prior to labeling it, is beyond words. That experience is the oneness we know with what we observe, as was described above in the story of the woman who saw a yellow rose. To see beauty in nature, or in an inspiring work of art, you must have space within yourself to perceive it. How could it be otherwise? When we are preoccupied with our problems, or the continual chattering of our minds, there is no space within us for beauty, and no ability to perceive what the physical body is experiencing.

You may, or may not, remember the first time you ever saw something truly beautiful. In that moment of perception stillness was within you. First you saw the beautiful thing then you may have said, aloud or silently, "That is beautiful!" But even before labeling it as beautiful you were only seeing, only perceiving. You were recognizing something that was wonderful, which could not happen without an available space within you to receive it and recognize it. While viewing the world with one's whole being may be unfamiliar to most people, many no doubt already do so, but have never thought of it as such. Perception with one's entire being, not just with the mind, is the way of the awakening artist, and it changes the way we perceive the world, works of art, and even, as we shall see, the history of art.

Chapter 3

The One Art Movement

Art History

When I used to sit in Monday morning art history classes listening to a professor drone on about obscure names and dates, I often felt that it would be more inspiring to listen to a recitation of an insurance policy. It wasn't until many years later, when I took an interest in the evolution of human consciousness and human spiritual development, that the subject of art history came alive for me.

Any comprehensive view of art history (which this book does not claim to be) will begin with the earliest forms of human creativity and end with the art of today. However art history has not, so far, shown the evolution of spiritual consciousness through art or portrayed the "flowering of human consciousness"[1] Nor has it been the role of art history to state what is 'good' or 'bad' art, or to attach a moral or ethical condition upon art. Instead, its function has merely been to record whatever happened in some kind of order, and then group styles and trends into various art movements.

Art Movements

Art movements, like Impressionism or Surrealism, were formed by cultural, stylistic or philosophical commonality that members of the movement shared. The members banded together to voice their creative cause. The entire span of art history can be seen as a vast collection of artistic styles but there appears to be no singular thread that unites them all. Generally, art history views them through a fragmented perspective, like a kaleidoscope, which includes thousands of past and present cultures, all different from one another, and each with distinctions useful for

discussing them.

The Span of Ages

Art history, and its kaleidoscope of art movements, is part of the overall development of humanity. Historians have sought to measure human development in many ways. One way has been to categorize human progress in terms of Ages, from the Stone Age, beginning around 2.5 million years ago to the Digital Age of today. Between those two poles lie many other Ages such as the Iron Age, the Bronze Age, the Industrial Age, the Machine Age, and the Nuclear Age. And out of each of these ages arose artistic expression that reflected the state of consciousness of the humans of that time. Archeologists and art historians have examined, catalogued, and stored in museums countless artifacts and works of art from all of these ages. The division of human development into ages is very useful when studying the intellectual and technological development of humans, but it offers little to our understanding of the spiritual evolution of human consciousness, which we will now look at.

Chart 1: The Span of Ages

The Spiritual Evolution of Human Consciousness

Throughout the span of ages many spiritually enlightened individuals have emerged. To communicate their spiritual teachings, these enlightened ones often used stories that were easily understood within the context of their cultures. For example, Jesus lived in a highly patriarchal society so he often referred to God as a Father. Spiritual teachers spoke in a manner that their culture could understand. And yet, when we study the teachings of great spiritual teachers of different ages, which also

include the Buddha, Lao Tzu, Meister Eckhart and others, we see that they shared certain commonalities. For example, sacred texts of each master have shown that each portrayed qualities of deep inner peace, a sense of wholeness and interrelatedness of all life, and a sense of connection to a greater source of intelligence than the human mind. No doubt, there have been many other awakened ones besides the spiritual teachers mentioned above, who knew these same qualities but went about their daily lives unknown to the larger world and the record of history.

The compulsion to awaken within the human species as a whole is evidenced by the emergence of wisdom in the world, starting before the earliest Greek philosophers. Religions have emerged to give humans inner peace, a sense of relationship to the world and universe, and a sense of resolution to the inevitability of the death of their human form. The sciences have emerged to enhance humanity's well being, and enable us to enjoy the marvels of the physical world. To what extent philosophy, religion or science have actually been helpful to humans could certainly be debated. However, it seems reasonable to believe that the highest potential of philosophy, religion and science is the well being of humanity. And yet these same fields of human development have sometimes been used to the detriment of humanity.

Another example of the evolution of spiritual consciousness is the emergence of human rights, which recognizes the respect, dignity and sovereignty each human deserves. And the field of environmental awareness has emerged to educate humans about their responsibility within a larger environmental ecosystem. All of these developments suggest that within human beings is an urge, a compulsion to awaken, to become aware. As Carl Sagan suggested, the universe is seeking to become conscious of itself through humans. Within this overall context of human development the artist has been there all along. They have created images that, in the most ideal sense, serve the well being of the

artist and the community in which he or she dwells. It is a service that contributes to awakening. This, and the love of the artistic creative process, is the common thread that binds all artists throughout time.

The One Art Movement (The Thread That Unites Them All)

It is out of the source of all Life that all art and art movements have emerged. Clearly, if there was no life there would be no artists, art, or art movements. From this perspective all artists are united as participants within the One Life that has created all human experience. This is the thread that unites them all. The One Art Movement includes all art and every artist throughout the ages, including those of the present day, who have contributed their creativity consciously, or unconsciously, to the expression of the One Life, and all artists have. Most artists would probably not think of their creativity in that way, which is understandable because this is an entirely different way of looking at artistic creativity. From the awakening artist point of view, all artists and art movements are contained within this one vast flow of human creativity. In the language of his day, artist Robert Henri, author of *The Art Spirit* (1923) described it as a [league] of artists whose relationship transcends time and space. For the purposes of this book I am calling it the One Art Movement.

The Three Ages of the One Art Movement

If you take the hundreds of art movements the world has ever known, throw them into a pot, add a dash of genius, stir in generous amounts of human insanity, season with spirituality, cook on high heat for 45,000 years, presto!—you get the One Art Movement. To simplify the recipe, I have divided the One Art Movement into three ages. Here is an overview of the three ages of The One Art Movement. Following this, I will discuss each one

in more detail.

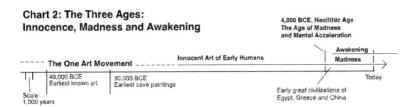

Chart 2: The Three Ages:
Innocence, Madness and Awakening

The first age of the One Art Movement is The Age of Innocence. The second age is The Age of Madness, and the third age is the Age of Awakening. When examining these ages we will see that human innocence, madness, and spiritual awakening are reflected in countless works of art, including today. We will explore many of those works of art, and the artists who made them, in following chapters.

The first Age of the One Art Movement, the Age of Innocence, began with the emergence of Homo sapiens and became especially pronounced during the Upper-Paleolithic Period about 45,000 years ago. This period has also been called The Creative Explosion by scientists because of the unprecedented burst of artistic creativity found in cave and rock paintings of that period. I refer to this same period as the Age of Innocence in order to emphasize the absence of technological complexity and sophistication, as compared to modern humans.

The second Age of the One Art Movement is the Age of Madness, which began about 4000 BCE and continues today. This Age began with the rise of the great civilizations of Egypt, Greece, China and others, and demonstrated a dramatic increase in technological complexity. However, according to many anthropologists and archeologists, this period also came with an unprecedented level of human cruelty. The Age of Madness continues today and the proof of its existence is the presence of cruelty in the world today.

The third Age of the One Art Movements is the Age of

Awakening. This Age is about the evolution of spiritual consciousness. The impulse to awaken has been stirring within human hearts for eons. As we shall see, this urge has been evident in many works of art throughout history. The fulfillment of the Age of Awakening is happening now as increasing numbers of people become aware that they are one with the same creative energy that has brought forth all of life.

As presented here, the three Ages are sequential, going from Innocence, to Madness and to Awakening. However, we will also see how they sometimes overlap and intermingle. And in some cases, all three can be seen fused together within a single work of art.

The Age of Innocence

In this book the word 'innocence' does not refer to an idealized or fairy tale state. It refers to a psychological state. The innocence of early humans stands in relative contrast to the insanity exhibited by humans who followed them, and whose madness we will discuss shortly. When archeologists and anthropologists have compared and contrasted artifacts from both eras, startling differences were discovered. They found that the art of early humans was without depiction of war, whereas after the madness began, in about 4000 BCE, depictions of war were common, even glorified. Three separate archeological overviews showed "no evidence of war in all of the Upper Paleolithic Period (40000 to 10000 BCE)"[2]

The art of early humans was without the portrayal of the subjugation of women and children, and without the domination and enslavement of people, whereas these abuses were common-place and often portrayed in the artwork of the Age of Madness, beginning with the Ancient Egyptians. The art of early humans contained images that are believed to relate to sacred rituals but not religious persecution, as was depicted only after the Age of Madness began. Individuals were portrayed in the Age of

Innocence but none were depicted as superior people who dominated others, as was common after the madness began. The art of early humans was without depiction of great heroic deeds that were performed by members of their societies. Compared to the insanity that followed, the psychological state of the early humans could well be described as innocent.

One of the ways archeologists have been able to examine the life of early humans, and compare their way of life to the mad humans who came after, has been through examining gravesites before and after the Age of Madness. Before that time gravesites were more or less all the same; none were particularly special. After about 4000 BCE however, archeologists found abundant evidence in gravesites that indicated social and wealth stratification in a manner that had never existed before. For example, they found graves of dominant male figures that contained an array of valuable objects, and also remains of their wives. Forensics has shown that the women in these cases were sacrificed and then placed into the graves with their husbands to keep them company in the afterlife. On the other hand, gravesites of people of lower status within the same community were no more than communal pits. Extreme examples of psychic disharmony revealed in graves are the Egyptian pyramids, which served primarily as ostentatious gravestones.

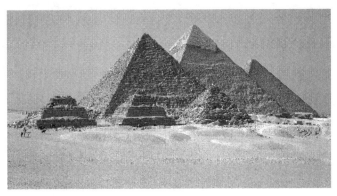

Giza Pyramids, ostentatious gravestones

The Age of Madness

After humans went mad, those who came to have power over the creativity of other humans were pharaohs, kings, emperors, popes, aristocrats, and the wealthy. They often portrayed themselves as gods, or in some way as superior to other humans. Since the Age of Madness began, the largest part of the history of art has been about human suffering. It has been abundantly portrayed through religious and political ideologies, and through images of 'superior' people. This madness has also been revealed in historic and allegoric paintings that either attempt to reclaim the innocent time that had been lost, or to glorify the accomplishments of the supposed 'superior' humans.

There are two salient periods in human history that archeologists tell us stand out among all others. One is the Upper-Paleolithic when humans demonstrated tremendous creativity for the first time. This period is what I have called the Age of Innocence. The other was an acceleration of human technology that occurred about 6,000 years ago, during the Neolithic Period when humans were evolving from the Stone Age to the Iron Age (See Chart 1: Span of Ages above). This evolutionary acceleration eventually led to the early great civilizations of Egypt, Greece, and China. However, along with it came a disastrous collective psychological trauma, which we saw vividly in our comparison of innocence and insanity in art above. Furthermore, this trauma has been portrayed in mythologies from around the world for thousands of years.

Chart 3: The Age of Madness, Viewed Mythologically

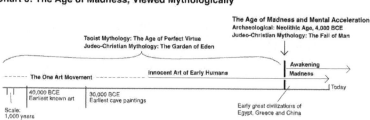

For example, most cultures of the world have a Fall story, spoken of in a variety of ways but meaning more or less the same: at some point in the past humans lost their relatedness to nature and each other, and to the whole of life. This time period in human history, mythologically called the 'Fall of Man', or the 'Fall', has been examined in literature and art, and studied by historians, archeologists, and mythologists for centuries. Many scholars have correlated the emergence of the human ego 6,000 years ago with the mythic story of the 'Fall of Man'. It was a time when humans lost their innocence and communion with nature and God and were expelled from the Garden of Eden as the Old Testament version of the story goes. Taoists called the time preceding the Fall as the "Age of Perfect Virtue." In Mesopotamian mythology, Adapa, like Adam in the Judeo-Christian version, represented humanity and was endowed with all wisdom, but because of his misdeeds was refused mortality. What mythologists have called the Fall, I am calling the Age of Madness.

In his book *The Fall: The Evidence of a Golden Age, 6,000 Years of Insanity, and the Dawning of a New Era*, (2005) author Steve Taylor describes this state of madness. He believes we are still living in it today yet imagine ourselves to be 'normal'. He cites the existence of war, the suppression of women and children in many societies, the domination of the masses and their economies by the few, ecological ignorance, obsession with wealth, fame, success, and power, as evidence of this madness. It is a set of pathological behaviors that is considered 'normal' in most societies today, and is insane, according to Taylor. In his book he explores where this madness came from, and examines if this really is 'normal' behavior. He and other scholars present a great deal of evidence to suggest that early human beings were much saner than we are today, and that these pathological behaviors did not exist in their time.

The madness began as a result of environmental catastrophes,

which produced culture-wide psychological trauma. One of the origins of madness is the desertification of the Saharasia region, which displaced entire cultures. Taylor says:

> According to scholar, Brian Griffith, at 9000 BCE the area of the Sahara desert was "The very portrait of a happy hunting ground. While much of Europe was still incased in ice, ancestors of the Europeans thrived in the green Sahara"[6]
> The area was like the savannas of Kenya, Griffith suggests, full of grazing antelope and big cats.
> The fertility of Saharasia before 4000 BCE was probably due to the retreat and melting of glaciers after the last age, which made sea levels rise. But eventually the glaciers shrunk and melted away, and there was no more moisture. Sea levels fell and, beginning in the Near East and central Asia, the area started to dry up. Rainfall decreased, rivers and lakes evaporated, vegetation disappeared and famine and drought took hold. Farming was impossible, and the lack of water made hunting treacherous. As a result there was a mass exodus of animals and people from the region.
> As we have seen, the peoples who lived in the region while it was still fertile were — like all other people on earth before 4000 BCE - peaceful and non-patriarchal, and egalitarian, with a healthy, open attitude to sex and the body. But it seems that this environmental change had a devastating effect on them, both in terms of how it affected their lives, and — most importantly — how it affected their *psyche*.[3]

Taylor also correlates this time in history to the mythological story of the Fall, the universal archetype of the expulsion of humans from a garden of paradise. Scientists suggest that a new kind of human came into existence at that time with a heightened sense of individuality and an entirely different way of seeing the world. These new humans were superior in many ways, with

their technological and scientific advances, but they also brought warfare, male domination, and social inequality. All of these behaviors created a schizophrenic nightmare that most humans live in unconsciously even today without knowing it. Yet, according to Taylor, some people are beginning to awaken to see the insanity.

Even though the insanity began to emerge 6,000 years ago, it has taken almost that long to spread around the entire world. However, relative to the millions of years of human existence, it is not an exaggeration to suggest that the emergence of the human ego a mere 6,000 years ago happened with a 'bang'. It was an "ego explosion".[4] Some remote cultures were able to avoid the ego explosion for many centuries, but today there are virtually no primal people who have not had contact with modern egoic humans.

Ultimately, it matters little if a person believes that early humans were savages that smacked each other with clubs, or innocent people who lived in relative harmony with each other and nature. Or whether there was an actual Age of Madness, or a Fall, in humanity's past 6,000 years ago even though evidence points toward that conclusion. What should be obvious to any observer, however, is the psychic disharmony that most of humanity suffers from today. That this psychic disharmony exists at all proves that it has an origin somewhere in humanity's past. My goal is to shine a spotlight on the madness found in art throughout the ages, and the artists who have sought to overcome it. And we will talk about these pioneering artists in upcoming chapters.

Anatomy of Madness

To understand the Age of Madness it is helpful to understand the human ego. In psychology, the ego is thought of as a personal sense of self, a sense of "I". It is our ability to distinguish ourselves from others, and from the world around us. If we did

not have this ability to distinguish ourselves from others we would be incapacitated. We would not be able to recognize ourselves in a mirror. If we were without a healthy sense of self we would not be able to empathize with the experiences of others because we would not be able to associate their experience to our own similar experiences. Without a healthy sense of self a person has difficulty relating to others. People who are severely psychologically codependent exhibit a lack of healthy awareness of self. On the other hand, when the sense of self is exaggerated others are not merely distinguishable from ourselves, they are perceived to be against us, and us against them. Even the environment appears to be against us. As with any other aspect of the human system, if there is an imbalance of its natural order then disease (dis-ease) occurs. The way in which I'm using the word ego is not strictly in the Freudian sense of a personal identity. I am using it to indicate a state of pervasive psychic disharmony in humans, which sees everything as separate from itself, and claims to have an existence and identity separate from life. The ego, in the way I am referring to it, is controlled by the fear of death, and the desire to possess things, even people, in order to feel complete. Ego is not personal because it is a condition that all humans have in common to greater and lesser degrees. Nevertheless, this psychic disharmony produced by the ego is evident throughout art history, easily seen in the myriad depictions of war, slavery, or the godly glorification of single individuals such as a pharaoh or emperor, over the "inferior" masses.

Going a little deeper, when a condition of psychic disharmony overwhelms a person, the person will forget that the psychic disharmony is merely a condition. He or she will begin to believe that the condition is who they are rather than a condition they have. When psychic disharmony is able to form into one's sense of identity it becomes the ego. Ego can only exist when insanity is allowed to coalesce into an identity, when it becomes "me".

Madness in Art

The Age of Madness has formed the foundation of most artistic creativity up to today. It offers a visual record of human suffering and wanting—as well as great beauty. Prior to the Age of Madness, the art of early humans also revealed great beauty but without the depiction of psychological suffering. After the Age of Madness, however, humans began projecting their suffering into the forms they created, including art forms. Today, for example, you can see both innocence and egoic madness masterfully expressed in works of art, and sometimes within the same work. 'Vincent van Gogh's flower paintings, for example, express qualities exuberance and vitality that resonates with those same qualities within the viewer. The paintings of Francis Bacon, on the other hand, resonate with unambiguous human suffering. In Van Gogh's painting *Four Cut Sunflowers* most observers will easily see the beautiful rhythm of floral forms that express an appreciation of beauty in nature. In Bacon's *Study after Velazquez's Portrait of Pope Innocent X* most viewers are immediately struck by the pain and suffering that is projected by the gaping scream of Pope Innocent X. I am not necessarily suggesting that Bacon suffers from egoic madness, just that his painting projects suffering.

Four Cut Sunflowers by Van Gogh (1887) and *Study after Velazquez's Portrait of Pope Innocent X* by Francis Bacon (1953)

The Content of Art and the Creative Flow

Any art with psychotic content such as depictions of war or the superiority of 'special' people over others may nevertheless show extraordinary skill and sensitivity in the making of the art. This is not to say that the portrayal of human insanity means that the artist who portrayed it was necessarily insane. There is often a mashing together of the innocence and intelligence of the natural creative expression of life with the pain and suffering produced by our mental illness. For example, in the picture below, notice the beautiful design and wonderful expressiveness of the horse — as it crushes humans. The creative flow itself is innocent because it is neutral, it just is. Whenever the artist gives complete attention to creating, he or she participates naturally in the egoless creative expression of life.

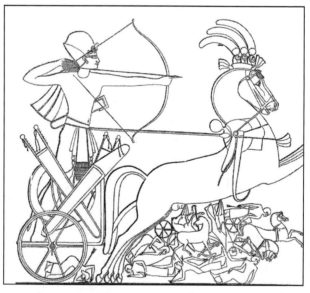

Ancient Egyptian art depicting a 'superior' being warring against perceived enemies. Superior beings were always depicted larger than other humans.

The madness portrayed in art often relates to the *content* of the

art, the insane ideas that are depicted in the art. However, the process of making art is just a process, it is neutral and therefore non-egoic. Nevertheless, the neutral creative process can be applied by the ego for its psychotic purposes. For example, when pharaohs, kings, popes, monarchs, and dictators wanted their images to appear everywhere, and show themselves leading the people, or crushing their enemies, they relied on artisans who were skilled at moving in the creative process, which is neutral and innocent, to produce their grand mad concepts.

Let us say, for example, that a king has his artisans paint a painting of him triumphantly crushing other humans in a battle scene. From the awakening artist perspective, this subject matter portrays madness. Nevertheless, the subject matter, though dictated by a psychotic mind, does not prevent the artisans painting it from participating in the creative process, which is a sane and innocent activity. The artisans can enjoy every moment as they are applying their skills and expertise, and in the end produce a masterful work of art. But the fact remains, the psychotic mind, represented by the king in this analogy, has dictated and controlled the content of the creation. Thus we have the mashing together of madness and innocence within a single work of art, and as we shall see, this same collision of madness and innocence will play out in works of art over, and over, throughout the ages.

The madness from which humans suffer has dominated human creativity for millennia it has been able to 'hijack' the creative spirit of humanity. You could say the innocence of true creativity has been cast and locked into forms dictated by the ego. The artist of course is not free of psychic disharmony either, but in the moment that he or she is moving in the creative process, ego may temporarily dissolve and sanity returns.

For the awakening artist there is no judgment of the psychic disharmony of humanity; it's madness. It is neither good nor bad, it is simply accepted as a fact. But it is also a fact that the

psychic disharmony is the source of humanity's suffering, and just by knowing this the awakening artist has taken a step toward moving beyond the dysfunctional ego's influence.

How does Art Contribute to Awakening?

We will be returning to the ego's influence on creativity shortly, but before we go too far, let us consider how an artist may contribute to the awakening of humanity. First, whenever artistic expression is an act of respect for what is observed, a contribution to the awakening of humanity is made. Second, whenever images are made that suggest or point to a higher state of consciousness, a contribution is made. Third, whenever images shock us and awaken us to see deplorable conditions we were unaware of. And fourth, whenever the artist is fully present, without ego, in the making of a creation, a contribution to awakening is made. Now let's look at each of these in turn.

Expressing Respect for what is Observed

Any human-made image that has contributed to the well being of the artist, and others, has contributed to the awakening of humanity. It could be as simple as the contour drawing of a bison or horse on a prehistoric cave wall. If for even a moment the image evokes respect for the life that is the animal, then the artist and image, have contributed to the awakening of humanity. This is because respect for all living creatures and their environments is a characteristic of the awakened state.

Of course it is doubtful that the earliest humans thought of, or conceptualized, some future awakened state of humanity to which they were contributing. It was beyond their awareness because they lived before the time when humans came under pressure to awaken out of madness. But *any* respect, whether expressed by an awakened person, such as the Buddha, or by an early human, or a modern artist, makes little difference. Respect is respect, and it contributes to bringing about awakening.

Images that Suggest or Point to a Higher State of Consciousness

Early human-made images, above all, provided humans with a way of comprehending the world. Sometimes, when used for religious purposes, they provided a connection to the great mystery of Life. Historically, images relating to something mysterious and beyond normal human awareness have always been perceived to be religious. To early humans it was the world of spirits that resided in animals and plants; to the Ancient Egyptians and Greeks it was a system of gods. To Christians it was, and continues to be, the image of God, and to the Buddhist it is Realization symbolized by the image of the Buddha. Something as simple as the image of a flower can evoke a sense of connection to the transcendent dimension. Even images of the madness and suffering of humans can jolt us out of our spiritual unconsciousness, for to recognize madness and insanity, one's own and that of others is to begin to awaken. To the extent that any artistic image served this purpose well, it has contributed to the awakening of humanity. Sensing the possibility that you are inseparable from the creative source is a step in the direction of awakening.

Images that Shock Us into Awakening

To see images of war, violence and other disturbing images communicate human madness. To recognize images of madness is to begin to awaken from it. If we did not recognize the insanity of violence then violence would be normal and perfectly acceptable in our lives. In this manner disturbing images may contribute to our awakening.

Being Fully Present in the Creative Act

The making of a work of art contributes to the awakening of humanity on this most basic level: Humans have always made marks. Perhaps by using one crude stone to scratch against

another, or by using the finest of brushes against the highest quality silk. If in the moment when the mark is made, the artist has forgotten him or herself, and there is only creativity flowing in the spaciousness of the artist's awareness, then a contribution to the awakening of humanity has occurred. In that moment of the stroke, the identity of the artist has dissolved and pure consciousness has been allowed to come through and participate in the making of a mark in the dimensional world. The light has shown through, to express it poetically, in the space of a single brushstroke, or scratch of a stone. What is that light? That light is pure consciousness—the universe becoming aware of itself.

A single brushstroke may seem quite small and insignificant, but that is the egoic view that imagines that significant changes can only come through sudden, bold, loud, and forceful actions. However, imagine the vast number of marks that all artists have ever made throughout the course of human existence. It would probably be a very large number of marks. To the extent that egoless consciousness has been allowed to express through any of them, they have been a contribution to the awakening of humanity to the spiritual dimension, and each stroke has played an important part in the One Art Movement. And as we have seen, the One Art Movement, of which all artists of all ages belong, began with the early humans making their first innocent marks. Let us now look at the beginnings of the One Art Movement through the artwork of the earliest humans and see what we can learn.

Part 2

Madness and Awakening in the Past

Chapter 4

Learning From The Innocent Art of Early Humans

The Clash of Madness and Innocence

Contrary to common belief, and prior to the Age of Madness, there is no evidence that early humans were 'savages' in a constant struggle for survival, who "went around bashing each other over the head with sticks."[1] Increasingly, archeological evidence has shown that the opposite is actually the case. Early humans were basically peaceful and lived in harmony with their environment.

Whenever I have shared this idea with others, it is sometimes met with skepticism because we have been told since childhood that early humans were savages. No example illustrates more clearly the distinction between mad humans and innocent people than Christopher Columbus' encounter with the Indians of America. It is the story of mad Europeans who came upon the primal people of the Americas who lived similarly to early humans before the Age of Madness. The primal people of America welcomed the European strangers with openness and gifts, whereas the mad Europeans, beginning with Columbus, responded by capturing them and enslaving them and stealing their gold. We will look at this specific collision between mad humans and primal people in greater detail later, including how it directly influenced the flamboyant European Baroque Period.

If early humans did, in fact, live in peace and harmony with their environment, then their art, would also have been peaceful and harmonious with their environment. Early humans, in the Upper Paleolithic Period, about 45,000 to 10,000 years ago, created cave paintings, Venus figurines, animal carvings and rock painting. Their art depicted animals, half-animals and half-

humans, and nonfigurative art, which included shapes and symbols. Nobody knows for sure what most of the art means, though it has been theorized that pictures of animals and symbols on cave walls had something to do with sacred rituals, or perhaps some of the images were even painted for pleasure. Regardless of what early humans may have intended, I think it is safe to say that much of their art was made with care and attention and related to their connection with the world around them.

The Beginning of Innocent Art

As we saw in the previous chapter, the One Art Movement contains three phases: the innocent art of early humans, egoic art of mad humans, and art of the awakening artists. But when did the innocent art of early humans begin? We are going to begin our examination of innocent art with the Upper-Paleolithic cave paintings, such as at Lascaux, and Chauvet in France, simply because scientists have learned more about the art of this period than previous periods.

The Upper-Paleolithic Period is sometimes called the "Creative Explosion" or the "Upper-Paleolithic Revolution" because of the unprecedented burst of artistic creativity that occurred at that time. Furthermore, it is now known that the early cave painters were just like modern-day humans, mentally and physically. They were Homo sapiens, not sub-human, and anatomically the same as we are today. They also had complex social structures and language. Many of their cave paintings were very complex creations, some were over eighteen feet long, a feat, which would have required considerable planning to accomplish, most likely requiring some form of preliminary sketches. Paintings on some of the ceilings would have required platforms constructed in the cave in order to paint high off the ground. The complexities of the undertaking, and physical evidence found near the

paintings, suggest the involvement of several people working together.

In his book *The Mind in The Cave* (Thames & Hudson) author David Lewis-Williams presents the latest and most convincing theories about early cave art. He suggests that the cave paintings had nothing to do with aesthetics, or painting for the joy of the experience. He proposes that the cave paintings were used for religious and social rituals.

It is well known that shamanism was, and continues to be, a part of the religious practice of many primal societies. Lewis-Williams developed a theory of shamanism that showed striking parallels to previously gathered data about European cave art. His research was based on ethnological data, neurophysiological research and an in depth study of southern African rock art, particularly that of the San people. Furthermore, his theories have helped to explain many anomalies in previously held theories. Today, Lewis-Williams' ideas have become the standard for Upper-Paleolithic cave art.

Lewis-Williams believes that a shaman led the Upper-Paleolithic society's religious rituals. His role was to link the society to the spirit-world. The shaman would enter an altered state of consciousness through chanting, dancing, or by ingesting hallucinogenic plants. In that state he would visit the spirit world where he encountered animal spirit-beings that gave him power, knowledge and magical abilities. Upon returning to the human world the shaman shared his journey with the community. However, the shaman did not act alone, his role was to be the shaman for the entire community. As such, other members of the community assisted the shaman by preparing him for his journeys, and by caring for his weakened body upon his return from his exhaustive journey to the spirit world.

One of the ways the shaman recorded and shared his experiences in the spirit world was by painting and drawing pictures on cave walls. Some of the cave artists were actually shamans.

The drawings and paintings were then used to introduce members of the society to the spirit-beings in the spirit world without having to go there themselves. The paintings and drawings were also used in cave rituals that initiated members into new social roles or that transformed their worldview in some fundamental way.

According to Lewis-Williams the entire structure of a cave was part of the ritual. Imagine being guided into a cavernous black hole by a shaman because you are undergoing an important social or religious initiation. You hear the thunderous echoing roar of your community's chanting and drumming at the mouth of the cave, and you hear the shaman's hypnotic incantations near your ear. And then suddenly, by the shaman's controlled flickering of torchlight on the cave wall, a giant bison or reindeer appears to lunge out of the dark spirit world toward you. Imagine the experience being so powerful that you feel completely crushed; reduced to nothing and completely overwhelmed at the sight of these great spirit-beings. But then the shaman whispers assurances to you that the spirit-beings are your friends and they will help you and give you strength. This new realization that the mighty spirit-beings are on your side causes you to feel enormously relieved and empowered. Certainly, with such an encounter your life would be changed forever.

To be clear, Lewis-Williams did not state that this specific event occurred, it was merely a dramatization. However, based on the most recent theories and findings about early cave art, Lewis-Williams suggests that there is a strong likelihood that cave rituals similar to this may have occurred. There is not concrete proof, of course, but there are striking similarities between the European cave rituals and other shamanic societies that have been well researched. With respect to this, it is intriguing that some cave paintings were painted deep within the bowels of the caves, making them difficult to reach. Some are

in passages so narrow that you have to crawl a great distance to reach them. Then you have to lie on your back and look up to see the paintings—by torchlight if you lived in the Upper-Paleolithic Period. For what possible reason would cave art be made in such cold, cramped, dark and inconvenient places for viewing? This unusual placement of the art is consistent with the practice of Shamanic rituals. Many forms of shamanistic rituals limit sensory perception and bodily comfort, and utilize sacred iconography in order to induce a spiritual transformation. In his book, Lewis-Williams offers many other intriguing clues that suggest that cave art was related to initiation rituals.

The art of early humans, such as the cave paintings of the artist-shamans of the Upper-Paleolithic Period, is innocent art. It reflects the innocent consciousness of the artist-shaman and his culture. The people of the Upper-Paleolithic Period had religious rituals, they made weapons for hunting, and they created clothes to wear. As mentioned earlier, they were physically and mentally the same as we are today, and they had a relatively complex social order. But what is conspicuously missing in the cave paintings, and archeological sites near the caves, is any evidence of war, social stratification, greed, suppression of women or violence. By contrast these are abundantly evident in the artwork and archeological sites after humans went mad around 4000 BCE (6,000 years ago). One might conclude that early humans did not suffer the same pathology.

It is also interesting to note that what early humans thought of as the spirit world that gave them power, knowledge and magic is analogous to what I am calling the 'infinite creative source' that gives us power, knowledge and special abilities. The difference, however, is that early humans saw their source of empowerment as being external to themselves and coming to them from a mysterious spirit world, whereas I am pointing to that source of empowerment as being within us. The artist and the source of creativity are ultimately one.

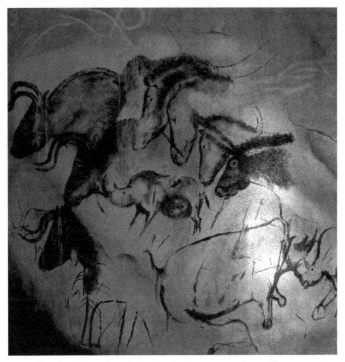

Replica of cave painting from the Chauvet cave 31,000 years ago.

States of Consciousness

As we saw, the artist-shaman cave painters experienced an altered state of consciousness when they visited the spirit-world, according to Lewis-Williams. Some people, like myself, are hypersensitive to hyper-perceptual consciousness. In other words, it takes very little to stimulate our imaginations. When I was a teenager I recall hiding in the attic to smoke pot at home. One time I acquired some especially good weed from the cook at Farrell's Ice Cream Parlor where I worked. After toking away for a while in the attic I decided to go for a walk. I carefully slipped out of the back door to avoid my mother. I walked down the street and before long all the houses began bobbing and rolling up and down. It was wonderful, floating along a sea of rolling concrete. Added to this, the trees and bushes sprouted faces and

began talking to me. This was frightening at first, until I realized that they were friendly. They were just there happily being trees and bushes, they explained. Eventually I became very tired so I sat down on the curb, put my head down on my folded arms and allowed myself to spiral downward, deeper into an elastic reality. I had no idea how long I was out; a few minutes or few hours? But the thought occurred to me that I should probably head back home. When I raised my head, however, I was shocked to see that I was still sitting in the attic. I had not left to go for a walk at all. Looking down, the smoldering joint, laced with who knows what, was still between my fingers. The whole experience had been absolutely and completely beyond my control. However, the artist-shaman's hyper-perceptual journeys, induced by chanting, dancing, or by ingesting hallucinogenic plants were undertaken for sacred rituals in service to his society. The journey was in service to a higher order and done with the support of his community.

Horizontal Consciousness

Discussions about the altered states of consciousness of the artist-shamans inevitably bring up deeper, fundamental questions among historians and anthropologists. How did humans become conscious in the first place, and what is consciousness? Scientists have no definitive answer for this, so they assume that the human brain creates consciousness. Nevertheless, scientists are able to measure some of the effects of consciousness. For example, they have observed that consciousness enables humans to self-reflect and ponder their own lives and experiences. They have observed that consciousness gives humans a sense of time, which allows them to think about the past and plan for the future. And scientists have observed that consciousness, in general, relates to (1) the sleeping state, (2) the normal awake state that we experience as we go about our daily lives, and (3) the hyper-perceptual state, such as the artist-shamans experienced on their journeys to the

spirit-world. The hyper-perceptual state is also experienced by mystics and saints when having visions. This continuum of states of consciousness is what I call horizontal consciousness. Here is a summarized version of Lewis-Williams' diagram of consciousness:

Horizontal Consciousness

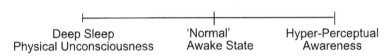

| Deep Sleep | 'Normal' | Hyper-Perceptual |
| Physical Unconsciousness | Awake State | Awareness |

The three general levels of consciousness are not necessarily sequential and they often overlap. For example, when you are walking down the street with a friend you may be unconscious of every footstep you take or that you are scratching your ear, however you may be quite conscious of the conversation you are having with your friend.

Vertical Consciousness

On the other hand, the awakening perspective does not view consciousness as originating in the brain, which is a conventional analytical point of view. Instead, it views consciousness as a fundamental quality of all life, which is a holistic point of view. Within this context, vertical consciousness relates to the relationship between egoic insanity and spiritual awakening. There is no scientific proof for this statement just as there is no proof that the human brain creates consciousness; they are each merely points of view; one is analytical and the other holistic.

In the awakening model, the brain is seen as a kind of mechanism or portal that enables humans to experience consciousness. From this point of view, all the ways by which the human brain may be analyzed, such as by measuring electrical impulses and blood flow to the brain, are not the source of human consciousness, rather they are only a small part of a much

larger integrated whole—universal consciousness.

From the awakening point of view, the possibility of vertical consciousness emerged as the Age of Madness emerged. Prior to that time, no psychological madness—in the way I have been referring to it—existed, therefore, no spiritual awakening was necessary to counter it. Vertical consciousness can be summarized in three levels: At the bottom of the vertical axis are madness, ego, and human insanity. At the midpoint there is 'normal insanity'. And at the top is awakening consciousness:

Vertical Consciousness

Awakened
Consciousness

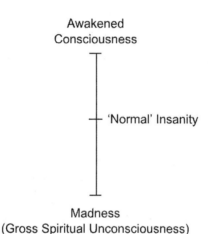

'Normal' Insanity

Madness
(Gross Spiritual Unconsciousness)

We have already discussed the nature of human madness with its fear, greed and the insistence that it is separate from others and the environment. Now let us consider 'normal insanity', which is the state that is half way between madness and awakened consciousness. Normal insanity is a socially acceptable level of psychic disharmony. From the awakening point of view, what is typically thought of as 'normal' human behavior is sometimes viewed as a mild form of insanity. How is this so? Here is an example: Many, if not most, so-called normal people appear to be sane and rational only because laws, secular and religious, and

cultural customs keep their insanity in check. If there were no laws governing society there would be social anarchy and chaos. Therefore, the existence of laws proves that even 'normal' people must have constraints limiting their behavior. A sufficient number of people unleashing their madness in a lawless state would quickly destroy an entire society. Without secular and religious laws you could do as you wish without the slightest hesitation. Lying, cheating and stealing would be considered 'normal' and would go unquestioned. If you didn't care for what someone said to you, you could simply kill him or her. Or, to make it less messy, you could contact Liquidators.com and they would rush over and provide that service for you. Perhaps they would offer you a Two-for-One coupon for your next order. Seriously, without laws, all forms of violence against oneself and others would be rampant and violence is a key characteristic of madness. This is not to say that I believe that all laws are just, or that some kinds of social protest are not sane. I am merely using the principle of lawfulness in general to illustrate my point that what is considered normal is merely a surface appearance.

Another stark example of normal insanity was demonstrated by a Yale psychologist in the early 1960s. He asked subjects in a study to deliver intense electrical shocks to other people who wrongly answered a series of questions. The excruciating shocks increased with each incorrect answer. For no personal reward or profit, the majority of subjects in the study willing gave torturous electrical shocks to other people. The point of the study was to demonstrate that normal people could easily be enticed into acts of violence for no reason other than they were asked to.

A few more examples of normal insanity include: becoming irate because you are stuck in a traffic jam; living for the future and missing the present; the inability of letting go of the past; trying to find lasting security in materialism; feelings of jealousy or envy; and feelings of superiority or inferiority to others. These are mild forms of mental instability that most people experience

all the time. Even many psychologists believe that it is 'normal' and acceptable to live with sporadic bouts of psychological suffering. However, the awakening perspective tells us that there is the possibility of something beyond not only full-blown madness but also beyond 'normal'.

And finally, at the top of the Vertical Consciousness diagram we have the awakened state. It is not an experience of a mystical or magical heavenly realm, which are states that more appropriately belong in the hyper-perceptual state of horizontal consciousness. Instead, the awakened state is simply the 'true normal'. It is true psychological sanity, which is characterized by love and respect for one's self, others, and the natural world without being forced to do so by laws. The awakening artist is interested in bringing the true normal into creative action. Here is one way of describing what human consciousness looks like from the awakening point of view:

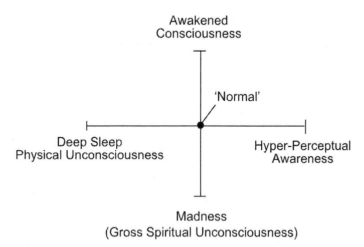

Horizontal and Vertical Consciousness

Awakened
Consciousness

'Normal'

Deep Sleep
Physical Unconsciousness

Hyper-Perceptual
Awareness

Madness
(Gross Spiritual Unconsciousness)

Learning from Innocent Artists

Early humans understood little of cause and effect so they attributed ordinary activities such as the wind blowing, a flood,

illness or death to magical causes.[2] An animal could be the embodiment of a deceased relative, or an evil spirit, or a helper being. To become one with the animal was to merge with its life force, and to take on its power and special abilities. From this the awakening artist can learn from the early human artist-shamans how to respect all creatures, and to honor their natural, noble presence, and to acknowledge the oneness we humans share with them.

The abundance of Venus figurines among early humans has suggested to many archeologists that early human societies were matriarchal and that the female figure represented the woman's reproductive powers and sexuality. What can we learn from this? We can learn to pay attention to the feminine, receptive, and sensitive qualities within us, to perceive the world around us with our whole being, not merely with our minds. To some men, suggesting that they connect with their feminine, receptive, and sensitive qualities would be an insult to their concept of masculinity. To them it would be an invitation to become 'soft', but in reality it's an invitation to know their own depth. I am not suggesting that male artists need to become effeminate; I am suggesting that they become whole. Monet's art is one of the greatest gifts any male has ever given to humanity, yet he claimed to have been inspired by the sweetest and most delicate of feminine-like forms, the flower.

What may we learn about creativity from the innocent art of early humans? Archeologists believe that early human artistic creativity served a utilitarian function when it was in the service of the community, or when representing sacred images. It was also used to portray the joys of daily life. The art of the old Europeans, for example depicts "a rich array of symbols from nature" which "attest to awe and wonder at the mystery of life."[3]

Why was artistic creativity used for these purposes? For that matter, why does artistic creativity exist at all? From the point of view of the flowering of human consciousness, the impulse to

create is pure consciousness seeking to know and explore the dimensional world through humans, however limited humanity's capacity to participate with it might be. The creative impulse is always present, and those who are open to it, so to speak, are moved and inspired to create. The urge to create is natural. Inspiration is what happens when we are fully present and our hearts and minds are still and open at the moment when the creative flow of life's greater intelligence shows up, which is another way of describing what I have been calling the infinite creativity that is beyond us. And the expression of infinite creativity through artists is the One Art Movement. However, the word 'beyond' is simultaneously misleading and accurate. It is misleading because many people assume that 'beyond' infers a separation by physical distance. And so they believe that God, for example, is out in the universe somewhere, and certainly beyond them. However, 'beyond', in the way I am using the word, always relates to Life's universal intelligence, which is everywhere, in everyone, and is only 'beyond' the awareness of the ego and the madness that obscures its presence here and now.

(See Chart Opposite)

Chart 4: The Innocent Art of Early Humans

The One Art Movement

Scale:
1,000 years

40,000 BCE
Earliest known art

30,000 BCE
Earliest cave paintings

Innocent Art of Early Humans

The Age of Madness
and Mental Acceleration
Neolithic Age, 4,000 BCE

Awakening

Egoic Art

Today

Early great civilizations of
Egypt, Greece and China

Chapter 5

Madness and Awakening in Ancient Civilizations

In much of the art of the ancients we see the forging together of egoic insanity with the great beauty of creative expression through artists. The artist of ancient civilizations was merely a 'messenger'. In many cases he was nothing more than the creative hand wielded by psychotic people in power. The ego, which had taken root in the human psyche, often dictated the subject matter of art, while the innocence of the infinite creative source within the artist continued to seek expression through the artist. It continued to form the One Art Movement.

We will spend much less time on the art of ancient civilizations than with other eras like modern art, because not only is more information available about Modern art than the ancients', modern art is closer to our own experience as artists. Books and museums are full of the accomplishments of ancient civilizations such as Mesopotamia, Persia, Arabia, the Phoenicians and many others, and I would recommend that the reader refer to them to explore the madness and spiritual awakening that can be seen in those civilizations. Our goal here, however, is simply to illustrate the movement of the infinite creative source in the work of artists throughout the ages—the One Art Movement; and to see, how the madness of the egoic mind has produced human suffering.

As was noted in Chapter 4, the beginning of the Age of Madness occurred about 4000 BCE, which was 6,000 years ago. It was also a time of tremendous acceleration of human mental capability, and was concurrent with the emergence of the egoic mind, which began producing immense human suffering. Some of the early civilizations to arise after the madness began were

the ancient civilizations of Egypt, Greece, China, Rome, and others. (See chart at the end of this chapter). As most great civilizations do, they each contributed in some way to the betterment of humanity. But along with their contributions came tremendous insanity and human suffering produced by egoic madness.

Ancient Egyptian Art

The Ancient Egyptians benefited their culture and other cultures by inventing the hieroglyphic writing system, the sailboat, ox-drawn cart and plow, which revolutionized farming, the door lock, and black ink and papyrus paper. They invented simple machinery in the form of levers, pulleys, wedges, ramps, and wheels. And they invented the 365-day calendar. All of these inventions were beneficial at that time and to people who came after. On the other hand torture, for whatever frivolous reason, was common in Ancient Egypt. So was slavery. However, there is doubt today among many scholars that the Egyptian pyramids were built by thousands of foreign slaves sweating under the grueling sun under the snapping whips of their Egyptian taskmasters. Given the primitive weapons of the Egyptians at the time, and the massive numbers of slaves that were thought to build the pyramids, there would have been little to prevent them from simply running away. A current, more plausible theory is that the pyramids were built by the Egyptians themselves, who were seasonally conscripted for the task. But slavery, in the Egyptian sense, is a relative word. The state and wealthy individuals owned slaves with whom they could do as they wished. However, everyone under the authority of an absolute ruler such as a pharaoh might be considered in some degree a slave, too. A disgruntled laborer could not simply walk off the job without severe punishment by the state.

The pyramids were built primarily to serve the insanity of pharaohs and their fear of death. Of course it was not just the

Pharaohs who experienced this affliction; the entire culture suffered from the same madness to greater and lesser degrees. However, the pharaohs, because of their position of power, were able to project their psychic disharmony throughout the entire Egyptian civilization for thousands of years. From the awakening artist point of view, pyramids were built by the accelerated human intelligence that came with the Age of Madness. However, they are also monuments to fear and craving, which are the two basic characteristics of mad humans who first emerged almost a thousand years prior to Ancient Egyptian civilization. The pyramids symbolize fear because they represent an attempt to escape the natural cycle of death. And they symbolize craving because pharaohs filled their pyramids with all the possessions, including people, they thought they would need in the afterlife.

State sanctioned art at left: Sobek, crocodile god of ancient Egypt, executed in a rigid, formal style. At right: Non-sanctioned art: Dancers and musician portrayed in a free and expressive manner in the Nebamun tomb.

Little is known about the individual artists of Ancient Egyptian society. They were considered artisans, such as carpenters and stonemasons, and most worked on only small parts of any particular project. One artisan would apply a drawn outline, and another would fill in colors, and another would apply detailed features. Most artists worked in royal studios from which a king would lend them out to temples or private persons as a mark of favor.[1] Some outstanding artists could afford their own tombs, which as most Egyptians believed, would protect them after death. These artists were also awarded land, human slaves to do with as they wished, and social status.

When artists were not working for the state, their own painting and sculpting quickly reverted to a more naturalistic representation of their subjects, even if only slightly. This shift suggested an inclination to return to a more natural and innocent approach to art making whenever possible. However, when the Egyptian artists were working on state projects, whether sculpting, inscribing, or painting, they followed strict guidelines called the "Canon of Proportions". These rules included a precise grid system of uniformly spaced vertical and horizontal lines to establish the proportions of the human form and angles of the body. For example, a hand would always measure the length of one grid unit; a head was always three grid units, and a torso was always six grid units. This grid system was enforced for thousands of years. Colors were also used according to strict guidelines: White represented light, luxury, and joy. Yellow denoted gods and eternity. Pale yellow was used for the female complexion, and brown-red for the male.

Objects in ancient Egyptian art were always placed hierarchically in the picture. Gods and pharaohs were positioned at the top and were larger than the other figures in the picture. Figures at the bottom of the picture were typically women and slaves and they were proportioned much smaller. Figures were also attired to denote their status as a god, or human.

Canon of Proportions

Canon of Proportions: Image at left shows the Canon of Proportion.
Image at right shows both figures measuring six squares high on the
same gird. They are different sizes but same proportion.

In the *Narmer's Palette* at left, King Narmer is slaying his enemies while
the small figures below and upper right are depicted as inferior beings.

Today we can look at ancient Egyptian art and appreciate its exquisite beauty without needing to know anything about the life of the ancient Egyptians. In other words, the appearance of the art—its design, patterns, color, and shapes—appeal easily to our contemporary sense of beauty. The content of the art, however, represented their worldview and what was considered normal to them. From the awakening artist point of view, though, a large part of the content of official ancient Egyptian art portrays unequivocally the fear, craving, social stratification, slavery, materialism and war, which is characteristic of mad humans.

The life of the ancient Egyptian artist may remind us that we are all participating in one vast creative expression. And though our part may seem small within its universal totality, we can delight in playing it fully, purposefully, and with our complete attention. And our inner-mad pharaoh, the ego, is not allowed to dictate our creativity. Rather, we allow our creativity to be a natural and fluid expression of the creative source.

Ancient Greek Art

The Ancient Greeks designed streets, invented cartography, the crane, plumbing, urban planning, survey tools, bronze casting techniques, the water mill, an early form of democracy, and many other important contributions to civilization. On the other hand, the psychosis of the egoic mind was right there too. Greece's city-states, such as Athens, were slave societies, whereby slaves comprised of as many as one third of the population. The Greeks oppressed their women and had no hesitancy in throwing deformed babies or babies of the wrong sex to the lions. Or, a less guilt-ridden method was to leave unwanted babies exposed in nature where the parents believed a passerby would pick them up or that the baby would be saved by the gods. Another example is that the ancient Greeks also invented the breaking wheel, which was a large wooden wheel

that a victim was tied to with their limbs spread over the spokes. Then a large hammer was swung between the spokes to break each of the victims' limbs in several places. This process was repeated several times leaving the victim alive but in pieces.

The logic and reason of Greek philosophy would seem like a great way to rule a society. However, if the minds of the humans applying logic and reason are distorted, then any logic or reason they apply will inevitably be distorted too. After all, it seemed to the Greeks perfectly logical and reasonable to enslave and torture others and to discard babies.

However, the pre-Socratic philosophers, who came before Plato, Aristotle, and Socrates, around 520 BCE, were among the first recorded humans to begin awakening. In other words, to rise above the egoic suffering produced by the Age of Madness. This is evidenced in their philosophy, which focused on the nature of being, rather than the nature of thinking as was the focus of the later philosophers. The pre-Socratic philosophers developed "ontology" and metaphysics that takes into account that which is beyond physical and mental observation. It is also worth noting that the pre-Socratic philosophers emerged at the same time in history as the Buddha in India and Lao Tzu in China. Lao Tzu was the author of the *Tao Te Ching*. We will be looking at the Buddha and Lao Tzu and their influence on artistic creativity in more detail later.

Before we leave Greek philosophy it is worth noting that it is commonly thought that the Greek concept of democracy was the inspiration for what eventually became American democracy. However, it is only folklore that democracy as we understand it in America originated with the Greeks. In fact, American democracy was inspired in large part by Thomas Jefferson and Benjamin Franklin's study of the governing system used by the Iroquois Indians of North America. The Iroquois were relatively primal people, according to Taylor.[2] The Iroquois were only *relatively innocent* because they had been in contact with the mad

humans and were influenced by them to a limited extent. Particularly the French who warred against them, introducing the Iroquois to organized war. However the Iroquois had not completely lost their original innocence and harmony with nature and each other. Consequently, the concept of the union of different states that the United States now has was inspired by the union of tribes into the North American Indian confederacy called the Iroquois. It was a non-hierarchical society in which everyone had equal rights. This model of government had tremendous appeal to Jefferson and Franklin. The American version of Iroquois democracy was modified dramatically to exclude the leadership and authority of women. Equality and freedom was granted to all in Iroquois democracy. However the American version of equality and freedom was extended only to white landowners, not to women, African American slaves, Native Americans and landless whites. Taylor also points out the ironic fact that Karl Marx and Frederick Engels were likewise greatly impressed by the Iroquois 'utopian' form of government, which partially influenced their concept of Communism. As we shall see later, Communism attracted many of the modern artists of the nineteenth century because of its professed egalitarianism.

Greek art in general is an extraordinary example, in my opinion, of the infinite creative source expressing through the heightened intelligence of humans that had emerged after the Age of Madness began. The Greek's portrayal of the human figure and animals is truly remarkable. And their methods of casting bronze set the standard of excellence for thousands of years to come. I would highly encourage you to view Greek artwork and enjoy it for yourself.

The content of Greek art, however, reveals the other side of the Greeks. It often portrays their mythologies, gods, and wars. All of which belies the deep psychic suffering within the Greek psyche. Images of war, portraying violence, brutality, and domination of one group over another were considered perfectly

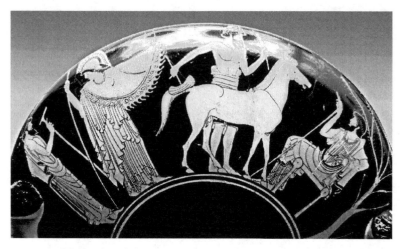

On this bowl the deity Athena appears as the Goddess of
Inspiration in a sculptor's workshop. The intelligence of life that
expresses naturally through the artist was imagined to be a deity from
another world.

normal. In these works, you have the forging together of
exquisite artistic execution, perception and technique with a
pathological subject matter. In this regard, it is always wise to
distinguish between the creative flow that produced the art and
the content of the art. The creative process relates to the tools and
techniques artists use. The creative flow relates to the inner state
of the artist while making art.

As far as pathological subject matter goes, we think nothing of
images relating to war in art history. However, what would you
think if you saw a beautifully and masterfully painted picture of
an adorable child who is insanely stabbing a kitten with a knife?
Or perhaps a painting of a mother who is baking her baby in a
microwave? Most people would find these images more than a
little disturbing. Images that glorify war or violence of any kind
are no different whatsoever. It is only because we have been
conditioned, as a result of the psychic disharmony that is
common to us all, that we accept violence and images of violence,

as perfectly normal.

One last thing worth mentioning about Greek art is its originality. Greek art was originally influenced by the art of the Egyptian and other cultures, but they soon came into their own. Greek art has influenced Western art as well as the art of many other cultures for thousands of years. The Roman artists looked to the Greeks for inspiration and the Renaissance artists looked to the Greeks for inspiration. Artists well into the nineteenth century looked back to the ancient Greeks for inspiration and as the standard of creative perfection. No other civilization in the world has had as much artistic authority. When you see Greek art in museums you quickly recognize that the Greek standard of perfection and beauty of form is as alive and vital today as it was thousands of years ago. It is relentlessly enduring. Apparently, the only people aware of the Greeks who were not inspired by the Greeks were the Greeks themselves. In other words, the Greeks had no one, for the most part, to look back to, to copy, emulate, or to be inspired by. We learn from the Greeks that artistic originality and excellence is what naturally results when the infinite creative source moves through the artist, especially when the artist has all the necessary skills, technology, and tools with which to create.

Ancient Chinese Art

Early Chinese art, unlike Greek art, did not have a direct influence on Western art history. However, as we shall see in much greater detail later, Chinese art (and Japanese art) influenced many of the Modern artists of the nineteenth century, and vice versa.

In China, the Age of Madness story is told in the myth of the Age of Perfect Virtue. In this myth, humans originally followed the way of heaven rather than the ways of men. They were part of the Tao, which is the natural harmony of the universal order. When humans fell into Madness they became separate from the

Tao. They became selfish and calculating rather than sponta-
neous. They began following the ways of men rather than the
way of the Tao.[3]

China was as overcome with the ego explosion as anywhere
else. It had as much cruelty, brutality, oppression of women and
exaltation of emperors and the wealthy, as anywhere in the
world. However, there was something eastern civilization had
going for it that the west did not: Buddhism and Taoism. By the
time Buddhism arrived in China from India, around 265 BCE,
Taoism had already been flourishing in China for nearly 200
years. Taoism and Buddhism where among the first enlightened
realizations among humans that did not look back to relive or
capture the Age of Perfect Virtue, but rather flowered forth into a
new state of consciousness that went beyond ego and longings
for the past altogether. This was the beginning of a new state of
consciousness that we have been calling the awakened state.
Buddhism and Taoism were very compatible in this regard and as
such were able to flourish together in China. This was about the
same time that the pre-Socratic philosophers were exploring
ontology and metaphysics in Greece. A distinct difference
between the two cultures, however, is that Chinese culture as a
whole came to embrace Buddhism and Taoism, whereas the
Greek culture came to embrace the rationality of the Socratic
philosophers over the metaphysical concepts of the pre-Socratic
philosophers. The result, for the Chinese artist, was that
Buddhism and Taoism were able to dampen, somewhat, the
effects of psychic disharmony among some of the Chinese,
including many artists.

Taoism even gained official status in the Tang Dynasty.
Several Song Dynasty emperors, most notably Huizong, was a
Taoist at one peaceful point in China's otherwise tumultuous
history, Mahayana Buddhism, Zen Buddhism, and Taoism gained
imperial approval. This indicates a less egoic environment in
which the awakening artist could flourish. So, while the Greeks

sought to understand the world through the assertion of logic and reason, the Chinese saw the world in relation to the passivity and receptivity of Buddhism and Taoism. Eastern and Western approaches to life and creativity could not have been more different. In Chinese painting, the artist often left empty space in the picture rather than filling the entire picture with objects. The empty space represented the Tao, because the Tao was formless and pervaded everything. It had to be portrayed in art, too.

On the basic level of the materials used in making art, Eastern and Western art were as different as they were on the mental and spiritual levels. For example, Western painting evolved from frescoes and mosaics that were applied directly to the walls and ceilings of temples, buildings and homes. The whole presumption of making art in the west was that the artwork would be applied to a fixed architectural surface. It wasn't until centuries later that Western artists painted on stretched canvas.

Chinese painting, on the other hand, evolved from writing, calligraphy, and literacy. Chinese scholars wrote on paper or silk scrolls with ink and brush in elegant calligraphic styles. It was only a natural progression that Chinese scholars would come to paint pictures on paper, or silk scrolls with ink and brush, too. The scroll allowed the painting and the text it related to, to be portable. The artist need only roll up the scroll and carry it off with him. The idea of affixing a painting permanently to a wall, or ceiling, like in the West, would have seemed impractical to the Chinese artist.

Another distinction was that the artist of early China was not a lowly artisan or craftsman as most were in other cultures. The artist was a scholar. Since painting in China had emerged out of writing, artists were naturally literate and therefore well educated. They were called scholar-painters, and they were sometimes also government officials. To the early Greek or Egyptian cultures, the idea that an artist would serve as a governing official would have seemed laughable.

Many of the early Taoist Chinese landscape painters, as early as the eleventh century, lived in the mountains with the Tao and sought neither fame nor fortune. They traded their paintings with each other. Or, as they traveled, they would give them away, sell, or trade them in villages along the way, for food, or lodging. Many of the early Chinese landscape painters were indeed masters at imbuing their paintings and lives with the Tao, and selfless realization.

Because the Tao is considered infinitely vast and spacious, the Chinese painters represented their awareness of it by using more empty space, blank paper, or blank silk, in their paintings. The

Tao was represented metaphorically as the emptiness that held all the visible elements of the painting. In Western thinking, a landscape painting is a painting of an object out there beyond us that we call land. However, Chinese Taoist landscape painters sought to paint the Tao. They believed that nature and the artist were contained within the Tao, and the Tao within them. You may notice a striking similarity between what I have been calling the infinite creative source and the Tao.

Title: *Inquiring of the Tao at the Cave of Paradise* Painted scroll for the Early Ming Dynasty (1368–1644) The Yellow Emperor, who reigned from 2697–2597 BCE, ascends into the mountains seeking the wisdom of a Taoist sage. See white circle.

One might wonder, if the early Chinese landscape painters had this beautiful connection with the Tao, then how did it ever get lost? Why does it not flourish in China today? The answer is ego, of course. Wars in China, just as they did in Europe, would disperse the Chinese artists far and wide. Tyrannical emperors would destroy their art or force them to paint in official styles and official subjects. Then, over time, as following generations of artists came along, they had no living Taoist artists to show them first-hand the way of the Tao and how to express self-realization in their art. The new generation of Chinese artists clearly saw the mastery of these earlier painters in surviving samples of their art. However, rather than learning of the Tao and Buddhism themselves, and rather than living in the mountains like many of the early Chinese artists did, the new generations of Chinese painters merely made copies of the early masters' art. They believed that by copying the artwork of the great masters they could learn to be great masters, too. Unfortunately, they were looking merely at the forms of creation rather than to the source of creation. This inevitably led to stylistic monotony, repetition and imitation. It was the loss of relationship to the Tao, in addition to the seemingly unstoppable flood of European commerce and culture, that led to the degradation of early Taoist Chinese art. Today, in the Post-Modern era, contemporary Chinese art has become globalized and internationally influenced so now there is less and less distinction between the art of the East and West.

Sumi-e Painting

Eccentric sixth century Chinese Zen monks painted in a loose style like some of the early Taoist Chinese landscape painters had, and always imbued every subject with a spiritual essence. This eventually became known as Sumi-e painting. In the sixth century Japanese scholars traveled to China and brought back this method of ink painting and Japanese Zen Monks soon

adopted its simplicity and elegance because it so naturally complemented Zen. The idea that making art can be used as a spiritual practice originated with the early Zen monks. The simple and elegant method of Sumi-e easily aligns with Zen. The word 'Zen' derives from "zazen", which means meditation. Zen emphasizes enlightenment through practical experience and meditation over theoretical knowledge. Sumi-e painting was used as a way of meditating in a dynamic, active state.

Japanese Zen Landscape Painting. Scroll Size 57 inches X 14 inches (145 c x 35 c). Early Sumi-e painting was thought to embody the essence of Zen: Simplicity, elegance, and emptiness.

Sumi-e painting is still being done today; unfortunately a great deal of it appears lifeless and relies on traditional formulas and subjects. Brushstrokes must be done in precise and predictable ways, and the subject matter in contemporary Sumi-e painting is often of stereotypically classical Japanese origin such as cherry blossoms, bamboo, and shrimp. There is nothing wrong with those subjects, of course, but they are imitations of what Sumi-e paintings may have looked like centuries ago, not what dynamic meditation would look like expressed through Sumi-e today. This is Sumi-e painting without Zen.

Zen Sumi-e painting can be described philosophically, but in the moment of creation a philosophy cannot guide the artist. Philosophically, Sumi-e painting expresses the contrast between harmony and tension and expresses simple beauty and elegance. It employs the dynamic movement between Yin and Yang and expresses the Chi or 'Life Force' of the subject. In Sumi-e, the blank paper is a metaphor for the 'Void', the 'Unmanifest', the 'Formless', and the Tao. The brushstroke represents the Tao in

motion, and expression. When the black ink moves on the wet paper the ink naturally disperses. The ink and water together cause the ink to bleed from black, to gray, and eventually to the white of the paper at the outer edges of the brushstroke. This was a metaphor for the formless merging with form.

Students of Sumi-e start by learning patience, self-discipline and concentration. But the master uses none of these things. He does not need patience because he is not tolerating time. He creates from timeless consciousness. He does not need self-discipline because he uses the 'method that is no method', which is simply letting the Tao flow. And the master does not need concentration because there is no effort, there is only attention. A masterful Sumi-e painting could, in theory, be painted in two seconds with two brushstrokes. A Sumi-e painting like this could be equal, or superior, to another finished in many months with ten thousand strokes, for mastery is not bound by complexity or time.

The awakening artist can learn from the early Chinese painters, and the Japanese Sumi-e painters, the pleasure of exploring creative ways of portraying the Tao—what we have been calling the infinite creative source—in ways that are appropriate for our time. Any empty space in a work of art may represent the Tao, for if there was no empty space there would be no art. Space and form always coexist.

Ancient Roman Art

The Ancient Roman Empire existed from 79 BCE to 475 AD. The Romans invented the aqueduct, concrete, the portable abacus, glass blowing, and contributed to advancements in architecture and engineering. Ancient Roman art often copied Greek art and Greek methods. The Romans' unique contribution to the evolution of art was the introduction of continuous narrative art. Up until that time a story familiar to viewers was inferred within a single image. For example, in Ancient Greece a work of art

depicting Achilles dragging the body of Hector around the city of Troy infers the entire story of the Trojan War to people familiar with the story. However, Ancient Rome's continuous narrative art style communicates an entire story through a series of sequential images, like scenes in a movie. This makes it appear as though the story is unfolding in time. For example, Trajan's Column created in AD 113 is a 125 ft. (35 m) column. The triumphal column commemorates Roman emperor Trajan's victory in the Decian Wars. Spiraling up the column are hundreds of carved images that tell the whole story one scene at a time. This is continuous narrative art.

In Ancient Rome public sculpture was created primarily to glorify rulers, celebrate victories in war, and to promote the authority of the state. These sculptures represent Roman egoic madness, including slavery, the conquest and looting of foreign people and religious persecution. The Roman Coliseum games are well known for their horrific cruelty that was considered entertaining. And within the government there seemed to be an endless string of assassinations of one emperor after another.

This happened so frequently, in fact, that sculpture workshops specializing in making sculptures of the emperor eventually began designing generic emperor statues in such a manner that the head could easily be popped off. Then when the current emperor was assassinated, all the artisans had to do was remove the head of the assassinated emperor and attach the newly sculpted head of the new emperor.

Another example of the egoic insanity prevalent in some Roman emperors has to do with the color purple. Tyrian purple is a red-purple natural dye and is extracted from sea snails. Clothing dyed with this rich and exotic color was prized because it did not fade and tended to become brighter and more intense with weathering and sunlight. The luscious purple was very expensive and became a status symbol of the wealthy and powerful. It was a color reserved only for individuals of rank,

such as emperors, generals, and senators. However, under Emperors Valentinian II, Theodosius I and Arcadius, the manufacture of Tyrian purple outside of imperial dyeworks was punishable by death.[4]

Except for rare instances, such as is found in the great wisdom of Emperor Marcus Aurelius, the psychic disharmony produced by egoic madness was extremely acute in Ancient Roman civilization.

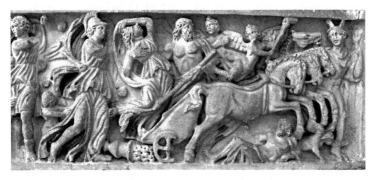

Ancient Roman relief sculpture carved with tremendous artistic grace, rhythm, sensitivity—and horses crushing humans.

Summary

It does not really matter of which ancient civilization we speak; they were all afflicted with the same madness that takes the form of the ego. Ego turns other humans into mere objects. Because of its inherent insecurity, the ego wants to compete to appear better and more powerful than others. The ego does not know harmony with life and nature, it has invented gods to worship who it believes will bring it happiness in another life, and after death will whisk it away from the hell it has created on earth.

Prior to the rise of the ancient great civilizations, the art of early humans related to sacred rituals and the joys of everyday life. After the Age of Madness began however, the artists' skills served the ideologies and belief systems of those who held power over them. The artist did not select what he would paint,

or sculpt. Those in power instructed him what to do and how to do it. It was always the vision and ambitions of those in power that ultimately determined the subject matter of the art. The artist was merely the 'hand' used to express the ideologies of 'superior' people. The artists of the ancient times were usually regarded as merely skilled laborers, except on rare occasions when outstanding artists rose above the level of other artisans. This would remain so for many centuries. Eventually a new surge of creativity would emerge through the Renaissance.

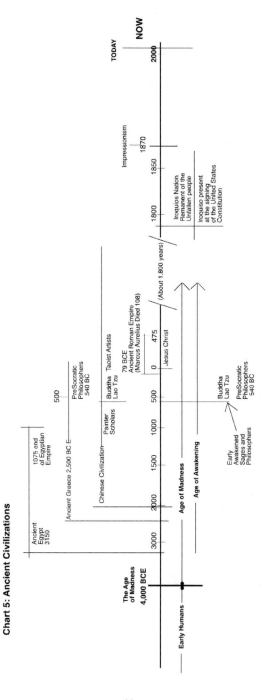

Chart 5: Ancient Civilizations

Chapter 6

From the Renaissance to the Hudson River School

Until Modern art, no other era in Western civilization had more of an impact on Western art than the Italian High Renaissance (1450-1527). In Western civilization, many art movements for 400 years following the Renaissance have either emulated some aspects of the Renaissance, reacted against it, or against what it came to represent. To the artists of following centuries who reacted against it, the Renaissance represented pretentious realism, insincere religion, social stratification, and materialism. We will discuss these reactions shortly, when we discuss the art movements that followed the Renaissance.

The Roman Catholic Church dominated the making of high-art during the Renaissance. The Church employed artists to portray Biblical stories in order to explain the mystery of life, which had been lost when the Madness began, or the Fall, in Christian terms. Meanwhile, the newly emerging Renaissance humanists looked back to ancient Latin and Greek texts to explain the mystery of life through philosophy and mythology. In essence, these were attempts to make sense of life in the present. Renaissance art also glorified war, elevated 'special' people, and promoted the stratification of society.

Within this context Renaissance artists were beginning to depict the world in ways that humans had never seen before. The Renaissance brought the illusion of three-dimensional space, shading of form, individuality, and greater emotion into art like never before. Prior to the Renaissance, when people were depicted in art, they were rendered flat with no shading to suggest volume. People began looking more like individual people and were no longer the same human figure and face

reproduced over and over throughout the work of art. The people also began to appear as though they were expressing emotion in their body gesture and facial expression. Foreshortening and perspective were used to accentuate the illusion of three-dimensional depth. And geometry, particularly what came to be called Fibonacci's 'golden ratio' was applied to some Renaissance art. The golden ratio is a geometric formula that produced what was thought to be perfect proportions. The Renaissance was the beginning of artistic realism. The images depicted in the works of Da Vinci, Michelangelo, and Raphael, and others, appeared "real" because they simulated the way the human eye sees. For example, the human eye interprets objects farther away as appearing smaller than objects that are nearer. Discovering this, the Renaissance artists portrayed objects farther away smaller and nearer objects larger. That technique, in addition to others like perspective, shading, foreshortening, and so forth, would dazzle the eye of the viewer.

One theory about Renaissance realism suggests that some artists, including Caravaggio, da Vinci, Jan Van Eyck and others, used a system of mirrors and lenses in order to project and trace their scenes and subjects onto their painting surfaces. British artist David Hockney wrote about this theory in his book *Secret Knowledge, Rediscovering Lost Techniques of the Old Masters*. The theory is supported by the fact that many figures in Renaissance paintings appear to be slightly distorted in the same way a lens would distort an image of a figure.

Realistic painting, whether done by hand or mirrors and lenses, emulated for the first time the way the mechanism of the human eye naturally interprets form, space, and dimension. Seen for the first time it was, no doubt, marvelous to behold. Realism also has so much appeal for the same reason that highly realistic painting today amazes people: an obviously opaque, flat surface, made only of an area of a wall, ceiling, or canvas could be made to appear as if it were a perfectly clear window through which a

viewer could look into another world of deep space and dimensional form.

This effect delights our eyes and possesses a magical quality to many people. Optical illusions have always fascinated humans, but most people are unaware that just about anyone can be trained to paint realistically and perform this delightful optical illusion. A contemporary version of realism is Photorealism, which mimics the way the human eye sees even better than they were able to do in the Renaissance. The underlying fascination with realism throughout the centuries appears to prove that the world we see is 'real'. A realistic work of art makes the world we inhabit appear stable, substantial and permanent. Believing this brings a sense of assurance, comfort and security.

The image at left shows how artists perceived space in the art of the fourteenth century. In the image at right, from the sixteenth century, the awareness of artists had evolved to the point where they were able to create works of art that emulated the way the human eye actually perceives space. During the Renaissance, painting became a window through which deep space could be seen.

Renaissance art, like the art of all other periods after the Age of Madness began, is a mixture of ego and the infinite creative source that is beyond the ego's awareness.

The subject matter of Renaissance art, just as the subject

matter of the artwork portraying human madness that preceded it, was never determined by the artist. Instead, it was dictated by the Roman Catholic Papacy and its theological experts or by wealthy merchants who employed the artist's services. The romantic idea that Michelangelo, for example, was "a solitary genius who would conjure original works of art from the fathoms of his own imagination, unfettered by the demand of the market place or patrons."[1] was completely false. He painted and sculpted as he was instructed to. Michelangelo's greatness was never because of the religious themes that were portrayed in his artwork. His greatness was in how he interpreted them and how he perceived the human form, and how he handled his materials.

In Michelangelo's *Pieta*, for example, the subject is Mary, mother of Jesus. She holds the dead Jesus, collapsed in her lap just after he had been taken down from the cross. This work, in Saint Peters Basilica in Vatican City, I found to be a truly extraordinary work of art. French cardinal Jean de Billheres determined the subject. He commissioned the *Pieta*, which was a popular theme at the time in painting and sculpture. In Michelangelo's *Pieta* is suffering upon suffering. There is the tremendous suffering that is implied by the body of Jesus having just been taken down from the cross. And further suffering is evident in the face and pose of his mother in whose arms the body of Jesus lies. However, it is the suppleness and tenderness, with which the subject was handled—through masterful, egoless technique—that is so deeply moving about the work. Once, standing before the *Pieta*, and as others snapped photos and listened to their tour guides, I was doing my best to hold back tears. I felt arising within me a wave of compassion for humanity. Such insanity, I thought. The *Pieta* made me wonder, what we have done to ourselves? My spontaneous reaction was an example of the transformative power of art. That power takes the receptive viewer's attention and casts it, so to speak, into the universal context, and beyond the limits of the subject matter. On

the other hand, if the same subject, the *Pieta* in this example, were drawn in stick figures with a felt-tip pen on the back of a napkin, it would not have the same transformative power. Therefore, how a subject is portrayed through egoless mastery makes all the difference. In the deepest sense, Michelangelo's greatness was not in the subject matter he portrayed, but in the egoless way he imagined the gestures of the figures, the way he handled his tools, and expressed his technique.

Michelangelo expressed such tenderness in his sculpture on the one hand, and such bold and dynamic energy on the other hand, that it has been said that God was working through him. Which begs an important question: who really created the *Pieta*? Was it God? Was it the infinite creative source that we are one with? Was it Michelangelo the person? Or was it the ego? The answer is "yes" in each case.

The word God is a term that points toward the invisible source of all, which is unknowable to the human mind and seeks to express into the world through the creative action of humans. I prefer to say the infinite creative source rather than God because of the misunderstanding and polarizing history around the word God. The advantage of using the phrase "infinite creative source" is that it doesn't explain much and yet suggests a transcendent origin of creativity. So God, or infinite creativity, was most certainly involved in making the *Pieta* through Michelangelo.

The creation of *Pieta* also required the participation of a particular life form that had been labeled "Michelangelo", and he was a character. It is well known that Michelangelo was grumpy, ornery, boastful, and a whiner. He was always complaining about something. And more than once Michelangelo fled the presence of Pope Julius II, who had commissioned him to paint the Sistine Chapel ceiling, fearing for his life for having made offensive remarks to His Holiness. Fortunately for Michelangelo, His Holiness, the Infallible Vicar of Jesus Christ, was unable to track down and kill Michelangelo because he and his military were too

busy initiating wars against other city-states in the neigh-borhood. (In time Michelangelo and the Pope made up). Here it is important to understand that attributes of personality such as grumpiness, orneriness, boastfulness, and whining cannot create art. Not even positive personality traits can create art. A 'good' personality cannot create art any more than a 'bad' one can. For any masterpiece to emerge, the human personality must be dormant. And personalities always go into a dormant state when an artist is completely present in the moment while creating. To the extent that the personality does manage to assert itself into creativity, it always produces inferior art. So, yes, the human named Michelangelo was involved in creating the *Pieta*, but only as a vehicle through which the infinite creative source was expressing itself. Putting it in Biblical terms, since man was created from the dust of the ground,[2] it follows that the temporary lump of dust that had been labeled Michelangelo was present when God created the *Pieta* through it.

And finally let us consider the ego's involvement in the creation of *Pieta*. Ego, expressing through Michelangelo, was in fact able to assert itself into the *Pieta* at the very last moment of

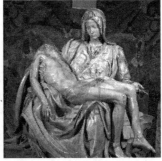

The *Pieta* at left looks stiff and stylized. Michelangelo's version of *Pieta* at right expresses tremendous suppleness and naturalness.
Nevertheless, Michelangelo's pride got the best of him when he wrote his name in bold letters on the sash that drapes across the front of the Virgin Mary's chest.

its creation. As the *Pieta* was being installed, Michelangelo overheard someone say that the sculpture looked like the work of another artist. Infuriated, Michelangelo got out his hammer and chisel and carved along the sash that drapes across the front of Mary's chest "MICHELANGELO BUONARROTI, FLORENTINE, MADE IT." It was an unnecessary and diminishing addition that detracts from the more important universal message of human suffering. And so, as this example of the creation of *Pieta* illustrates, there is often a mashing together of ego and the infinite creative source in artistic creativity.

Another great Renaissance artist is of course, Leonardo da Vinci. He is considered by some to be the greatest artistic genius the world has ever known. For our purposes, however, da Vinci offers another example of the mixture of the infinite creative source as it flows through the artist and the psychic disharmony that reside within the artist. On the one hand, da Vinci painted figures that seemed to be almost more than realistic; he seemed to capture the inner light shining through many of his subjects. On the other hand, he spent vast amounts of creative energy inventing devices and war machines that would kill and maim as many other humans as possible. To me it seems that da Vinci was a great artist, but not completely an awakening artist. As far as geniuses go, Albert Einstein, who lived in the twentieth century,

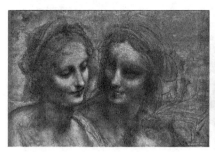

Da Vinci's sketch at left portrays maternal love and sensitivity. On the other hand, the image at right of a war machine shows da Vinci's fascination with methods of killing humans.

was an example of a truly awakening genius. And even though Einstein invented the theories that enabled the atomic bomb to be made, he had no intentions of his theories being used in that manner. He also refused to participate in the Manhattan Project that produced the bomb. He was at heart a pacifist, and many of his statements revealed a deep inner wisdom.

What the awakening artist can learn from the Renaissance artists is how to create realistic works of art. That is to say, to create optical illusions that emulate the way the mechanism of the human eye and brain interpret visual information. Also the awakening artist can transform the use of mythology and metaphor. Instead of portraying God as an old bearded man floating on a cloud, as Michelangelo did on the Sistine Chapel ceiling, the awakening artists might explore ways of portraying the creative intelligence of the universe by using contemporary motifs and imagery.

Between the Renaissance and the era of Romanticism were various other art movements, including Mannerism, Baroque, and Rococo. As mentioned, awakening and psychic disharmony can be found in any art movement. For our purposes however, the Baroque Period offers an interesting example.

Baroque Era

The Baroque Period (1600-1750 CE) started in Italy and eventually spread throughout Europe. Baroque art was originally used by the Roman Catholic Church as a tool for propaganda. The art was infused with religious themes from the past and employed exaggerated emotions in order to lure the common person toward Catholicism and away from the temptations of joining the newly established Protestant Reformation. Themes were overt and without subtlety, symbolism, or references, which allowed the illiterate to understand them more easily. The aristocracy of the time used the flamboyant Baroque art to impress visitors with their social status, power and wealth.

Tremendous genius in the form of music created by Johann Sebastian Bach, Antonio Vivaldi and many others, came forth at this time. Nevertheless, the period came to be typified by its overt, energetic, lusty, overflowing exuberance, and ornamentation as seen in the painting of Peter Paul Rubens, for example. There is certainly nothing wrong with ornamentation and lusty exuberance because the universal play of form naturally celebrates decoration and sensuality. However Baroque art also portrayed insanity. It was used to manipulate commoners and inflate the importance of religious ideology and its institutions, and it was used by ego to impress others in order to feel superior. When Chinese artists of the same period first saw Baroque art, they thought it was blatant, vulgar, and produced by amateur painters.[3] When they saw Peter Paul Rubens' *The Rape of the Daughters of Leucippus* (1618) they were shocked that European artists would glorify rape by making it the subject of art.[4] To the egoic mind, though, rape is just another subject. Violence is normal, so 'normal' in fact that it is unrecognized as violent. It's not violent, the ego thinks, it's merely thematic. But to an outside observer, like the Chinese artists in this case, the whole idea of using art in such a manner was incredulous. Furthermore, the wealth that financed the production of Baroque art, came predominantly from the plunder of gold and silver by the Spanish from the land of primal people in the Americas. The Spaniards brought back gold and silver to Europe, shipload, after shipload.[5]

Related to this, the contrast between innocent people and mad people could not be more graphically illustrated than the encounter of the mad Europeans in their search for gold, with the innocent primal people of America. Columbus reported that the Indians were so naive and free with their possessions that they would give you anything you asked for. In fact, they would go out of their way to find ways of sharing their possessions with you. Columbus was so taken by their selfless ways that he

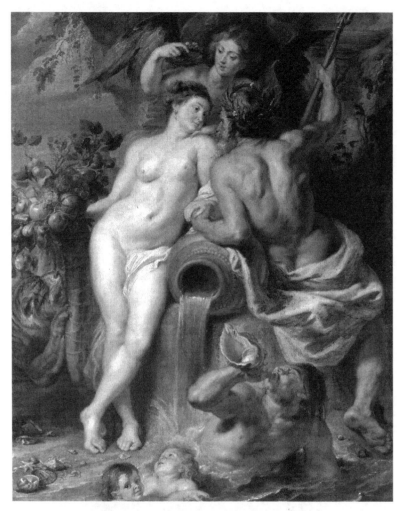

The Union of Earth and Water (1618) by Peter Paul Rubens. The sensuality of Peter Paul Rubens' paintings came to symbolize the lusty exuberance of the Baroque era.

concluded one report with a promise to bring back as many of them as possible to be used as slaves, to the glory of God.[6] The mad Europeans were so cruel to the innocent Americans that the Spaniards "thought nothing of knifing Indians by tens and twenties and of cutting slices off of them to test the sharpness of

their blades."[7] (Another example of the clash between insane Europeans and innocent primal people is when Captain Cook described the Aboriginal Inhabitants of Australia as "living very happily without the necessary conveniences so much sought after in Europe". However, by 1800 the aboriginals were nearly exterminated across Australia and Tasmania because of colonization. Ordinary routine shootings were deemed necessary to make the country safe for cattle breeding."[8])

To mad humans, cruelty is considered normal, even entertaining. Mad humans, including those of today, are incapable of recognizing cruelty as cruelty. It was in this manner that the cruelty and enslavement of innocent primal people, and the plundering of gold and silver of the Americas, played a central role in financing the Baroque era. And while the Chinese viewed Baroque art as vulgar, ostentatious, and "amateurish", the Roman Catholic Church and the European Aristocracy displayed it proudly.

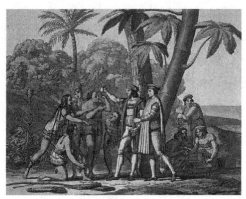

Christopher Columbus, and other mad humans dazzle the innocent people of the Americas with objects and trinkets before enslaving them. The profits from America's gold helped to finance the lusty European Baroque era.

The Dutch Golden Ages, Seventeenth Century

While Baroque art was the trend in all of Europe, the Dutch in the

north, who were also considered part of the Baroque Period, were turning their art the other way; away from ostentatiousness and toward awakening. This time was called the Dutch Golden Age of painting. Their art included fewer religious, and historical themes and instead developed secular genres, including still life painting, landscape painting, townscapes, flower painting, maritime painting, animal paintings and scenes of everyday life. These genres were traditionally considered insignificant by connoisseurs of European culture because those subjects did not reiterate the stories and mythologies of the past, or glorify 'superior' people such as religious, or wealthy figures with their ideologies and accomplishments. Instead, the Dutch artists' subject matter honored and respected the artists' immediate life and surroundings. The Dutch artist looked out into the world around him and simply enjoyed painting what he saw there. Or he would invent good stories out of scenes from everyday life. Among the many great Dutch painters, were Rembrandt and Vermeer, whose works point toward awakening.

The Baroque painting at left shows a lofty allegory involving the mythological gods Venus, Satyr, and Cupid. The Flemish Baroque painting at right, however, depicts the artist's appreciation for everyday experiences around him, like a family buying a fish.

Rembrandt (1606 - 1669)

Rembrandt's artwork expresses a depth of human emotion like few other artists, whether they were Biblical stories that he portrayed, or portraits of peasants in his hometown of Amsterdam. According to art critic Robert Hughes, Rembrandt had the ability to seamlessly meld the earthly and the spiritual as has no other painter in Western art. His artwork was devoid of the rigid formality that his contemporaries often displayed. His work had a deeply felt compassion for mankind, irrespective of wealth, age, class, or gender. Rembrandt was truly a painter of compassion.

Vermeer (1632 - 1675)

Very little is known about Vermeer, and there is very little record of his personal life. It is known that his father was an art dealer,

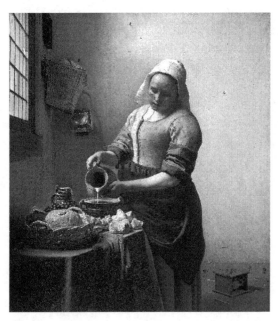

The Milkmaid by Joannes Vermeer (1658). Few artists have ever captured the qualities of deep calm, inner peace, and stillness that can be found in the present moment like Vermeer did in many of his paintings.

that he became baptized as a Catholic in order to marry his wife. He fathered fourteen children and was, up until his last few years, financially successful. He was unknown outside of his hometown of Delft, and he left very few sketches or records of how he developed his paintings, or what he thought about art. Vermeer painted only 35 paintings in his lifetime. And then, for 200 years, he was overlooked by Dutch art historians before his artistic genius finally surfaced for the world to see.

Vermeer is known for his masterful handling of soft light, color, perspective, and his rock solid compositional structures. To me, however, the most powerful aspect of Vermeer's art is his portrayal of stillness and peace. I know of no other artist who has ever portrayed stillness and peace with such palpable tangibility. In addition, the spaciousness left around his figures further heightens the sense of inner peace, stillness, and the quiet contemplation of his subjects. These qualities of inner peace, stillness, and quiet contemplation are attributes of the awakening artist.

And what brought the Dutch Golden Age to an end? You guessed it—ego. The invasion of Holland by the French, in 1672.

The French Academy

From the beginning of the Age of Madness, 6,000 years ago and onward, the subject matter of official art had been dictated throughout the Mad world by pharaohs, emperors, kings, popes, and aristocrats. Entering into the eighteenth century in the West, however, it was increasingly less the case, as artists were given authority to govern their own activities. This was an indication, for the first time since the madness began, of a loosening of control of artistic creativity by political powers.

The first self-governing society of artists in Europe was the Académie des Beaux-Arts (Academy of Arts) in France. The main task of the academy was to organize the *Salon* art exhibition, since the French government had ceased to do so. The Salon was

held annually in the Louvre, and it was the greatest art exhibition in the Western world. At that time, France was the center of the Western art world, and all eyes looked to Paris to see the greatest examples of Western art. High art was now overseen by the Academy, which upheld the standards of the classical tradition. The Academy carried forward the style and content of Renaissance art, which continued to influence Western art. Realistic representation, historical subjects, religious themes, mythological motifs, and portraits were valued, but landscape and still life paintings were considered of lesser importance. The Academy preferred carefully finished images, which mirrored reality. Color was somber and conservative, and all traces of brushstrokes were suppressed, concealing the artist's techniques. If the art did not strive to emulate the styles and themes of the old masters, such as Raphael or Botticelli, then it was dismissed out of hand and considered amateurish.

So, on the one hand, with the emergence of the Académie des Beaux-Arts artists gained the 'separation of art and state' and of 'art and church', so to speak. On the other hand, they had the dictates of the artistic leaders of the Academy who were ensconced in realism, past styles, themes, and techniques. Many works of art created by Academy artists were wonderful, such as Bouguereau's painting *Captive* (1891) that beautifully depicts the affections shared by a young woman and her child. As wonderful as some Academy art was, emerging artists no longer wanted to base their creativity on the limits of Academy-approved painting methods, and tried-and-true themes from the past. The infinite creative source was urging these new artists to express their deep emotional feelings that were arising in the present. These passionate artists came to be called Romantics.

Romanticism (second half of the eighteenth century)

The Renaissance brought a realistic and mechanical way of seeing the world and of making art. And, the Renaissance methods

dominated Western art for four hundred years and eventually calcified into a rigid, dogmatic method that all artists were expected to uphold. However, not even the calcified dogmas of the French Academy could stop the infinite creative source from flowing through the consciousness of some artists. Consciousness continually seeks ways of evolving and expressing creatively wherever artists are available to allow it expression through them. The Romantics were the first in the Western tradition to move beyond the influence and stagnation of Renaissance realism. Romanticism originated in the second half of the eighteenth century, in England, Germany, and France at a time when artists were becoming increasingly free to explore their own themes. These artists felt that powerful emotions and deep inner feelings were of a higher form of artistic expression than the rigid, formulas of the Renaissance, so their paintings portrayed human passion. (See comparison photo below) They valued intuition over rationalism and were a counter balance to

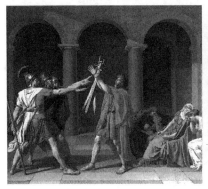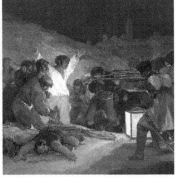

The French Academic painting at left, by David, depicts a heroic allegiance among soldiers. The Academic painters could only use themes and techniques allowed by the Academy. At right, however, Romantic painter Goya depicts the tragic reality of human madness with emotion and expressive brushstrokes. The infinite creative source working through Goya wanted to see the world honestly and realistically.

the mechanization of the Industrial Revolution and the acceleration of the predominantly logical way of viewing the world. The Romantics, which among many others included Constable, Goya, Delacroix, and Turner explored individuality and personal perception. They embraced imagination and sense perception over reason. The Romantics sensed there was something more to the human experience than defining life in rational terms. The Romantics perceived with their emotions, so to speak, and sought to embrace life with their whole being, rather than just the intellect.

Romantic sentimentality was a label attached not only to artists of the eighteenth century but was, and continues to be, a label used by intellectually orientated critics to describe anything that expresses personal depth and genuine emotion. During a much earlier time, the thirteenth century Persian poet Rumi was also categorized as a sentimental romantic yet his poetry is a powerful example of the awakening artist and of divine art. Such poetry is beyond the creative ability of the intellect, logic and reason when they are devoid of emotional and spiritual depth. Today, Rumi's poetry is considered, by many who are awakening to the spiritual dimension within themselves, as expressing universal spiritual truth. Here is an excerpt that portrays Rumi's sensing of the infinite creative source within the artist:

> In your light I learn how to love.
> In your beauty, how to make poems.
> You dance inside my chest,
> Where no one can see you,
> But sometimes I do,
> And that sight becomes this art.
> Rumi-
> (Excerpt from Chinese Art and Greek Art" by Rumi)[9]

While the Romantics were exploring their inner passions and

expressing them in their artwork, another group of artists began moving away from tradition, too. But rather than going inward, they went outward and into the beauty of nature to find inspiration.

John Constable

John Constable (1776-1837) was an English Romantic landscape painter who was one of the first to realize that an artist could paint landscape paintings for the mere beauty and emotions they evoked. Up until then, most landscape painting was relegated to amateur painters. 'Important' paintings, insisted the traditionalists of the old consciousness, were those that harkened to past times and represented historical events. However, Constable's magnificent landscape paintings managed to elevate the discussion of what great art could be. His work would soon inspire the Barbizon School, influence The Hudson River School painters, and even the Impressionists.

The Barbizon School (1830 to 1870)

The Barbizon School painters were another group who sought to escape the gravitational force of the Renaissance and the strangulation of the French Academy that insisted on approved painting techniques and subjects. The Barbizon School flourished between 1830 and 1870, and included artists Jean-François Millet, Jean-Baptiste Camille Corot, Théodore Rousseau and others. The name of the School came from the village of Barbizon, France, near Fontainebleau Forest where the artists gathered to follow John Constable's vision of making nature itself the subject of painting instead of using nature as mere backdrop for dramatic events. Their ideas eventually expanded to include people in their paintings doing ordinary tasks. The Barbizon School artists had awakened to the realization that painting mythological beings enacting fanciful allegories was part of the old consciousness and they had moved beyond it. To

the Barbizon artists, painting nature, and people going about their ordinary lives was the 'truth', was 'reality' and worthy of their artistic attention and respect.

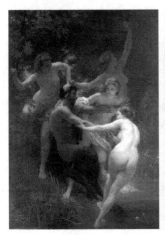

At left: *Nymphs and Satyr,* by the French Academy painter, William-Adolphe Bouguereau. At right: *Farmer Inserting a Graft on a Tree,* by Jean-François Millet.

When comparing the pictures above, some observers may feel that the warmly lit and fanciful mythological scene of *Nymphs and Satyr* is more tantalizing than the scene at right of a graft being inserted on a tree by a farmer. However, from the Barbizon artist's point of view, a fanciful mythology was just that—a fantasy, whereas the scene of farmers inserting a graft was unglamorous reality. In fact, it was the reality of most people not only in France but all of Europe at that time. To Barbizon School artists the portrayal of reality in art was the most honest thing an artist could do. Furthermore, the graft itself may symbolize the emergence of a new consciousness out of an old consciousness.

Imagine this modern-day comparison: On the left would be an advertisement showing a group of beautiful people sizzling with sexuality. The ad would subliminally communicate that if men purchased the cologne that the handsome man in the picture is

wearing, they too would soon have beautiful women slithering over their bodies. On the right would be an ordinary man mowing his lawn as his wife and child look on from the porch, as happens in typical modern-day suburban neighborhoods. From an artist's point of view, which picture portrays more accurately the reality of normal life and which is a fantasy?

The Hudson River School (about 1830 - 1875)

The Hudson River School painters were well aware of and inspired by the Romantic artists and Barbizon School artists in Europe. They were a group of mid-nineteenth century American artists who painted vast panoramic scenes depicting the grandeur and beauty of nature, in contrast to the industrialization of society they saw around them. One member of the group, artist Thomas Cole, described the madness in his day in this way: "The spirit of our society is to contrive but not to enjoy—toiling only to produce more toil and accumulation in order to aggrandize."[10]

The Hudson River School painters were the first artists in America to devote themselves exclusively to landscape painting instead of portraiture, that had been the prevailing genre at the time. The grandeur of Niagara Falls and the scenic beauty of the Hudson River valley, the Catskills, and the White Mountains, and other panoramic landscapes throughout the United States particularly attracted the Hudson River School artists. For example, Albert Bierstadt's *Looking Down Yosemite Valley* portrays a grand vista with distant clouds, and rugged mountain in gauzy warm light. The foreground is painted in fine detail capturing every leaf, and shards of light are glinting on rocks and trees. The Hudson River School artists often used light and mist as primary compositional elements in their work, and quite often the light and mist would become more important than the subject of the painting. This effect was later called "luminism" by historians of the following century. The Hudson River School

paintings always direct the viewer's attention toward the vastness of nature and toward the fact that human beings are relatively small by comparison. It is an appropriate and humbling realization to anyone who grasps it. And yet being in nature may also connect us to its vastness, as it is a reflection of the same vastness within ourselves. If we are in stillness in nature, we may sense our own inner stillness. Painter Thomas Cole pointed out "people throughout all the ages and nations have found pleasure, consolation, and inspiration, in the beauty of the rural earth."[11] This is because within the deep peace of nature, which is rooted in Being, the psychic disharmony that humans experience momentarily diminishes.

At left, the landscape in many Renaissance paintings served merely as a backdrop behind a dramatic scene. In this instance an activity that included people getting whacked with clubs. At right, however, Hudson River School artist, Thomas Cole, depicts St John celebrating the vastness, and sacred wonder of Nature. (See tiny figures just below the center of the image).

Some of the artists, like Cole, would travel the world to find

landscapes and scenes to inspire his paintings. Hudson River artists were sometimes criticized for romanticizing nature. And from a purely intellectual point of view that would appear to be true. The artists sometimes infused their paintings with more glory and grandeur than the scenes actually had. However, from the awakening artist point of view it is clear that expressing strong feeling and deep respect for the grandeur of nature is a much more effective pointer to the transcendent and spiritual dimension than the alternative, which is the reduction of nature to scientific categories and objects which only flatten nature into an assortment of things to be used or abused, by the human ego, which has no sense of the sacredness of nature. Reverence and respect for nature have always been characteristic of higher consciousness. By painting scenes of the grandeur of nature the Hudson River School artists were pointing metaphorically toward the infinite creative source that is beyond us, that flows through us and that ultimately we are one with.

George Inness (1825 - 1894)

George Inness' early works were often associated to the Hudson River School because his early landscape paintings bore all of the features of the School: He painted exclusively landscapes with wide vistas, dramatic lighting, and sharp detail. However, the paintings of his later years were influenced by the loose brushwork of the Barbizon School. Inness became exposed to the Barbizon School, in France, during his travels there. Inness' artistic philosophy was partially influenced by Emanuel Swedenborg (1688-1772) a Swedish scientist, philosopher, theologian and Christian mystic.

According to his son George Inness Jr. "When he painted, he put all the force of his nature onto it. Full of vim and vigor. He was a dynamo. He was indefatigable."[12] That was in his studio, however, when in nature he was quiet and inward. He walked, contemplated, and made drawings to be used as studies for

paintings later in his studio.

According to his son:

> My father had the idea firmly established in his mind that a
> work of art from his brush always remained his property, and
> that he had the right to paint over it or change it at will, no
> matter where he found it or who had bought it, or what
> money he had received for it.

There are many stories of Inness going to collector's homes and
taking the paintings back to his studio to give them a little
improvement. But as was his tendency, he would sometimes
paint an entirely new painting over the old one. When Inness
returned the painting, the collector would protest that the
painting he brought back was not the painting he left with, to
which Inness would reply: "Yes it is, but now it is improved".
This tendency of Inness' to continually repaint over finished
paintings was well known. If, for instance, a collector went to
Inness' studio and purchased a painting of a summer evening, the
smart collector knew to whisk the painting away quickly
knowing well that if he did not, the summer evening painting
could quickly be transformed into a winter morning scene if it
occurred to Inness to improve it a little before it left the studio.
Sometimes when Inness visited the home of a collector he would
arrive to find that all of his paintings had been hidden.

Inness was a deeply spiritual man who enjoyed engaging in
spirited debates about theology, art, and science. Few, if any,
could prevail against his carefully crafted and well-researched
arguments that he would deliver with the same characteristic
fiery enthusiasm with which he lived his life.

To Inness all of nature was the outer appearance of an inner
spirituality. That is why his later works were more suggestive
and loose in technique. This change in his style illustrates how he
was seeking to convey a deeper truth than outer appearances

Compare these two paintings by George Inness. At left: *The Lackawanna Valley* (1855). Inness' early works were filled with details common to the Hudson River School style. At right: In his later works, such as *Sunset on the Passaic* (1891) details were omitted and the landscape was seen as a unified expression of nature. Evening scenes were especially conducive to creating a sense of wholeness and simplicity, as well as peace and stillness. In his later years, Inness' artwork reflected his spiritual awakening.

would suggest. His style became less detailed because he believed that when subjects were painted with extreme realism, it distracted the viewer from the deeper truth that lay beyond the form. To Inness, that deeper truth was God, and God was the 'real' reality. The outer forms were illusions, which is essentially the same concept held by the early Chinese Taoist painters. Here we see that God and the Tao are the same. "God is always hidden", he said. "Beauty depends upon the unseen—the visible upon the invisible."[13] Comparing Inness' early work to his later work it is clear that he sought to bring this realization into his art. The earlier works are tight and controlled, bringing attention to detail, and his later works are by comparison vague and suggestive, which communicates an overall wholeness and warmth, rather than merely an assemblage of assorted details; a tree here, a rock there, and a river over there. Inness said:

The true end of Art is not to imitate a fixed material condition, but to represent a living motion. The intelligence to be conveyed by it is not an outer fact but an inner life.[14]

Inness also said:

The true use of art is, first, to cultivate the artist's own spiritual nature, and secondly, to enter as a factor in general civilization. And the increase of these effects depends upon the purity of the artist's motive in the pursuit of art. Every artist who, without reference to external circumstances, aims truly to represent the ideas and emotions which come to him when he is in the presence of nature, is in the process of his own spiritual development . . .[15]

Inness explored the theme of spiritual awakening just as so many artists of The One Art Movement had before him. He lived it and breathed it. At the end of his life he said: "I am seventy years of age, and the whole study of my life has been to find out what it is that is in myself; what is this thing we call life, and how does it operate."[16] Adrienne Baxter Bell, author of *George Inness: Writings and Reflections on Art and Philosophy* stated:

Given that all art maintained a theological identity for Inness, it is likely that Inness viewed the capacity of art akin to a spiritual awakening.[17]

In nature, Inness pondered the hidden reality behind her. He thought about art, theology and science, and made many sketches. Inness died while walking in nature. When he died, according to his son, "George was looking at a sunset and proclaimed "My God, what a beautiful sunset!" and then fell over dead".

While many mad humans of the Industrial Revolutions were

busy conquering the land with their machines and using nature as a mere means to an end for industry and profit, Inness offered the possibility of a deep and loving relationship with nature and the hidden reality behind her. He offered the awakening alter- native.

Comparing Chinese and Western Artistic Points of View

From the perspective of the awakening artist, we have under- taken a cursory survey of art history from the time of the ancient civilizations of Egypt, Greece, China and Rome, up through the Italian Renaissance, to the Romantic era and finally the Hudson River School. Before we move on to the rowdy explorations of the modern artists, let us first compare the Chinese artists' approach with the approach of the Renaissance, Romantic, and the Hudson River School artists.

To the Chinese Taoist landscape painter, it would make no sense to paint a landscape separate from the Tao. To their way of thinking, the Tao was in everything and beyond everything, thus the landscape painter sought to paint that knowing. The Taoist's view is very similar to George Inness' theology. The objectifi- cation of nature did not exist for the Taoists as it did in most of the Western world. That is to say, nature was not viewed as merely a resource for the consumption of industry; instead it was experienced as sacred. This is quite different than the approach of the European Romantic landscape painters, and most of the Hudson River School landscape painters who saw nature as out there and separate from the artist. In that separation the Western Romantic artist might portray himself as bracing against one of Nature's mighty, powerful storms. The early Chinese landscape painter, on the other hand, would portray his inseparable relationship to the storm, for the artist and the storm are one. He would seek to paint how the storm and artists are at peace together within the Tao.

As Chinese artists became aware of Italian Renaissance art in

the fifteenth and sixteenth centuries, many of them experimented with perspective, foreshortening, and the shading of form. So it is clear that the Chinese understood the Renaissance concepts of art and perspective. They were able to create works of art that emulated the way the human eye saw, which was one of the main goals of Renaissance art. However, in the final analysis, the Chinese artists abandoned Renaissance realism because they found it too constricting, and they returned to their own methods. To them it seemed strange to view the world as if it were a static assortment of objects that could only be viewed from a single, unmovable, and fixed point of view. Whereas Chinese painting usually put empty space between objects, mountains and people, which tended to negate perspective. It allowed the viewer to float freely through the painting, so to speak, and not be bound to a single point of view. And, because early Chinese art did not use shading, as was common in the West, there was rarely an implied time of day, for there were no shadows. Thus, Chinese art was able to imply timelessness. More than anything, to the Chinese artists, there was no space for the Tao in Western style painting.

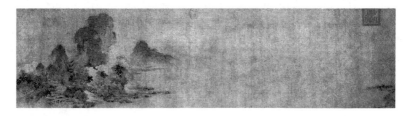

Chinese landscape painting by Wang Shen, Northern Song Dynasty (960–1279). The early Chinese landscape painters used empty space in their paintings to represent the Tao, which is the formless dimension out of which both humans and the earth have arisen.

We have seen in this chapter how the infinite creative source sought expression through the artists of the East just as it sought

expression through artists of the West, because they are all included in the One Art Movement. But the infinite creative source is not stagnant, it continues to change, evolve, and explore. So as spiritual consciousness evolves so does the artist, and the old forms of art are no longer able to contain the new consciousness. As we shall now see, it was not just the artists of the East who found Renaissance style realism constricting. Western artists, too, increasingly found it limiting. As we have already seen, the European Romantic artists broke away from the influence of the Renaissance by embracing nature with a depth of feeling and passion. And the Hudson River School painters portrayed the vastness, and sacredness of nature. Meanwhile a whole new kind or art was exploding in brilliant color and light in Europe. It was called Impressionism.

(See chart overleaf)

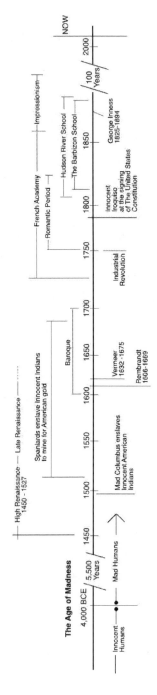

Chart: From the Renaissance to The Hudson River School

Chapter 7

Modern Art

Impressionism marks the beginning of the Modern Art era. Before we discuss the Impressionists, let us briefly review how we have arrived at this point.

First a Review: From Cave Art To Modern, The One Art Movement, which is contained within the overall flowering of human consciousness, includes all artists throughout the ages, from the earliest humans through the present. Prior to the Age of Madness, which occurred about 4000 BCE, there was what I have called 'innocent art', which was the art of early humans. Their art portrayed their harmony with nature. It was a part of their sacred rituals and also portrayed the beauty of the world around them and the activities of everyday life. With the Age of Madness came egoic art, which has portrayed the psychic-disharmony, suffering, and cravings of humans ever since. We saw that throughout the ancient civilizations of Egypt, Greece, China, and Rome, and up to the Italian Renaissance, most artists were merely skilled laborers, with greater or lesser creative abilities, who depicted the egoic themes dictated by those who had power over them. Examples of these themes are: triumphant victories, mythologies harkening to past times, or themes that revealed their separation from nature and God. And the Renaissance brought forth the artistic ability to paint the way the human eye actually sees. This is why it is called "realism".

Of course there is no real entity called the Renaissance. It is merely a word that scholars came up with centuries later in order to categorize the themes and trends of that period. Some scholars today would even argue that the term Renaissance does not accurately describe that period. From the point of view of the awakening artist, however, labels are sometimes handy but

ultimately not all that important. What is important is the realization that the infinite creative source is seeking to express itself through humans, and therefore their art movements. And to the degree that humans are receptive of the infinite creative source, it will seek to come forth into the world and through the artistic forms humans create.

For example, the Renaissance principle of perspective was unknowable to artists prior to that time because the infinite creative source had not created it through them. How do I know this? Because the great artists prior to the Renaissance, Cimabue and Giotto for example, were doing everything in their power to make their art appear realistic, and accurate perspective is a necessity in realistic painting. In fact, by the standard of their time, Cimabue and Giotto's art was believed to be realistic. Compared to High Renaissance realism, however, their art is not realistic at all. Except in the most rudimentary sense, the concept of perspective was beyond Cimabue and Giotto's imagination. This is not to say they would not have comprehended the concept of perspective if someone were to explain it to them; they most

At left: The white lines drawn over the fourteenth century painting show an incomplete understanding of single-point linear perspective. At right: A painting created about two hundred years later shows an understanding of single-point perspective and more accurately emulates the way the human eye naturally sees.

likely would have understood it. But the fact that the principles of perspective remained unknown to them shows that they had not realized it or awakened to it on their own. From the standpoint of the infinite creative source, there was not yet the spaciousness in human consciousness sufficient for them to invent perspective.

How is it that the infinite creative source can 'view' and 'create' through humans? To understand this we have to recall the fundamental flaw of the egoic mind. And that is found in the illusion of separation that the egoic mind has created and sustains. The egoic mind imagines it is separate from itself, others, the world, the universe, and from the infinite creative source beyond it. Seen from a non-egoic point of view, however, there is no separation, therefore would not the creative source and the artist be one and the same? It is only the human mind that can hold a position that it is separate. And so, to say that the infinite creative source is "viewing" and "creating" through the artist is to point toward a greater oneness that already exists and to which the artist may awaken.

Following the Renaissance, the infinite creative source explored emotional depth and feeling through the paintings of the Romantic artists. And it explored the vastness of its sacred nature through the Hudson River School artists. Through examples of art we can see the "flowering of human consciousness".

Modern Art, an Overview from 1863 to 1975

Modern art emerged in Europe with the rise of industrialization, capitalism and secularization in the middle to late part of the nineteenth century. Modern Art began with the Impressionists, in about 1863, and ended with the Minimalists in the mid 1970s. The latter part of the nineteenth century was a time of unprecedented artistic exploration. It all started when the Impressionists went beyond the limitations of classical realism that had been

rigorously adhered to for over 400 years by European artists such as Jean Auguste Dominique Ingres (1780-1867). If you compare, for example, the painting *Princess Albert de Broglie* by classic painter Ingres, with Impressionist Mary Cassatt's painting *Mary at the Theatre* you will notice how carefully controlled and precise Ingres' painting is compared to the shots of bold contrast and high-energy brushwork of Cassatt's painting:

At left: a portrait by Jean August Ingress. The Classic-style that began in the Renaissance demonstrates the realistic method that had been required of artists for 400 years. However, consciousness evolving through the Impressionists, such as Mary Cassatt, at right, began exploring more vibrant ways of seeing the world.

Today any student new to making art might wonder why anyone would *not* want to paint like a Classical master? Because some artists, like the Impressionists, felt there was something more to artistic vision and creativity than following age-old formulas that could produce a high-degree of realism in painting, but no passion or exuberance. In addition, most Classical painting was done in the studio. And then tube paints were invented which are paints that could be purchased in tubes rather than made from

raw pigments by the artist himself in the studio. This allowed the Impressionists to take their paints, canvases, and brushes and go out into the sunlit meadows and hills of France to paint.

Following the Impressionist Period, the traditional standards of art in the West began unraveling until eventually there were no standards at all. Modern artists began asking deeper philosophical and reflective questions like: What is art? What is the purpose of art in society? What is beauty in our time? What is truth in art? Who is an artist? They began searching for answers to these fundamental questions that had never been asked before, and expressing their findings through their art. From the point of view of the awakening artist, their entire quest was inspired by an inner urge to awaken, though it was rarely described in that way.

What we see in most contemporary art today is the result of that self-examination and experimentation. Some of the artistic results have lead to new ways of seeing the world, and others have only magnified human egoic insanity. In a nutshell this is what has happened to make contemporary modern art appear both inspiring and beautiful and sometimes chaotic, ugly, and insane. And it all started over a century ago with the Impressionists who broke free of the restraints of the classical Renaissance tradition.

How the Impressionists Saw the World

The Hudson River School artists were in their zenith, exploring the vastness, sacredness, and beauty of nature in the mountains, valleys, and rivers of North America. Simultaneously and half-way across the world, other awakening artists were also giving their complete, and therefore egoless, attention to nature in an explosion of light and color. The Impressionists sometimes painted trees and mountains in a manner that was indistinguishable from the colors and light of the shimmering atmosphere around them. Their art expressed strong visual and

emotional sensibilities. Impressionism offered artists an unprecedented and lively way of seeing the world. They saw nature not as an arrangement of objects, such as trees, hills and mountains, as did the Classical realists. Instead, they saw the world as an effervescent dance and interplay of light and color.

As Monet put it:

"When you go out to paint, try to forget what objects you have before you, a tree, a house, a field or whatever... merely think here is a little square of blue, here an oblong of pink, here a streak of yellow, and paint it just as it looks to you, the exact color and shape, until it gives you your own naive impression of the scene before you."

Branch of the Seine Near Giverny by Claude Monet (1897)

For the Impressionists, even the simplest expressions of life, like a flower, became the inspiration of a much deeper kind of perception. Monet even said that he owed having become a painter to flowers. What could he have possibly seen in flowers that would inspire him to become an artist? I believe he saw innocence and purity in them. And once you have seen that, have felt it within you and have known its truth within you, it is hard to turn your attention away. In Impressionism there is a great love of the visual world. There is no suffering in it. It is pure joy.

It may seem that I am casting an overly positive light on the Impressionists. After all, Monet claimed to be 'tormented' by color, and Cezanne was considered rude, shy, and sometimes even a lunatic. However, as we noted earlier in the case of the ornery Michelangelo, personality characteristics cannot make art.

The personality of artists may be anecdotal and amusing, but creativity can only occur when an artist is completely present in the moment. In the present moment there is no personality, there is only consciousness exploring form and expressing itself. From the awakening artist point of view, universal consciousness was allowed expression through the Impressionists. Through human eyes it saw the world in a way that had never been seen before. The world was seen through the dimension of light and color, rather than as an arrangement of solid objects in space, as had been the tradition of realism. That is what realism was, the portrayal of objects as independent solid forms as they appear to the human eye. Whether the Impressionists thought of it exactly this way or not, I am not sure, but the impressionistic style is a beautiful visual metaphor of the inherent absence of anything solid in nature as physics has since demonstrated.

For example, the closer physics has looked at matter, the less matter they seem to find. On the atomic level solid objects are composed of atoms but physicists tell us that atoms are composed mostly of empty space. Furthermore, because atoms are mostly space on the atomic level, there is little distinction between one 'solid' object and another. To be able to see the world as an arrangement of separate objects has its usefulness. It helps us avoid walking into things, like trees and other people. But it is also a very narrow and conditioned point of view of the world. Another point of view would be to recognize that all forms are unstable, temporary and illusionary, because eventually they all transform into something else. As an analogy of this phenomenon, it may be said that Impressionism plays with the intermingling and merging of space, light, and not-so-solid objects.

Post Impressionism

The Impressionists, like the Romantic and Hudson River

painters before them, had broken away from the creativity-stifling traditions of the Académie des Beaux-Arts. They showed open-minded artists how to see beyond the mere form of things, and to begin seeing the world as an exotic arrangement of exquisite shapes of light and color. They also brought their feelings into their art by letting the brushstrokes show their own character, and by using bold colors to express mood. This was contrary to the French Academics who, as previously mentioned insisted upon brushstrokes being concealed to hide the artist's technique.

Once the Impressionists had demonstrated that their style could survive in the world without the dictates of the Academy or religion, this realization expanded the possibilities for artists to explore and experiment artistically in whatever ways they wished. In addition, with the advent of photography and its increasing ability to replace artists in the task of recording images of people and events, artists had to begin searching for a new purpose for artistic creativity and began questioning their role as artists.

In the Western tradition art no longer served pharaohs, emperors, kings, popes, and aristocracies, or society at all. Its only purpose was whatever purpose the artists alone brought into it. On one hand, art was becoming increasingly socially 'useless', on the other hand it was increasingly liberating because there were fewer limits that could constrict the flow of creative consciousness through art. A question is, how was this new kind of art financially sustainable if it served little purpose for those in power, a government, or society? The audience and buyers of this new and strange art were never the general public, government, or religious institutions as in the past. It was like-minded people including art dealers, collectors, and museums that had the financial firepower to purchase Modern Art and support it. It was artists and these supportive, like-minded people who eventually formed what is commonly called the art world.

Cezanne: Squeezing and Bending Space

Artist Paul Cezanne was also an Impressionist until he went off to explore on his own. He is considered the father of modern art because so many of the art movements within Modern Art can be traced back to Cezanne. His view of nature and his approach to painting was to see the world in flat overlapping planes. Whether painting a carrot, or mountain, each brushstroke would define a plane.

Cezanne made landscapes and still life paintings appear to simultaneously have both spatial depth and two-dimensional design. He did this by treating the background in his paintings in the same manner as the foreground, and in so doing he appeared to be ignoring the rules of spatial depth. For instance, one rule of spatial depth states that brushstrokes should be applied smaller in the background and larger in the foreground. This creates the illusion of spatial depth because distance objects always appear smaller the farther away they are, therefore smaller brushstrokes would appear farther away. By ignoring this rule and making background strokes the same size as foreground strokes, the background objects would appear to be on the same plane as foreground objects. This technique would simultaneously emphasize both the illusion of three-dimensional space and the two-dimensional design of the picture plane. The illusion of space was flattened onto the surface of the picture plane.

In addition, Cezanne would paint objects to simultaneously appear from two separate points of view. The effect in some still life paintings was that a water pitcher, for example, would appear to be seen at eye level at the bottom of the pitcher, but the top rim of the same pitcher would appear to be seen from above. Curiously, this apparently naive distortion is exactly how many amateur artists, or children, will render a cylindrical form like a pitcher. The difference is that in Cezanne's painting his distortions always sought to conform to an overall integral sense of

design. This is also why you will sometimes see doorjambs, windows, and chairs tilted to one side or another in a Cezanne. It prompts the viewer's eye to see spatial depth and two-dimensional design simultaneously, and this is a delight to the eyes of many viewers.

In *Apples and Oranges* by Cezanne you can see uniform-size brushstrokes throughout. The tilted plate, pitcher and vase, distort our expectation of space and encourages us to see the overall two-dimensional design of the whole.

It is unclear whether Cezanne distorted objects in his paintings intentionally or if it was just the way they came out. However, he once stated that it took him 40 years to finally figure out that painting was not sculpture. Regardless, by flattening the space in his paintings and by creating multiple points of viewing, Cezanne contributed a unique way of seeing the world and of painting that other artists would enjoy exploring for themselves.

In his quest to understand the underlying structure of nature, Cezanne often spoke about seeing geometric forms in nature, such as a cylinder in a tree trunk or a triangle in a mountain's

silhouette. However, he never reduced the vast sacredness of nature in his paintings to geometric forms, as did the Cubists.

Cubism (1906 - 1921)

It was never Cezanne's intention to become the Father of Modern Art. Furthermore, he did not live long enough to see the birth of his first child, Cubism, because he died before its birth, in 1906. There is no point is speculating what Cezanne might have thought of Cubism. However it is clear that Cezanne's creative intentions could not have been more opposite than that of the Cubists. Cezanne said "When I judge art, I take my painting and put it next to a God made object like a tree or flower. If it clashes, it is not art." To me he implied that he wished his art to align in some way with Nature - with the infinite creative source beyond us that also flows through everything. Whereas Pablo Picasso, a co-founder of Cubism, stated of his art: "I paint objects as I think them, not as I see them." For Picasso, and many artists to follow, art was no longer about relating art to Nature; it was about relating art to the human imagination. Instead of looking out into the world for a source of visual inspiration, Picasso looked inward at the visual forms within his imagination. From the awakening artist point of view, forms are forms. Whether they are observed externally in the world out there, or internally with imagination makes little difference. Both methods were expressions of the infinite creative source exploring the world of form through artists. At that time, for an artist to paint purely from imagination was unprecedented and liberating.

Visual Scientists

Impressionists, as we have seen, were explorers of the visual beauty of the world. The Cubists, and some of the artists who followed, however, where no longer seeking beauty, per se; they were experimenting with visual effects like visual scientists, just to see what would happen. And as with any kind of experimen-

tation there were many failures and some unexpected successes. Some of those successes have contributed to the awakening of the artist by pioneering new ways of seeing.

Pablo Picasso and Georges Braque invented Cubism. Or, putting that in context to the theme of this book we could say that, while exploring the world of form, universal intelligence created Picasso, Braque and Cubism. Continuing now with the normal way of thinking, we would say that essentially, the space-flattening effects in Cezanne's art inspired Cubism. Cubism was the fracturing of an image in order to make it appear to be made of fragmented planes, as if seeing through the facets of cut crystal. Cubism also portrayed subjects as if viewed simultaneously from multiple angles. The Modern Art era was a time of experimentation and Cubism was one such experiment. As with the Impressionists before them, the Cubists were not beholden to any governing authority or to any standards whatsoever. They enjoyed complete liberation from the artistic traditions of the past, and their ideas emerged from their imaginations. Writers and critics who supported the modern avant garde artists wrote about their work, while galleries that encouraged new artistic experimentation exhibited their paintings. And collectors who felt that Cubism was important to the development of Modern Art purchased their art.

Violin and Candlestick by Cubist artist Georges Braque takes Cezanne's idea of still life painting and pushes it to the limits. The still life now appears to be a two-dimensional design with shallow, dark spaces carved into it.

Cubism, like Modern movements before it, continued to question common assumptions about realism. A basic assumption was that the surface of the painting was a window through which the

viewer peered into another orderly, logical world. When the Cubists came along, they said, wait a minute; there is no 'other world' inside the picture. And there is no imperative that requires art to conform to the way the human eye sees the world. With that came the realization that they could bend forms and space in any way they wished. And so they did.

At that time many people found looking at Cubism to be disturbing. For many people it was, and continues to be, more comforting to look at pictures that resemble the way the human eye sees. There is always a sense of comfort in the familiar. For the Cubists, however, what the artist could imagine became more artistically interesting than the fixed external world that the artist could see.

The co-founder of Cubism, Georges Braque, produced some very engaging and delightful Cubist works. Braque approached Cubism in a Zen-like manner and many of his statements about art seem to me to be universally true and instructive for the awakening artist. Braque said: "There is only one valuable thing in art: The thing you cannot explain." In other words, explanations of art are merely mental opinions and qualifications, but the true value of art is what it may evoke beyond mental interpretation. Braque also offered this similar gem: "To define a thing is to substitute the definition for the thing itself." In other words, once art is explained away, or defined, it is reduced to a mere thought form and its transformative power is lost. For example, coming upon a beautiful sunset a person could say that they don't need to bother looking at it because they have already seen many beautiful sunsets in the past. Here the person has reduced all beautiful sunsets to a mental definition, which includes mental images. He thinks he doesn't need to look at an actual sunset anymore to experience one. He need only recall sunset images stored in his memory. Here, as Braque has suggested, the person has substituted the real thing for a definition. The problem is, however, that mental definitions and

images do not carry the transformative power that real things do when they are experienced in the present moment without mental definition.

Someone could ask me, are you not now explaining and defining art, and thereby diminishing its transformative power? No, I am suggesting that we explore artistic creativity from the largest possible context, that of the spiritually awakening point of view, which may assist in restoring the transformative power of art.

The Primal Child

Many years ago I was involved in the Colorado Council on the Arts and Humanities' artist in residency program. In it I had the distinct privilege of teaching art to first graders. One time I had them make found-object sculptures. They were to find objects to bring to school that they would then assemble into a work of art. I put four or five kids at each table and instructed them to glue, tape, staple, and paperclip their objects together, creating one finished group creation. This went well for a while.

Suddenly there was a loud crash. Rodney had apparently lugged what looked like a twenty-pound rock from the playground as his found object. The kids at his table had assembled a magnificent tower made of sticks, pencils, and cardboard paper towel tubes. Rodney's contribution was apparently to glue his rock to the top of the spindly tower. The rock instantly crushed everything beneath it sending Popsicle sticks, paper clips and stubby scissors flying. For a moment the kids sitting at the table were shocked speechless; their eyes as big as white balls of play dough, then came the tears.

Meanwhile, at another table, Charley had brought pockets full of live grasshoppers as his found objects. He glued them to the empty milk carton that the kids at his table were attaching things to. Excitedly, Charley explained what he was doing as he pointed to the grasshoppers flailing in mounds of white glue. I told him

that it looked wonderful but that we cannot use insects for our found objects, a detail I had overlooked in my instructions. Charley's face went from one of radiant joy to bewildered sadness as I tried to figure out how to wash Elmer's glue off a dozen gasping grasshoppers.

Even though the ideas of children are not always practical, professional artists have been fascinated by children's art for centuries. Children's art has raw expressiveness and energy and an absence of self-judgment. These are qualities that professional artists also find inspiring in the art of primitive cultures.

The Cubists, and other modern artists such as Matisse, Gauguin, and Kirshner, looked for inspiration in the art forms created by the indigenous primal peoples of Africa, Micronesia, and Native Americans for inspiration, who, from the awakening artist point of view, were relatively untouched by mad humans. The simple, unsophisticated, and child-like 'crudeness' of their art expressed an exciting, raw, visual energy. Many of the modern artists were drawn to these 'primitive' art forms because they were free of Western concepts, doctrines, and the traditions of artistic creativity that went back to the Renaissance. As Picasso put it: "It took me four years to paint like Raphael, but a lifetime to paint like a child." Here we see the modern artists seeking to reconnect to the original creative innocence that had been lost as a result of the Age of Madness. However, instead of attempting to reconnect with creative innocence through mythologies and Biblical stories, as the classical artists did, the modern artists were attempting to reconnect to original creative innocence by incorporating into their work the motifs of primal art. Many artists were well aware of the pervasive madness that humans experienced. To be aware of the madness and to be able to observe it is to be one step removed from it. And to be one step removed from the madness is to be one step closer to awakening.

Harkening back to a past time of human innocence, however, can never connect an artist to the infinite creative source that

seeks to flow through the artist now. Picasso may have taken a lifetime to paint like a child, but a real child takes no time to paint like a child because the child is already transparent to the infinite creative source. So, while Picasso and other modern artists used primal art motifs to reconnect to original innocence, the most powerful form of creativity comes when the artist is completely transparent to the creative source that is here and now. For example, if an artists thinks he wants to express a child-like innocence in his art, and he paints paintings that look childish, he has completely missed the point. That is not real innocence; it is a mental concept of innocence. It is merely the egoic mind imitating innocence. True innocence emerges from the infinite creative source. When the artist is in alignment with that, then he *is* innocence. That is transparency.

Cubism contributes to the awakening artists of today by inviting us to experiment freely with ideas and visual forms. We can practice exercising our imaginations without judging the results, or ourselves.

Wild Beasts (1905 - 1907)

Meanwhile, as the Cubists were fracturing the picture plane and bending noses and ears around, another group of artists began experimenting by applying even bolder colors and larger, rugged brushstrokes as a way of accentuating their feelings and emotions. These artists included Gauguin, Matisse, Braque who was also a co-founder of Cubism, and many other artists. Some of them were eventually labeled The Fauves (Wild Beasts) because their painting style seemed out of control with wild bursts of color. The expression of strong feeling in art was a way of including the whole person, the whole being, in the creative act, not just the ideas of the intellect. These artists were discovering that nothing truly artistically creative could emerge without passion, and deep feeling.

As in the case of the Cubists, the Fauves were even more inter-

ested in primal art. The Fauves, in other words, were remembering on some level their relationship to the innocent state of consciousness of early humans. One of Gauguin's most famous quotes was, "In order to do something new we must go back to the source, to humanity in its infancy." Innocent art was simple, unrefined, non-egoic, and certainly non-intellectual. Innocent art had emerged out of a direct relationship with the world around the artist, and it was unencumbered by pictorial systems, like perspective or the golden ratio, that came later.

In *Under the Pandanus I* by artist Gauguin, we see that he painted primal people in an unrefined, and unsophisticated manner in order to recapture the lost expressive vitality of the innocence of early humans.

The innocent motifs appear in the Fauve's artwork in the form of childlike applications of paint, and the rendering of forms, images, and totems, similar to that which the early innocent people were thought to paint. The point of all this was to somehow reclaim that pure and innocent way of seeing, and knowing the world. There was something true within the Fauves

intentions because there was the sensing that "humanity's infancy" reconnected the artist with the infinite creative source beyond him. But did emulating innocent art make Fauve art, or the Fauvists, innocent? Of course not. It seems to me that these artists, like all humans who begin to awaken, were searching for something within themselves that had been lost. Truly original innocent art, however, could only come from people who had no exposure to egoic consciousness, and who did not see, or hardly saw, the world as separate from themselves. But once humans saw the world as separate from themselves as in Western civilization, they could not go back to the way it was before. In the same way, an adult human cannot get rid of adult consciousness and somehow go back to having a child's consciousness. Artists cannot have an innocent view of the world by trying to become innocent; they can only do it by becoming conscious, by awakening. The only way is forward, it is like a blossoming, and it relates to the flowering of human consciousness, which we have been exploring.

Innocent motifs in art remind the awakening artist of humanity's Innocent past. That state of early humanity has sometimes been referred to as the state of unconscious innocence and we have been associating that with the innocent art of early humans. And then the egoic state emerged, which is the current state of most humans today. This state has been referred to as the state of unconscious suffering. It describes the state of suffering, or psychic disharmony, produced by the egoic mind after the Age of Madness began and continues today. And finally the awakened state, which many are beginning to awaken to, is the state of conscious innocence. This describes the state beyond mind, in which the creative source flows freely and innocently through the artist. The Fauves explored the motifs of unconscious innocence, but awakening artists can begin to explore and create motifs of conscious innocence.

Dadaism (1916 - 1922)

From 1914 to 1918 World War I destroyed more than 15 million human beings. That is an average of about 10,000 human beings killed every day for four years straight, all to avenge the assassination of a single human being; an archduke. And to accomplish this monstrous task required the consumption of virtually all the scientific, industrial and financial resources of Europe. It seemed that few people saw the absolute insanity of this war and the related waste and suffering. However some did, including the artists known as the Dadaists. They looked out upon the world and saw madness everywhere. The war was obviously insane, as well as the bourgeois who created it. The Dadaists observed the mindless nationalism expressed by people who went along with whatever their country's leaders told them to do without thinking for themselves. They observed capitalism being used as a system of greed. The Dadaists were anti-culture. To them, bourgeois highbrow attitudes appeared meaningless and shallow. The Dadaists were even anti-art because they believed that the art of modern times was based on insane traditions. They believed that the concepts and aesthetics of Modern Art were completely relative and subjective, and therefore had no absolute meaning. So to them, art, too, was meaningless.

Mechanical Head by Dadaist artist, Raoul Hausmann, symbolizes modern man being completely taken over by the machinery of the mind.

Dadaism, if it is not already apparent, was based on nihilism, irrationality, sarcasm and irreverence. In a portrait by a Dada artist you are likely to see a machine with gears and copper

tubing where the head should be. And the torso of the figure clothed in the latest bourgeois attire. Or you might see an eyeball floating in the air suspended below a zeppelin. Or a collage of machines, people, and nonsensical words scrambled together. Dadaism was an art form that mocked the 'preciousness' of art, such as Marcel Duchamp's famous 'Mona Lisa' sporting a goatee.

One of the most effective anti-art forms was the "found objects" concept that Marcel Duchamp came up with. Essentially, he would find an object, such as a shovel, bicycle wheel, or any object and then hang it on the wall or place it on a pedestal, and call it art. Since there were no guiding standards in art anymore, who could prove that a found object was not art? His most famous found object was a urinal, mentioned earlier, which he attempted to enter into a prestigious art exhibition in 1917. Not surprisingly it was rejected; nevertheless, it caused the art world to ask: What is art?

If an ordinary found object could be considered art, then can anything be art? And if so, then what is art? The answer: It all depends on context. The found object demonstrated that art could be created merely by the way in which an object was observed. For example, a shovel: It is an ordinary utilitarian object that is usually stored out in the tool shed with all the other tools. However, if the same shovel is placed on a pedestal in an art museum, in that new context it is assumed that the shovel is presented for the artistic contemplation of viewers. Some would dismiss the shovel out of hand as some kind of joke, which is a valid response. For others, it would open up a broader discussion about the meaning of art, which is also a valid response. Duchamp's unconventional ideas of art have been described aptly as "Zen but without the enlightenment".[3]

To Duchamp and the other Dadaists, art was not about making a beautiful form, it was a way of making a statement about society, human behavior, and art itself. As Dadaist Hugo Ball expressed it, "For us, art is not an end in itself ... but it is an

opportunity for the true perception and criticism of the times we live in."[1]. Art historians have described Dada art as being, in large part a "reaction to what many of these artists saw as nothing more than an insane spectacle of collective homicide"[2] — what this book has been calling human madness.

I believe that the Dadaist view of Europe was correct. If you lived in a world in which the psychic disharmony of the ego had completely taken over the inhabitants, you might want to stand on a chair and shout: *"Attention everyone! —What we are all doing here is not really normal at all—it is absolutely INSANE!"* So the Dadaist solution to the madness they saw all around them was to mock it and express opposition to it. Therefore, in their attempt to portray the absurdity of human collective insanity in their anti-art, their art naturally looked insane, too. (However, the famous Swiss psychologist, Carl Jung, quipped that the Dadaist's art was too idiotic to be schizophrenic). Unfortunately, for all their efforts the Dadaists were unable to provide a 'sane' alternative. And the only sane alternative in an insane world is to awaken. It is not to make anti-art; it is to make awakened art. As contemporary artist Jim Dine once stated, "Pretend ugliness is real ugliness." Likewise, I would say, a mockery of madness is more madness.

Chance Art

Artist Jean Arp, one of the founders of Dada, was among the first to explore 'chance art'. This was accomplished by letting the laws of chance determine the outcome of a work of art. An artist, for example, would toss cut scraps of paper onto a canvas and then glue them down wherever they landed, and however it appeared in the end was the art. The goal was "total surrender to the unconscious" according to Arp. At that time, the term "unconscious" was commonly believed to be an organizing force that would move through an individual without the individual's awareness. Therefore, Arp believed, if the conscious mind of the

artist were to step out of the way, then this organizing force would be able to make the art. Arp and others were clearly sensing what this book describes as life's universal intelligence. What they did not fully realize, however, was that the infinite creative source expressing through humans is not unconscious; rather, it awakens through them.

The notion of giving yourself over to the unconscious as the Dadaist thought of it was a very frightening prospect to the bourgeois ideologies of the time. If you gave yourself completely over to this other force inside of you, they feared, you might go out of control. You might go insane. You might act without moral or ethical reflection. Society would degenerate into chaos.

But Arp's artistic goal was not chaos, it was an attempt to remove ideology, identity, and fixation on the past—in other words ego—from the creative process and allow life's organizing principle to express freely. An anarchist, whom the bourgeois believed Arp to be, does not make statements like this:

> Soon silence will have passed into legend. Man has turned his back on silence. Day after day he invents machines and devices that increase noise and distract humanity from the essence of life, contemplation, meditation.—Jean Arp

The idea of Chance art was that the art would be uncontaminated by the artist. In his time, Arp's art was considered chaotic, but by today's standards Arp's works are considered quite elegant and well designed. To a contemporary audience there is nothing especially chaotic about Arp's art, or the art of other chance artists, because over the years people have come to appreciate random qualities in art as pleasing visual effects.

In art school my artist friends and I enjoyed experimenting with chance art. Here's how we would do it: We would take a piece of mat board or cardboard and cut a rectangular opening in it creating a frame. Then we would walk down the street, in the

woods, in a house, or anywhere, and toss the mat board window frame into the air. Then we would go to wherever it landed and within the window we would see the 'art' that we just 'created'. Often the images were not particularly noteworthy, other times the results were spectacular, especially because they were unexpected. This exercise allowed us to begin seeing beauty and order in completely unfamiliar arrangements of visual elements. A similar exercise in art school was to take photos while you were blind folded, guided only by the sounds around you and a person leading you. What we saw in our photographs was being added to our inner visual vocabulary and expanding our breadth of appreciation for what can be seen. There is always something to learn from apparently random occurrences.

Here is what Eckhart Tolle has said about seeming random events:

Behind the sometimes seemingly random or even chaotic succession of events in our lives as well as in the world lies concealed the unfolding of a higher order and purpose. This is beautifully expressed in the Zen saying, "The snow falls, each flake in its appropriate place." We can never understand this higher order through thinking about it because whatever we think about is content, whereas, the higher order emanates from the formless realm of consciousness, from universal intelligence. But we can glimpse it, and more than that, align ourselves with it, which means be conscious participants in the unfolding of that higher purpose.[3]

And this is the point, no matter how random or accidental our art, or lives, may appear to our minds, there is always universal intelligence behind it. Or as we have been calling it, the infinite creative source that is beyond us, that expresses through us, and is ultimately who we are.

Surrealism [Early 1920s - Present]

Surrealism began in Paris in the early 1920s as a reaction against World War I and the dawning of the Machine Age. Many artists began aligning their creativity with political philosophies and causes. In Europe during this time, many artists were caring, thoughtful and socially responsible. And they wanted to align their impassioned integrity with others who shared their views of fairness and respect for all of humanity. Consequently many of the Surrealists either became Communists, or felt an affinity with the Communist cause. Many artists were anti-capitalistic because capitalism, they believed, created economic stratification and greed. Communism was also anti-bourgeois because bourgeois society they believed, created social stratification.

Pure Communism in the Marxist sense refers to a classless, stateless and oppression-free society. In a Marxist society, decisions would be made democratically, allowing every member of the society to participate in the decision making process in both the political and economic spheres of life. In theory, Communism was very similar to the social order of the early innocent humans, for example, the Iroquois Indians of North America, as we noted earlier. Plus, Communism offered a bright alternative to the legacy of Imperialism, capitalism, and nationalism that clouded Europe at the time. Imperialism was power held by the few over the many. Capitalism was believed to be the concentration of wealth in the hands of the few to the exclusion of the many. And Nationalism was the belief that one's nation superseded the importance of the individual. In other words, you as an individual were disposable but your nation was not. These were some of the reasons that Communism was so attractive to artists of that time. Even partially awakened people could see the huge inequity of wealth and power in society. And they could see the total disregard for human life recently demonstrated in World War I. Communism offered, in theory, social equality and a fair distribution of wealth. However, then as now, any political

system is only as effective as the state of consciousness of those who participate in it. Many artists chose to align their creativity with Communism because they believed it would produce a fair, pure, egoless, society.

Though the Surrealists were interested in a fair and just society, at the heart of Surrealism was 'psychic automation', which is giving over control of the creative act to the subconscious. They believed this allowed the subconscious mind to express itself in art without the control of the conscious mind, and without the censorship of ideologies or morals. To Surrealists creativity was the raw expression of the subconscious mind. Consequently they created weird, dreamlike, and sometimes nightmarish works. The Surrealists were also inspired by Freudian psychology. However, Freud (1856-1938) pointed out that the Surrealists were creating their art out of conscious intention, not out of the subconscious. For to choose to paint a painting, or to mix colors, or to select a theme is a conscious act. So really, the Surrealists were painting what they consciously believed the unconscious state looked like, which to them was a bending and twisting of forms such as Dali's 'rubber' clocks, and the juxtaposition of unrelated images, like a giraffe on fire.

One thing the awakening artist may learn from Surrealism is to not take the appearance of things seriously, 'realistically', or too literally. "Maya" is a Hindu word that describes the world of form as an illusion. Maya describes what is typically thought of as 'concrete' reality, as actually being a dream-like state. For example, right now if you think of something you did

Surrealist painting *The Elephant Celebes* (1921) by Max Ernst

last year, or a week ago, does that memory not have a dreamlike quality now? It will appear no differently than a dream as far as your recollection of the event goes. In this example there is little difference between being awake and being asleep.

From the Surrealists we can learn about the elasticity of reality. For example, it could be argued that a dream is not like being awake because things in dreams can be distorted, whereas things in the normal awake state are logical and orderly. However I would ask: Is the so-called normal awake state really undistorted? Is it possible that what we imagine to be logical, and normal, is actually distorted and abnormal? For example, slavery was considered logical and normal centuries ago; today it is considered a distortion, and abnormal. In Medieval times it was completely logical and normal for church scholars to have people burned alive because they could not accurately state how many angels could fit into a room. Torture was considered a logical and normal consequence for theological ignorance. Today, a person can go online and entertain themselves by viewing images and movies of actual people being maimed or killed. In all of these examples, when so-called 'consciously awake' people find cruelty, suppression, and death to be normal, entertaining, and even humorous, is that not abnormal and nightmarish like a Surrealist painting? They do not know it is a nightmare because they are participating in it, to them it is normal. It is only when they begin to awaken spiritually that they see it as the dream it is, a distortion. Examples of the human nightmare go on endlessly, with genocide, torture, and great human suffering. All of these examples show that there is little difference between the dream state and the normal awake state. Compared to the nightmare in which many humans have lived, and yet called normal, Surrealist art could only be described as harmless and a bit quirky. The awakening artist always aspires to awaken to sanity—the spiritual dimension, and that is a great gift to those who are also beginning to stir from their slumber.

Kandinsky (1866 - 1944)

Meanwhile, in Russia, artist Wassily Kandinsky was discovering a way of seeing that was completely pure, and free of ideologies, history, and even subject matter. When Kandinsky saw one of Monet's haystack paintings (in Moscow, in 1896) at first he did not see the haystacks, rather he saw only wonderful shapes and beautiful colors. It wasn't until he read the description on the wall next to the painting that he learned that it was of a particular scene, of haystacks in a field. This he found simultaneously disturbing and exhilarating. He said Monet's painting "stamped my life and shook me to the depths of my being."[4] I am guessing his experience was disturbing because it contradicted how a painting with subject matter should be seen. And the experience was exhilarating because he was seeing in an entirely new way, without subject matter, without content. A color could just be a color; it did not have to be the color *of* anything.

Eventually Kandinsky began painting pictures without any subject matter whatsoever. He called this new kind of art "pure painting." It was not until many years later that others began calling it "abstract art". What it is called is not really all that important but in the following few comments about Kandinsky, I am going to refer to his art by its original description, "pure painting."

Books about Kandinsky's life often refer to the story of when he went for a walk after a long painting session. In the meantime, a friend had tidied his studio and inadvertently turned the canvas Kandinsky had been working on, on its side. Upon returning and seeing the canvas with fresh eyes, in its disoriented position, Kandinsky fell to his knees and wept, saying it was the most beautiful painting he had ever seen. He believed it to be a deeply spiritual experience; his perception had been liberated, similar to his experience when he first saw Monet's haystacks. He saw for the first time that the beauty of visual qualities could be enjoyed without them being associated to any

object. The experience would change his life, and the history of Western art.

Kandinsky did not return to his studio with a plan to invent pure painting; rather, he discovered it. Was his discovery an accident? No, it was a moment of awakening. He entered the room and suddenly saw pure art right there before him, already existing. In that moment his conscious mind had become aware of what the infinite creative source had already created through him. That is why he fell to his knees and wept.

While other artists in Europe were making political, philosophical, and psychological statements with their art, Kandinsky always saw the creative act as a spiritual experience as this quotation illustrates: "The artist is the hand that plays, touching one key or another, to cause vibrations in the soul."[5] Kandinsky, and many other Modern artists including Piet Mondrian, Paul Gauguin, Constantin Brancusi, Robert Delauney, Paul Klee, Franz Marc, were also known to have had an association with the Theosophy Society, which is a spiritualistic and esoteric society founded in 1875 that promotes universal truth and love.

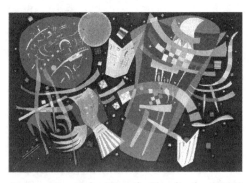

Composition X, by Wassily Kandinsky (1939)

Kandinsky was also an art theorist and explored the relationship of colors to music. He also associated geometric figures to various spiritual concepts, as did his friends Kazimir Malevich and Paul Klee. To Kandinsky, the circle, for example, was the most peaceful

shape and represented the human soul. Most importantly Kandinsky was seeking to evoke a spiritual resonance between the viewer and artist. This spiritual communion of the viewer, the painting, and the artist was felt by Kandinsky to be a spiritual experience beyond words.

While Kandinsky's theories of art may sometimes be interesting and sometimes fanciful, his discovery of pure painting was a clear contribution to the flowering of human consciousness through art. In Kandinsky's words "The world is full of resonances. It constitutes a cosmos of things exerting a spiritual action."

Ashcan School (Early Twentieth Century)

At the same time that Kandinsky was exploring pure painting, across the Atlantic the Ashcan School artists were creating truth-telling images of the seedy underbelly of New Your City. French Impressionism had eventually found its way into the studios of many American artists and American Impressionism became the vanguard in the late nineteenth and early twentieth centuries. American Impressionist paintings shimmered with color and light just as the French Impressionist paintings did. However, the Ashcan School artists, which included artists Robert Henri, John Sloan, George Bellows, Everett Shinn and others, felt that gentrified American Impressionism overlooked the harsh realities of many New York neighborhoods. It was the prostitutes, drunks, overflowing tenements, laundry hanging on clotheslines, boxing matches, and poverty that the Ashcan School artists wanted to capture. The Ashcan artists sometimes recorded an unsettling, transitional time in American culture that was marked by confidence and doubt, excitement and trepidation. While American Impressionistic paintings may have been filled with light and color, to the Ashcan artists Impressionism lacked the power of truth-telling realism. The Ashcan School artists invite us to awaken the factual conditions in which we live. They

teach us to have empathy for our fellow humans, for an increase in empathy is an increase in spiritual awakening.

At right: *In the Orchard* (1891) by American Impressionist Edmund C. Tarbell. At left: *Bandit's Roost* (1888) by Ashcan School photographer artist Jacob Riis. Ashcan School artists painted an unadorned honest picture of poverty and crime in America. They had no interest in the gentrified pleasures of the upper class as portrayed in American Impressionism.

Brancusi (1875 - 1957) The Flash of Spirit

Brancusi's highly significant contribution to the One Art Movement, to which all artists belong, and which was introduced in Chapter 3, is that his art points our attention toward an essence, which is beyond the outer appearance of form. Brancusi was said to have summarized his approach this way: What is real is not the external form, but the essence of things... it is impossible for anyone to express anything essentially real by imitating its exterior surface.

Constantin Brancusi was a Romanian modernist sculptor. He was another great explorer of abstraction like Kandinsky. Brancusi traveled to Paris in 1904 and stayed there for 50 years. There he exhibited his work and became friends with other art explorers, Marcel Duchamp, Picasso, Degas, and Matisse. His

worldview was formed not only by his humble Romanian peasant upbringing, but also by others including the Greek philosopher Plato, Chinese philosopher and author of the *Tao Te Ching*, Lao Tzu, and the writings of Tibetan Buddhist, Milarepa.

In order to achieve his desired effects in his sculpture Brancusi would use extremely simple shapes and forms to express the "essence" of a form. For example, his sculpture *Fish* (1930) is an oblong, smoothly polished piece of marble. It has no fins, scales, or any distinguishable feature. However the natural veins of the marble look remarkably like a blur of light that might catch on the body of a fish as it darts by.

Brancusi explained:

"When you see a fish you don't think of its scales, do you? You think of its speed, its floating, flashing body seen through the water... If I made fins and eyes and scales, I would arrest its movement. I want just the flash of its spirit."

Brancusi's artwork always emphasized the essence of a thing. As such his artwork appeared somewhat primitive to some, like the art of the early humans. The primary difference is that Brancusi's art is highly polished and was made with modern tools. The similarities are that they are iconic, totemic, phallic, and vulvar.

The Modern artists of this time (Picasso and others) often utilized the primal motifs of early humans to reconnect with an original child-like creative innocence that had been lost. And to many of Brancusi's contemporaries, this appeared to be the case in his artwork. It seems apparent, though, that Brancusi saw it differently. He was not trying to reach back into our ancient past to regain a lost innocence as much as he was seeking to portray the essence of Life that he believed resided in all things in the present—the "flash of spirit" as he called it.

Eastern philosophy had an enormous influence in Brancusi's art, suggested by its Zen-like content and simplicity. Take for

example his monumental work *Endless Column*, which is composed of stone sections that form a single tall column that soars 96 feet (29 m) into the air. It is said that Brancusi wanted the viewer to "feel like an atom" when standing next to it. This is a very Eastern way of looking at humans. It is well known that Renaissance theology and philosophy saw man at the center of the universe, which is typically how the ego likes to think of itself. In *Endless Column*, however, Brancusi saw the human as infinitesimally small compared to the universe, as Eastern philosophy suggests.

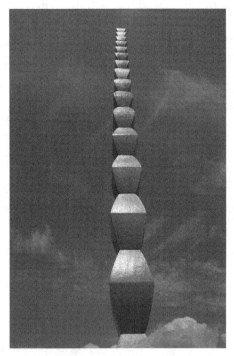

The Endless Column by Brancusi

Brancusi was known for his sage-like aphorisms. Though some critics have suggested that Brancusi's pearls of wisdom were merely a pretense that he would put on to make himself appear as some kind of mystic-artist. They believed this because even

though there was a perceptible aura of spiritual atmosphere that visitors noticed in his studio, when not working he was also well known as a heavy smoker, heavy drinker, and chaser of women. Aside from Brancusi's life style during off hours, the fact remains that his art looks like visual aphorisms. They are simple, direct, and point to a deeper truth. It seems to me that his spoken aphorisms where very much in keeping with the way he approached his art, and that was to explore the essence of things, as all aphorisms do. Furthermore, if we are to learn anything about awakening from Brancusi, we should not discard his contribution because his politically correct contemporaries objected to his smoking, drinking and chasing of women. In other words, if an aphorism is true, does it really matter where it comes from? Whenever wisdom is expressed, it is far more important to learn from it than to reject it because we don't like something about the messenger. Here are a few samples of Brancusi aphorisms:

Don't look for obscure formulas or mystery in my work. It is pure joy that I offer you. Look at my sculptures until you see them. Those closest to God have seen them.

Simplicity is not an objective in art, but one achieves simplicity despite one's self by entering into the real sense of things.

There hasn't been any art yet. Art is just beginning.

Towards the end of his life, old and ill, he said: "I am no longer of this world, I am far from myself, detached from my own body. I am among the essential things."

Abstract Art, A New Way of Seeing
The early Abstract artists pioneered an entirely new way of

seeing—the ability to see visual *qualities* without them having to be related to any particular object. Red, for example, could just be red; it did not have to be a red something, such as a red apple. Viewers unfamiliar with abstract art will often struggle to see something familiar in an abstract painting. They will squint and say the red patch of color looks *like* this, or it looks *like* that. They are trying to force a representation into what they see because their minds are so object centered that they cannot understand what they are looking at in any other way.

To the abstract artists however, visual art had finally achieved what music always had, creative expression without objectification. When we listen to music we do not insist that it sound *like* something that we might hear in the natural world, such as a brook, or the wind, or the cry of an animal. Nor do we expect that the more a musical instrument sounds like a moose, for example, the more realistic and better the music is. No, we accept that music should sound like the instruments from which the music comes. We usually do not evaluate music on the basis of the accuracy of its replication of sounds in nature. Certainly, awakening musicians have had their own challenges with traditions and cultural expectations; however, the expectation of making perfect copies of nature has not been one of them, as it had been for the visual artist. Abstract art finally arrived at this same place, at least in the minds of abstract artists. What you see are shapes, lines, colors, form, textures, composition, and nothing more. And any aesthetic value the viewer experiences must come from how the artist has expressed and assembled those visual qualities. It can only be viewed for its visual appearance, like music can only be heard for the sound it makes.

Art for Art's Sake

Today, you might hear the phrase "art for art's sake" and it often has a derogatory connotation. It can imply that the artist doesn't really care about the viewer and that the artist is just 'doing his

own thing' without regard for anyone or anything. But the original use of that phrase was a proclamation of freedom from representation. It proclaimed freedom from conceptual thinking, political and religious ideology, the past, and freedom from the known. The 'known', in this regard, is always of the mind, which produces conceptual thinking, ideologies, and the past. And if we are not liberated from the known then we can never experience the now, out of which emerges true originality and creativity.

Artistic Conditioning

Art students who are unfamiliar with making or viewing abstract art often have difficulty understanding it. In my classes I can have them play on the canvas with colors, shapes, lines, and textures without any subject matter. In the end their marks may be exciting and delightful from my point of view, but they will only see a mess, a blob, something a monkey could do. They are unable to observe their creation and appreciate it just as it is. In one workshop on composition, in which I demonstrated the principles of abstract art in order to explore pure composition, two students were so flustered that they gathered up their supplies and stormed out of the studio. They had come to make art, not garbage! In this case, they were unable to let go of their familiar and habitual ways of seeing.

Visual Vocabulary

When we learn to see the world without objectifying it we begin to see it freshly. In this manner we begin to develop what is called a visual vocabulary. It is a phrase that describes an assortment of visual qualities. And the more visual qualities you become familiar with, the more complex your vocabulary becomes. Lines, colors, shapes, forms, and textures that you see in the world or paint on the canvas, are like words that can be arranged into sentences, and paragraphs in written or spoken

language.

We become familiar with visual qualities when we give them our full attention. The visual qualities automatically become stored in our memory. Then, as you view more scenes without objectification, your ability to see visual qualities will become increasingly complex, subtle, and unexpected. And then someday, somewhere, you may come upon an arrangement of visual qualities that stop you in your tracks because they are absolutely breathtaking, while others looking at the same thing will see nothing special.

The Battle of the Art Movements

In art history books the relationship between art movements, particularly in the Modern era, is often couched in terms of opposition. You might read phrases such as: The Impressionists *rebelled* against the French Academy; The Ashcan School artists were *against* the Impressionists; The Dadaists *challenged* the meaning of art, The Pop Artists *opposed* the Abstract Expressionism. It is true that many artists in history felt they were in a struggle against whatever the prevailing trends were of the time. However, from the viewpoint of the One Art Movement nothing is really against anything. Instead, each transition from one art movement to another is seen as a new realization. Each transition is a step toward awakening.

The Coming Storm

In the first 50 years of the Modern art movement, which included artists Monet, Kandinsky, Duchamp and Picasso, between about 1863 and 1913, the general public hardly gave notice to what the Modern artists thought or painted. It is doubtful that the general public cared about their political beliefs or their struggle to become liberated from stifling traditions. During that time it was the intellectuals, high-culture society, writers, poets, and collectors who participated in this 'pond', which was more or

less, separate from the popular culture and the everyday concerns of the majority of people. Nevertheless, these artists were shaping art history. Some of the general public might have either been shocked or indifferent about Modern Art, but their outrage, while certainly pleasing the artists, was only a fringe benefit. The real goal was to create an art that was free of the past, and that was pure. And if fame and fortune came along, that would be fine, too. In this regard, the early years of the Modern art movement were much like the art world is today. Most people had no interest in it.

The more artists searched for a universal meaning in their art, the more it became divorced from society because it was so intensely inward looking. As we have seen, from the time of the Age of Madness, in about 4000 BCE, up until the time of the Romantic Era of the mid eighteenth century, the creativity of artists was financed by pharaohs, emperors, kings, popes, aristocrats, and the wealthy to influence a society's—even an entire civilization's, views and beliefs. Historically, in many cases, art was kind of a collective 'thought-shaping' devise, much like the advertising industry is today. Everyone, more or less, went along with it. But in the Modern era, from the mid eighteenth century onward, art increasingly expressed the views of individual artists. Or it expressed the views of a small collection of artists who would form art movements. This subculture gradually evolved into the art world and included writers, poets, filmmakers, and was financed by wealthy art collectors who sympathized with their Bohemian, anti-bourgeois view of life. The art world was clearly liberal, progressive, intellectual, and always ready to point out the failings of the bourgeois (who, coincidentally, the artists also depended on to purchase their art). The Modern artists relentlessly questioned traditional ways of living and thinking. Officially there was no authority that oversaw Modern artists and no standards that controlled what they created. So their artistic experimentations and soul searching continued unabated. With

greater and lesser awareness of the fact, the Modern artists were freely exploring the infinite creative source beyond them that also flowed through them. Then the Nazis arrived.

The many atrocities the Nazis committed during World War II are not our topics here. Relevant to our discussion on the awakening artist, however, it is worth noting that while Hitler had been completely taken over by the madness that all humans share, he was also an artist. He tried to get into art school but was rejected twice. Most would scoff and say he deserved to be rejected. But what would have happened had Adolph been accepted into art school and mentored by an awakening art instructor who was able to expose him to the vast and wonderful nature of artistic creativity? Maybe nothing would have changed. Or maybe Adolph would have dedicated his life to acting out his pathology in art rather than in real life. Speculation is pointless, but the irony is obvious: The man who was rejected from art school twice, came back years later with tanks to destroy among other things, Modern art.

The Nazis began their campaign against Modern art immediately wherever they seized power. Impressionists, Expressionist, Cubist, Abstract, and Surrealist art—anything intellectual, Jewish, foreign, socialist-inspired, or difficult to understand—was targeted, from Picasso and Matisse going back to Cézanne and Van Gogh. In its place traditional German realism and patriotism was inserted. Virtually over night, the flowering of human consciousness through Modern art had been squelched, as if it had been thrown back to the age when it was under the thumb of pharaohs, emperors, and kings.

The Modern artists scattered in every direction to flee the Nazis. Many went to America, like Jewish folklorist and modern artist, Marc Chagall. He and his family barely made it out of France long after the German invasion and occupation. Other Modern artists of Jewish decent were sent to Nazi concentration camps. All modern art was either destroyed or confiscated. Over

600 paintings by German Expressionist, Ernst Kirshner were stolen from museums and collections and either burned or sold. Over 500 of Max Beckmann's paintings were destroyed. In 1937 the Nazis organized the 'Degenerate Art' exhibition in Munich that featured the confiscated works of modern artists including the works of Paul Klee, Wassily Kandinsky, Franz Marc, Marc Chagall, Piet Mondrian, and many others. The public was invited to come and see this despicable art. After the exhibition in 1939 approximately 4,000 Modern works of art were burned because the Nazis were unable to profit from their sale in order to further finance their madness.

National Socialist Art

The Nazis targeted Modern artists because they did not follow rules. They rejected ideologies, created freedom of individual expression, ignored traditions, questioned social norms and morals, and questioned the role of art, and the artist within society. All of these behaviors, while being untidy, had nevertheless loosened the grip that the past, and the madness of the ego held on the creative spirit of humanity. The egoic-centered art of the Third Reich, on the other hand, emphasized national socialistic themes that portrayed racial purity, militarism, and obedience. The art of The Third Reich emulated, and identified with the heroic and monolithic artistic style of the ancient Roman Empire, with its rigid adherence to rules and regulations.

Egoic madness as expressed through The Third Reich, was always afraid of change and afraid of the unknown and wanted to dominate and crush others. The ego insisted upon the adulation of authority and conformity. It will not tolerate authentic creativity. Modern Art was banned under Hitler in an attempt to extinguish the creative spirit that would have otherwise flourish freely through Modern artists. It was an abrupt ending to a wonderful era of creativity.

Chapter 8

Post War America

I grew up a few blocks from Reed College in Portland, Oregon. In the early 1960s the college campus was adjacent to an undeveloped wooded area. It was in these dark woods that my elementary school buddy and I would hide out to smoke cigarettes. Mine were usually unfiltered Lucky Strikes that I fished out of the bottom of my mother's purse and tasted like perfume when you smoked them. As we puffed away at the edge of the woods, we often watched the Reed College beatniks, or 'Reednicks' as we called them. Sometimes they sat in circles on the lawn playing bongo drums, flutes, and guitars while smoking pot and reading poetry aloud. On a really good day we might catch a glimpse of naked coeds swirling to the music.

By then beatniks had been a well-known influence on American culture. In the early 1950s, the Beat Generation was one of several sub-cultural forces that began to awaken within the nationalist conservatism that had taken root in America after the war. Now let us see how these awakening sub-cultural forces formed the backdrop behind the American art scene in America after World War II.

Immediately after the war in Europe ended, the cold war between the United States and the Soviet Union began. Each side was arrogant, fearful and poised to annihilate the other. In elementary school we were taught to hide under our desks in the event of a nuclear explosion. (Nothing withstands a nuclear blast like a school desk). Conservative values dominated American culture, which was racially segregated, nationalistic, and promoted staunch Judeo-Christian values. In the early 1950s McCarthyism emerged and the House Un-American Activities Committee undertook a nationwide witch-hunt to weed out and

punish any Americans who sympathized with Communism. The commission focused primarily on writers, musicians, actors and academics with liberal leanings. Many who were found guilty were fired from their jobs and unable to find employment in their respective fields. Shortly thereafter the United States plunged into a hopeless war in Vietnam based on an unfounded fear of communist expansionism from China and the Soviet Union in East Asia.

In reaction to America's extreme conservatism, racism, and sexism an awakening counterculture arose that changed American culture and influenced the Western world. The counterculture was a combination of the Beat Generation, an infusion of Buddhism, the civil rights movement, Women's Liberation, and the hippie movement. The epicenters of the counterculture were New York City and San Francisco. Surely, each of these forces contained varying degrees of their own egoic psychosis, however the awakening light was sufficiently forceful to shine through.

The Beats

The Beat Generation was composed of writers including Jack Kerouac, Allen Ginsberg, William Seward Burroughs II and others. They wrote and lectured on alternative forms of sexuality, Eastern religion, a rejection of materialism and conventional American morality. Many young Americans embraced their message and lifestyle.

Zen Buddhism

Daisetsu Teitaro Suzuki introduced Zen Buddhism to Americans. Suzuki was a Japanese Zen practitioner, writer and scholar. In 1952, many artists, writers, musicians and thinkers attended his public lectures at Columbia University, in New York. Zen seemed peculiar to many Westerners and yet they were curiously drawn to it. It presented an alternative to the logical thinking of

the Western mind. Zen also offered the concept of liberation from the entanglements of opposites, good and evil, beauty and ugliness, life and death. Many attendees at Suzuki's lectures acknowledged his impact on their work, including Carl Jung, Erich Fromm, Gary Snyder, Allen Ginsberg, Jack Kerouac, John Cage and Alan Watts. And artists Ad Reinhardt and Isamu Noguchi. Suzuki played a significant role in exposing Americans to Zen.

Civil Rights, Woman's Liberation and Hippies

The American civil rights movement in the 1950s and 1960s was a political movement that fought for racial equality. It was led primarily by black Americans in an effort to establish civil rights for blacks. Women's Liberation Movement was born in the 1960s and was a series of campaigns for reform on issues of women's reproductive rights, domestic violence, maternity leave, equal pay, and voting rights. The hippie movement promoted love, harmony with nature, communal living, happenings, recreational use of drugs, anti-war protests, and sexual freedom. They also held anti-establishment values and embraced Eastern Philosophy and Native American spirituality.

It could be said that the combination of these sub-cultural forces shared the same core truth; the liberation of the human spirit. It grew into a massive countercultural movement and was a reaction to the psychic disharmony of American society at that time. However, the question that most concerns us presently is, where were the artists through all of this?

The art world was another subculture of American society. However, its main issue concerned the liberation of the artist from traditional artistic styles. Artists wanted to be free of all limitations. For this reason their artwork did not associate with any cause, political affiliation, or moral stance that was promoted by the greater counterculture. Artists wanted their art to be about art and nothing else. That is one reason they began exploring

abstract art. And for the most part the McCarthy Committees ignored visual artists. As hard as they tried, the Un-American Activities Committee could not see how blobs and splatters of paint could possibly relate to Communism.

Abstract Art in America

Against the backdrop of the American counterculture came the rising crescendo of the great Modern art experiment. The experiment began with the nose bending and ear twisting art of the Cubists in 1906, but was interrupted by the invasion of France by Nazi Germany. By the end of the war in 1945 most of the Modern artists in Europe had been scattered far and wide by the Nazis. Some had escaped to America; others kept low and weathered the war. While Europe lay in ruin, across the Atlantic, America's massive industrial base had been stimulated by the war and America's mainland remained virtually untouched. American soldiers had come home from Europe and the South Pacific and they were in a mood for making babies and settling down. New York was full of money and entrepreneurs with big ideas and it became the new blank canvas for more artistic experimentation and soul searching. Or, as New York art critic Clement Greenberg preferred to think of it, the artist was thrown into a "genuine existential predicament" and that the purpose of American Modern Art was to "transmit this anxiety to the spectator."[1]

Abstract Expressionism (Mid 1940s to mid 1960s)

Abstract Expressionism began in New York, in 1946. It was abstract because it had no subject matter. And it was expressionistic because it was often executed in a manner that included dripping, splattering, smearing or throwing the paint. However, there were also less 'sloppy' methods of painting included in the movement. It was the first specifically American movement to achieve worldwide influence and put New York City at the

center of the Western art world, a role formerly held by Paris.

Some readers may wonder, how is it that drips, splatters, and smears, that seemed like anyone could do, were able to shift the center of the Western art world from Paris to New York? Because Paris, and all of Europe, was exhausted from the war and the creativity of European artists was also exhausted. Other artists including Kandinsky, Malevich, Klee, and Miro had already explored abstraction. The new American form of abstraction, however, did not depict thought-out abstract compositions that were more or less carefully rendered, as the early explorers of abstraction had done. Nor did Abstract Expressionism relate to music, like Kandinsky's and Klee's art. Instead, Abstract Expressionist painting was often wild and messy, with dripping, slashing, slinging, and pouring of paint onto the canvas. However, more than anything, it was the theory of Abstract Expressionism put forward by influential and unchallenged art critics of the day. They made the convincing argument to the world that Abstract Expressionism was the most forward thinking art of the time. They believed that the artist's raw, energetic expressiveness was a pure expression of the unconscious. More pure, they theorized, than the Surrealists' and Dadaists' concept of the unconscious. Furthermore, this bold new kind of art was made for art's sake. In other words, artists were finally painting just to paint. In the end an artwork meant nothing more than its own physicality. Art critic Harold Rosenberg explained the art of this time:

> The big moment came when it was decided to paint 'just to paint'. The gesture on the canvas was a gesture of liberation from value—political, aesthetic, moral.[2]

The mainstream Abstract Expressionists included, among many other artists, Mark Rothko, Jackson Pollack, Willem de Kooning, Barnett Newman, and Ad Reinhardt. Rothko was known for his

large "color field" paintings that utilized large rectangles of colors that filled most of the space of the canvas. The colored rectangle fields would have soft diffused edges that made the colors seem to vibrate. Rothko did not think of his work as abstract. Many viewers then and now consider his work to be spiritually transcendent. Jackson Pollack's contribution to Abstract Expressionism was to drip paint on large pieces of canvas placed on the floor. One of his goals was to express the raw energy of the unconscious, even as he gave careful thought to the pattern, rhythms and colors of his drips. Willem de Kooning became known for painting grotesque images of women with harsh, slashing brushstrokes. Barnett Newman painted colorful stripes on large fields of color. And Ad Reinhardt was most well known for painting solid black paintings, which he claimed, obviously unsuccessfully, would be the last paintings anyone would need to paint.

Abstract Expressionism was a term that applied to a broad range of stylistic experimentation. Some artists went completely abstract, and others had hints of subject matter. Some were wild in their handling of paint and some were extremely precise. Increasingly though, art had become estranged from the viewing public. Hence, art theories and explanations were put forward in magazines, museum catalogs, and in literary essays to help explain this strange art to the world. For the first time, looking at art was not enough to appreciate it, or to understand it. Now, you had to read an explanation of the art first, then look at the art, and then contemplate how the art and the theory matched. When, or if, you saw the relationship between the art and the theory, then you 'got' the art. It could be said that art had become an illustration of art theories. In other words, appreciation of Abstract Expressionism had been reduced to comprehension of theories.

While the Abstract Expressionists and their critics could claim to be artistically liberated from history and the dictates of aristo-

crats and the bourgeois, they were now, from the awakening artist point of view, enslaved by the dictates of their art theories. True artistic liberation is centered in Being, and therefore no theories are needed to give it meaning and there is no need for existential struggle.

What can the awakening artist learn from the Abstract Expressionists? We can learn to loosen up and to let spontaneity happen. We can learn to see the beauty of drips, splatters, and smears and enjoy their raw expressive power. We can also make sure that our art ultimately transcends theories of art, even theories about awakening art. As artists, we simply explore the infinite creative source beyond us as it emerges through us and our art.

Many of the mainstream Abstract Expressionists and their supportive critics-theorists became ensconced in their theories of art. Meanwhile, others were using their new artistic freedom to create wonderful visual metaphors related to awakening. Two of these artists in particular were Mark Tobey, and Morris Graves.

Mark Tobey (1890 - 1976)

"Transcending human consciousness, it could be said, is Tobey's ultimate theme."[3]

In 1958, Mark Tobey became the first American painter since Whistler (1895) to win top prize at the Venice Biennale. In 1961 Tobey had a retrospective exhibition at Muse'e des Arts D'ecoratifs in Paris. An art critic in France, though not inclined to give credit to outsiders especially since the focus of art had moved from Paris to New York, wrote that Tobey was perhaps the most important painter of our epoch. Quite an extraordinary compliment it would seem. Tobey was a member of the Bahai faith; he studied Arab literature, Asian philosophy, learned Chinese calligraphy, and spent a brief time in a Zen monastery in Japan. He also practiced Sumi-e painting and he was the first American to ever exhibit in the Louvre.

In the art world, the label 'important' when applied to an artist is often determined by an artist's impact on art history, which is formed by the opinions of scholars and historians. But as far as the flowering of human consciousness through artistic creativity goes, important artists are determined by those whose artwork points toward the possibility of spiritual awakening. By this criterion one of the truly important artists is Mark Tobey. He said:

> The dimension that counts for the creative person is the space he creates within himself. This inner space is closer to the infinite than the other, and it is the privilege of the balanced mind ... and the search for an equilibrium is essential—to be as aware of inner space as he is of outer space.

To Mark Tobey, inner space is the space of consciousness, and to be aware of inner space, as Tobey suggests, is to not be identified with the content of consciousness.

While Tobey's contemporaries were exploring the act of throwing and splashing paint, Tobey thought of creativity as emerging from a place of inner stillness: "I believe that painting should come through the avenues of meditation rather than the channels of action."

If it is not already obvious, these quotations are important to us because they are rare examples of an artist speaking with such clarity about art from a transcendent point of view, rather than from the point of view of struggle.

Like Kandinsky, Klee, Mondrian, and Brancusi before him, Tobey saw the highest reality as spiritual, not physical or psychological. He chose to emphasize unity—the oneness of all life in his art. He did this by unifying his paintings with what he called "threads of light." Tobey's threads of light were thinly painted white lines that would sometimes fill an entire painting. The thin white lines were visual metaphors for higher states of

consciousness and enlightenment. Threading light in this manner symbolized light as a unifying essence that flows through all form and brings to our awareness the energies of a larger reality. For Tobey, threading light was a way of portraying the fundamental oneness that all seemingly separate forms share. Tobey said: "All humanity . . . is connected through the bonds of divine affection; for we are all the waves of one sea."[4]

Tobey integrated his spiritual awareness with his artwork. He is an example of the awakening artist in action. He thought about and meditated upon what was to him a profound spiritual truth, and then explored it further in dynamic expression through his art. Tobey, like most other Modern Artists, saw beyond the Renaissance concept of fixed forms in space as seen through a window. Tobey's friend Teng Kuei once asked him why Western artists made pictures "that look like holes in the wall."[5] Unfortunately Tobey's reply was never recorded. Tobey did say, however, that forms in a painting "should be free and not separate from the space around them."[6] In his art he wanted to dissolve form and release the light that was within.[7] Tobey had a deep respect for Asian, particularly Japanese aesthetic sensibility as expressed through this insightful quotation: "I have often thought that if the West Coast had been as open to aesthetic influence from Asia as the East Coast has been to Europe, what a rich nation we would be!"[8]

At a casual glance, many of Tobey's paintings appear similar to Jackson Pollock's. This is because Tobey's artwork was Pollock's primary inspiration. Pollock was known to have studied Tobey's artwork on several occasions at Willard Gallery, in New York, before Pollock began his famous action painting technique, which looks similar to many Tobey paintings only on a larger scale. At Willard Gallery, Pollack saw Tobey's exuberant and energetic lines exploding over the surfaces of paintings. If Tobey and Pollock's artwork are so similar then why do I consider Tobey an example of an awakening artist and not Pollock? Because

Tobey made the convincing argument in his artwork and spoken statements that the topics of higher consciousness and enlightenment were important to him. Pollack did not. Intentionality makes all the difference. All artists are nevertheless included in the One Art Movement and each offers us a spiritual lesson. Tobey encourages us to let our interest in spiritual awakening be expressed right along with the subject matter of our art. He teaches us to sense the underlying oneness that resides behind all seemingly separate forms. He shows us that lines and shapes, or any element of art, can symbolize aspects of the spiritual dimension.

Morris Graves (1910 - 2001)

Morris Graves was an American painter who founded the Northwest School art movement in Washington State that thrived through the 1930s and '40s. The artists of the Northwest School synthesized into their art many of the styles popular among artists of their day. What made the Northwest School particularly unique, however, was its emphasis on 'transcendent' or 'spiritual' ideas, prompting the original members of the Northwest school to be labeled "The Northwest Mystics" in a *Life Magazine* article in 1953.

In the early '30s Graves became involved in Zen Buddhism and his artwork thereafter was influenced by East Asian philosophy and mysticism. Graves often used images such as a bird or a chalice to symbolize consciousness. According to art critic Delores Tarzan, "He meditated, painted, and listened intensely to night sounds, trying to imagine and to draw the creatures that made them."[9]

She also wrote, "It has been said that many of Graves' paintings sprang from visions received in meditation. It might be more accurate to say that for Graves, painting was itself a meditative process."

Graves understood that the highest quality of creative

expression emerges from the space of an awakened consciousness. He writes:

> The value of enjoying the arts is that the energy channeled into the aesthetic emotions refines and sensitizes the mind so that it can more skillfully seek and more readily grasp an understanding of the Origin of Consciousness. In great religious works of art, the unique value of the revealed images and symbols is that they become supports for the mind of the person who is seeking knowledge of the cause (and ultimate goal) of this mad-sublime dance we call LIFE. Secular and scientific 'art' is concerned with evolution. Spiritual art is concerned with involution. Involution is defined as an inward transformation.

Graves sought to bring the space of consciousness, spiritual awareness in other words, into his art. Even the simple act of setting up a still life to paint was done with reverence. As Tarzan describes it:

> A line of single blossoms, each in its own simple container, radiated a sense of beingness that is little short of reverential. As still life paintings, they were profoundly still. The subject seems not to be flowers or fruit, but light. They are painted so delicately that the pigment seems breathed into place. Graves projected intensity into them by rendering the images veiled and shimmering, suggesting not only the fleeting life of blossoms, but the evanescence of life itself.[10]

With his sensitivity to "beingness" and the "evanescence of life" Graves shows us that the awakening artist must put spiritual realization ahead of artistic creativity. As he put it: "My first interest is Being — along the way I am a painter."[11]

Graves also used the titles of his paintings as a way of adding

another metaphoric dimension to his work. There were few artists who could do so with such metaphoric power, which carries the perceptive viewer's attention beyond the material limits of the art. Powerful metaphors may connect us to the creative source. I find it particularly delightful that the titles of his art sometimes seem to have no particular relation to the art object. The apparent disconnection has the viewer pondering a spiritual meaning, like a Zen koan.

Here are some of my favorite Graves' artwork titles: *Bird Maddened by Machine Age Noise, Consciousness Assuming the Form of a Crane, The Opposite of Life Is Not Death; The Opposite of Life Is Time* and *Dawn Tao"*. These are not just labels; they are metaphors that hint at a vastness beyond the form of the art. They point our attention beyond the play of form, and to the Unformed, out of which all form arises.

Let us examine the meaning of Graves' mysterious title, *The Opposite of Life Is Not Death; The Opposite of Life Is Time.* If you wanted to live for a long time, then would you not want to be aware of as much time as possible as you lived it? Be aware of every passing hour? If so, then wouldn't the best way to live with as much time as possible be to sit in front of a clock and watch every minute go by? That way, you would be aware of every second you are living and not wasting any time missing your life. In reality, though, watching time go by is the most boring thing in the world. Watching time, or counting time, or sitting around waiting for the future is a boring, lifeless experience, is it not? There is no creativity, joy or fun in it. On the other hand, artists, or anyone who enters the timeless creative flow finds the experience exhilarating and enjoyable for the very reason that time disappears, because timelessness is our natural state. When time goes away we experience an increase of life, not a decrease. We are not designed, so to speak, to live in time; we are designed to live in the timeless flow of life.

If moving in the timeless flow of life creates the experience of

joy and a greater feeling of being alive, then it follows that trying to live in time creates unhappiness and lifelessness. And lifelessness is just another word for death, is it not? This is what Morris Graves was telling us in the title of his artwork *The Opposite of Life is Not Death, the Opposite of Life is Time.*

Mark Tobey and Morris Graves were well known in the New York art scene and among the Abstract Expressionists. They showed their art in New York galleries and received notable reviews by prestigious New York art critics and their works were purchased by major art museums. But they did not live in New York, nor did they become entangled in the existential struggle or art theories that powered the Abstract Expressionism art movement. Simply, they were beyond it. They preferred a more serene living environment in the Pacific Northwest of America, in the Seattle area, where they both lived for many years. This is because the awakening artist does not have to make a show of himself. He does not need or want personal attention, or fame, nor does he shun it. Tobey and Graves preferred to not play the game with critics, collectors, and the New York social scene, consequently they were frequently overlooked and forgotten.

Tobey and Graves were both considered by Life magazine to be "mystic-artists", which is, I suppose, better than being labeled frustrated or tortured. However, neither of them thought of themselves as mystics. Certainly they each had their personal foibles and cultural conditionings like most people. The label mystic conjures up a saintly purity that most artists do not have or want. To say, however, that Mark Tobey and Morris Graves were awakening artists pioneering awakening creativity is perfectly accurate.

Andrew Wyeth (1917-2009)

Andrew Wyeth was one of America's most beloved artists, and his artwork is given less attention in most art history books because his art did not fit into the Abstract Expressionist theories

that dominated the art world at that time. Nor was Wyeth a mystic-type artist, as Mark Tobey and Morris Graves were thought to be. Rather, Wyeth was a warm-hearted man, unburdened by the intellectual concepts of modern art, and he possessed extraordinary artistic skill. He loved painting the places and people near where he lived. While the history of Modern Art found little of historic relevance in Wyeth and his artwork, the awakening artist can learn plenty.

While Abstract Expressionism was raging in New York, Wyeth lived only 124 miles away in Chadds Ford, Pennsylvania. His paintings were regionalist in the sense that he painted mostly scenes and people from the rural areas of Chadds Ford and Cushing, Maine where he also lived. Wyeth was not concerned with the big issues of the modern artists, like the questions: What is art? Or, is abstraction the purest form of art? Wyeth's paintings, often simultaneously warm and haunting, appealed to the average viewer at the time but not to the intellectual art theorists who dismissed his art as merely sentimental illustrations.

The word sentimental, as we examined earlier with the Romantics, has become a derogatory label usually applied to art by those who are disconnected from their own feelings, sentiments, and the physical body. They live in their heads and believe that good art could only come out of a clever or interesting idea. The true meaning of sentiment, however, describes a refined or tender emotion, a sensibility. Great art, in my opinion, cannot arise without a certain quality of sentiment. On the other hand, the words 'maudlin', 'effusive' or 'melodramatic' would more accurately describe an over emphasis on the emotions. Wyeth, in my opinion, brought true sentimentality into his art.

However, it also seems to me that Wyeth's tendency to create narratives for his paintings did not add to their exquisite and haunting beauty. Take for example, his famous painting of a woman sleeping in a field while a dog nearby is looking into the

distance. It is a deeply peaceful painting and needs nothing to improve it. All the same, Wyeth titled the painting *Distant Thunder*, which was intended to encourage the viewer to imagine they are hearing thunder in the distance and the dog is looking up in that direction. He did this, as if the painting alone was not enough, and we needed a story to go along with it. Whereas Morris Graves' titles add dimension to his art, Wyeth's titles detract. So when I look at Wyeth's paintings I sometimes ignore his titles, his stories, and enjoy the paintings by themselves.

Wyeth was taught oil painting by his father and learned tempera technique from his brother in-law. It was to Wyeth's advantage, I believe, that he was not trained in modern art techniques and theories. Wyeth is an example of an artist who was given artist training without the influence of the philosophies and theories of Modern Art and abstraction. While the Modern Artists were exploring the philosophical meaning of art, Wyeth was apparently happy to paint the world he saw right around him.

The Sweater of Timeless Dimension

Wyeth was a master with the brush, subdued color and composition. He had an extraordinary ability to hold and focus his attention on what he saw for extended amounts of time. This is abundantly evident in the exquisite detail in his paintings. When you look at *Braids*, painted in 1979, you see a portrait of his neighbor Helga who Wyeth had painted many times. It is a bust of her from the chest up and she is wearing an ordinary grayish sweater with no pattern or design on it. She looks awake and attentive but has no special expression on her face, in my opinion, which is normal for most models when holding long poses. As with other Wyeth paintings, you are struck by the attention to detail in *Braids*. Every hair on Helga's head is in place. But what is more remarkable is that the detail in her sweater is so refined that you cannot see it clearly with the naked eye. However, when

holding a magnifying glass up to the painting, you see every weave, loop, strand, and twist of fiber in the sweater.

To the layperson, the idea of painting this amount of detail is almost incomprehensible. When I was speaking about this painting to a group at the Seattle Art Museum, one man approached me afterward and told me in all sincerity that he believed Andrew Wyeth was a very disturbed man with some kind of illness to paint with so much detail. "He must have been crazy," the man insisted. On the other hand others were so astonished by Wyeth's exquisite detail that no words could be said.

But why are we amazed by the extraordinary detail Wyeth put into the painting of an ordinary sweater? Most of us have seen similar sweaters many times in department stores and on people, and yet we do not stop and look at them in amazement like we do when viewing Wyeth's painted sweater. Why is that so? It is because painting the sweater appears to have been very difficult to do. It would seem to have taken an excruciating amount of time and patience. But I can tell you for certain that it was not difficult for Wyeth to accomplish. And even though he worked on the painting over a period of two years, it required neither time nor patience. It was not difficult because he clearly had the ability to do it, developed through many years of training and practice that anyone dedicated to his or her art is happy to do. It did not require time, in the psychological sense, because time does not exist in the creative flow. Artists do not check their watches every few minutes to see how long it is taking them.

If I see a student looking at their watch during a painting class I know they are not in the place of creativity, so I encourage them to get up and walk around, go outside and get some fresh air, walk down to the end of the block and back. Either the student needs this kind of visual down time or they need to go home and get some rest. Nothing could be further from creativity than thinking about time. In addition, Wyeth's sweater did not require

patience, which can be defined as tolerating time. However, if time does not exist then it does not have to be tolerated. When someone says they wouldn't have the patience to do something, they are really saying they are a prisoner of psychological time, which is a preoccupation with the past and future when they have no direct relevance to the present moment.

Clock time, on the other hand, is a practical tool for knowing when something happened or is supposed to happen. Painting class starts at 5 pm and ends at 8 pm, but between those two posts, time, as far as creativity goes, is not necessary. We are amazed by Wyeth's *Braids* when we learn that it took two years, off and on, of clock time to complete. Some people have difficulty focusing their total attention on something for more than two minutes. To them, two years would seem excruciating.

We rarely witness another human being putting so much of himself into something. Compare the kind of attention required of Wyeth to paint the sweater to the kind of attention required to knit a real sweater. Both take attention, skill, and time, so what is the difference? Why are we struck by the loops and weaves of Wyeth's sweater and hardly notice them on a real one? For one, you can probably watch TV or chat with friends while knitting a real sweater, but not while painting one. Just as in many classical paintings, the placement of each and every hair-width brush-stroke in Wyeth's painting was an individual choice resulting in hundreds of thousands of small individual choices. All without mental strain and none by rote. Each brushstroke is saying, "I am fully present here". This is so very rare to see. It is the artist's complete presence and attention that is so delightful to behold in such a painting.

Andrew Wyeth teaches the awakening artist to simply enjoy viewing and painting the world right around us. He also teaches us to not be overly concerned with big ideas. Even the idea of becoming an awakening artist could be made into a complex theory. However, it is not necessary to do that. All that is required

of an awakening artist is to avail him or herself fully and innocently to the creative process. The awakening artist can be the "space of consciousness" as Morris Graves said, in which we can enjoy the play of form.

Pop Art

Pop Art began in Britain in the early 1950s and came to New York in the mid 1950s. It was the polar opposite of the serious, intellectual, and theoretical approach of the mainstream Abstract Expressionists that had gone before it. Pop Art got its name from artists using images from popular culture such as cartoon strips and soup cans. Pop artists selected iconography that was contrary to what was expected of high-art. With this new kind of art the viewer no longer needed to be a sophisticated insider who was educated in the latest theories of art. Now anyone could understand art. What is there to understand about a Brillo box or Campbell's soup can? Pop artists proudly celebrated banality and materialism.

In a 1966 interview in *Abstract Purest*, the artist Ad Reinhardt said this of the Pop Artists:

There's a kind of moral prestige that an artist has, like a priest in a sense. [But] there isn't anything that doesn't go on now. The Pop artists exploded everything. They really ran all those meanings into the ground. Pollack wanted to become a celebrity and he did. De Kooning is living like Elizabeth Taylor. But finally it was Warhol. He ran together all the desires of artists to become celebrities, to make money, and to have a good time...[12]

What can the awakening artist learn from the Pop Artists? We can learn to not get high-minded and take ourselves too seriously and simply enjoy the play of form.

Minimalism (late 1960s to mid 1970s)

Minimalism, like Pop Art, was another reaction to Abstract Expressionism. But instead of going banal like the Pop Artists, the Minimalists went the other direction, toward austerity. In minimalism the art is stripped down to its most fundamental features. Minimalism often includes geometric and cubic forms devoid of any symbolism or metaphor. It generally contains repetition of elements, neutral surfaces, and industrial materials like metal, Plexiglas, and plywood. The minimalists claimed that their art was more pure than the Abstract Expressionists' art because there wasn't even evidence of an artist involved in it. That's how pure it was in their opinion. No artist, no problem.

Since there is not much to look at in minimal art, many viewers hardly notice it as they pass through minimalist exhibitions in museums. Minimalism as a theory may offer little to most people. On the other hand, it is quite amazing to see how the infinite creative source is able to express through such austerity. For example, Donald Judd's work *Untitled* is composed of six polished bronze cubes sitting on the floor. They are so polished, clean edged, perfectly cubic and reflective of the surrounding environment that they are truly beautiful. The work is worthy of our attention because it expresses beauty, not because of a minimalist theory about them. Beauty of form will always supersede any theory that the artist or anyone may have about it. This is because a theory is merely a mental reduction of a thing, and the reality of a thing is always infinitely more dimensional than a theory. To create minimal art effectively requires a well-developed sense of simplicity and perceptual beauty.

Consider the work of minimal artist Robert Irwin, who made works of art that appeared to simultaneously stand out and disappear into the surrounding environment. For example, on one occasion Irwin was given a room at a museum to display his art. Most other artists would have thoughtfully and carefully arranged their art throughout the room, but not Irwin. Instead,

he would leave the room empty and make adjustments to the space itself. He used lighting techniques on walls, floors and ceilings that would bring the viewer's attention to the beauty of the empty space without any objects in the space. The setting for art became the art. Irwin's art is a wonderful metaphor for the Tao, which is no-thing but contains every-thing.

Another master of minimal art is James Turrell, who makes spaces of light. The viewer walks into a gallery space and the only thing they see is an ocean of light. You feel that you are standing in a field of soft light, however you cannot see the room itself. No matter what direction you may look you will not see any walls, ceiling or floor. Nor do you see any edges or corners where the walls, ceiling and floor meet. Turrell bathed the viewer in soft light within a formless space. This is another outstanding metaphor for spiritual consciousness.

Modern Art Summary

The entire Modern art era, in addition to the Romantics and Hudson River School, arose in direct contrast to the Classical era. The defining characteristic of the Classical era was to look to the past. Modern artists, however, wanted their creativity to be an expression of their own time and their collective now, not of a previous time. In this regard you can see how the flowering of human consciousness, and the One Art Movement, encompassed the entire Modern art movement, regardless of its many quirks and failed experiments. As stated earlier, the entire Modern art era spans history from the time of the Impressionists, starting in about 1863, and ends with Minimalism in the mid 1970s. According to many scholars, by that time everything that could be done in art had been done.

What can we learn from the Modern artists? We can learn to be explorative and adventurous in our creativity. We can survey the works they made and find inspiration in them. We can learn to think about what we are doing without getting lost in thought.

The Modern artists attempted to understand artistic creativity relative to overcoming the traditions of the past. Thanks to them, we do not have to do that. Because of their soul searching, questioning, and experimentation they have made it possible for us to explore artistic creativity without the obstacles and existential struggle they felt the need to overcome. The term, existential struggle was a philosophical way of describing the pain many artists felt as a result of their separation from the natural flow of Life. More than anything, however, the Modern artists have shown us many extraordinary, beautiful, and thoughtful works of art.

The Postmodern Era

One of the main themes of Modern art was the reexamination of the role and purpose of art, as well as the artist. There has been some debate as to when Postmodern Art began. Nor can Postmodern art be precisely identified as a single style or movement. Some say that Postmodern art does not exist at all; to them Modern art continues on. Why is there such a debate? Up to that point every aspect of art, it seemed, had been explored and questioned. In addition to the Modern art examples we looked at, artists also asked questions like: Why should we hang our paintings on a wall? So they 'hung' them on the floor. They asked: Why should we paint on canvas? So they painted directly on the wall. They asked: Why should our art even be physical? So they invented conceptual art in which the art is merely an idea. They asked: Why should art be displayed in a museum or gallery? So they took it outside and made environmental art. Then asked: Why should our art be made to last for centuries? So they made art that would disintegrate rapidly. Basically everything that could be done to art had been done, and henceforth, after about the mid 1970s there was nothing an artist could do with, or to a work of art that did not have its roots in something that had been done to works of art previously. This is why some critics have

said 'painting is dead' and that media art, which uses videos and computers, and installation art, which fills up all, or part, of a gallery with various materials, are some of the forms of creativity in the Postmodern Art era.

In the present Postmodern era, there has been more of an emphasis on the exploration of the human condition, gender identity, race, social-political issues, personal psychology, assumptions of perception, and more explorations of materials, processes, technology and media. Postmodern trends include performance art, video art, earth art, street art, pop Surrealism, feminist art, Postmodern sculpture, algorithmic art, and information visualization. Clearly there has been a turning point in art, whatever the turning point may be called. Modern artists, from the Impressionist to the Pop-Artists, broke the grip that the past has had on their art for hundreds of years. And now, the creativity of Postmodern art is more global in nature.

Most important, however, is that everything that has gone before brings us to the present. The real question, therefore, is how artists will use this freedom now? Will it be used to continue the madness of the egoic mind, or become a vehicle through which life's greater intelligence may flow? Some artists and viewers have complained that art has no standards now; anything goes. And if that is so, it is reasoned, then anything can be art and anyone can be an artist. How can you quantify art, they wonder, if there is nothing to compare it to and nothing to contrast it against? Some artists and viewers may find this situation frustrating. I would be among those who find the current state of art an opportunity because there are fewer limitations restricting the infinite creative source from flowing freely through the artist.

The One Art Movement Summarized

Throughout this brief survey of human artistic creativity we have explored the art of early humans, the art of ancient civiliza-

tions, the art of the Renaissance, and the Classic Era, and Modern Art. To reiterate, it has not been my intention to write a comprehensive history of art, as I am neither an historian nor an art scholar. My goal has been simply to pull out selected examples of art throughout history in order that we might become aware of the madness and spiritual awakening found in them. There are many cultures and countries that could have been included in this survey such as India, Islam, Russia, Central America, Australia and others. And there are many extraordinary artists of the past, and present, who could have been included in this book. Aside from space limitations, their inclusion would not have necessarily made my point any clearer.

To explore the One Art Movement further you can do as I have done, which is to look at the art of any time and any place and ask: How does this art participate in the flowering of human consciousness? And then you can enjoy exploring possible answers to that question again and again. There are answers to that question for every work of art and each artist who has ever lived.

The entire scope of human artistic creativity from the earliest cave painters to the present day is the One Art Movement. It can be summed up as having three distinct phases. The first was 'unconscious innocence' seen in the art of early humans and the primal people who survived the Age of Madness. The second was 'unconscious suffering', as seen in the psychic disharmony as the result of the Age of Madness that gave rise to the human ego and its control over much of human artistic creativity. And the third phase, 'conscious innocence'. This phase is now possible because many people are becoming aware that it is possible. This realization is evidence itself of the flowering of human consciousness. It is the realization of the oneness that is shared by the artist with all of life.

(See chart opposite).

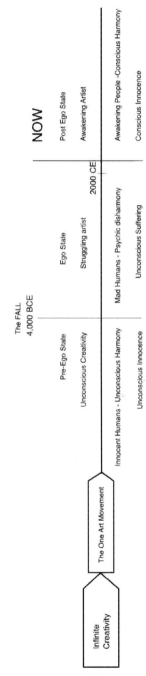

Infinite Creativity
Expressing through Artisists throughout the Ages

The FALL
4,000 BCE

2000 CE

NOW

Pre-Ego State

Unconscious Creativity

Innocent Humans - Unconscious Harmony

Unconscious Innocence

Ego State

Struggling artist

Mad Humans - Psychic disharmony

Unconscious Suffering

Post Ego State

Awakening Artist

Awakening People –Conscious Harmony

Conscious Innocence

The One Art Movement

Infinite
Creativity

Part 3

Madness and Awakening in the Present

Chapter 9

The Transformational Power of Art

In his book *How Art Made the World*, which also became a BBC television series, author Nigel Spivey discusses how art has transformed human societies from the time of the earliest artistic creations to the present day. For example, Spivey shows that throughout history various features of the human body have been unrealistically exaggerated in order to elicit a greater response from viewers. He points out that in Greek sculpture, shoulders were made broader, waists narrower and legs longer than normal because these exaggerations were more attractive to the human eye. Sculptures with these distortions were considered finer works than those without distortions even though those without distortions were truer to human anatomy and more realistic.

Spivey also points out how kings, emperors and politicians throughout history have used images to manipulate the illiterate masses and to project an image of power. These images were intended to thoroughly impress, if not frighten friends and enemies. Furthermore, artistic images have been used to promote visions of life, death and a hereafter. In short, art has always been used to shape the visions, beliefs and behaviors of a society.

However, in context of our discussion of innocence, madness, and spiritual awakening in art, we see that not all art was necessarily used to manipulate people in sinister ways. For example, the cave paintings of the early cave artist-shamans that we spoke of in Chapter 4, may have been ritualistic but not manipulative creations intended to control people. Rather, they were intended to evoke a transformation of consciousness and foster a connection to a higher power. It was used to transform and empower the individual, not to subject him or her.

Nothing demonstrates more vividly the transformative power of art within a culture than iconoclasm, the destruction of religious and political images by conquering enemies, or the destruction of images after the death or overthrow of a ruler. Humans invest so much meaning and power in their culture's images that to see them destroyed by an enemy is tantamount to loss to the enemy.

The national socialist art of the Third Reich, which emulated the art of Ancient Rome, was meant to project power and authority. It was meant to make the ideals of Nazism seem very substantial, and permanent. Ideas alone are somewhat intangible; however, a monolithic sculpture expressing those ideas can make them appear solid and immovable.

Prior to the collapse of the Soviet Union, in 1991, official Soviet art was created to project the indomitable power and glory of the Soviet Union in the hearts and minds of its citizenry and the world. Monumental sculptures portrayed stoic workers, square shouldered soldiers, and portraits of Stalin and Lenin. After the collapse of the Soviet Union, however, many of the Soviet works in Eastern Bloc countries were hauled away and dumped, their transformative power completely gone. (In one case a 16 feet (5 m) bronze sculpture of Lenin was dumped in a Slovakia scrapyard. The monolithic sculpture portrayed Lenin marching forward fiercely, surrounded by torrid flames. An art lover from Seattle, Washington found it and bought it for $13,000. Today it stands just outside a falafel shop and a gelato shop in the center of the Fremont neighborhood, in Seattle. At Christmas time the neighborhood decorates Lenin with Christmas lights. Once during Fremont's Solstice Festival, Lenin was dressed as John Lennon. During Gay Pride Week Lenin is usually dressed in drag. On any day you might drive past the monument and see Lenin holding something unusual in his hand, like a giant paper mache burrito. The monument had been transformed from a symbol of power and glory into one of irony and humor).

Monumental sculpture of Lenin outside a falafel shop in Seattle,
Washington, a monument to irony and humor.

The early artist-shaman cave artists, believed that the images and
objects they created had magical powers that connected them and
their societies to magnificent spirit beings who dwelled in a
spirit-world. Did these images and objects have magical powers?
Not really. Magic is a word used to describe occurrences that are
not understood, or that appear to defy logic and reason. I recall
as a young child being fascinated by flipping a light on and off.
Magically, a light in the room would turn on, or off every time I
flipped the switch. In the case of early humans, merely believing
that certain images and objects had magical or transformative
powers was enough to effect a change in their experience. In
other words, the image or object served as a trigger to heighten a
sense of something that was already within the human. It would
open an awareness within. For example, the prehistoric cave

painting of a bison or reindeer was intended, as many paleontologists believe, to inspire an inner transformation of the viewer. However, the transformation was not caused entirely by the images. The images merely awakened the transformative powers that lie dormant within the viewer. Going forward in time, the image of Buddha sitting peacefully in meditation reminded Buddhists of their own inner peace. For Christians, an image of Christ suffering on the cross would trigger the awareness of their own great suffering.

As human consciousness has evolved through the ages, so has the ability to make ever more believable and persuasive images and objects, as we saw in our examination of Renaissance art. An example of this is Michelangelo's depiction of God on the ceiling of the Sistine Chapel, painted from 1508 to 1512. Until that time no one had depicted God with such persuasive power. The early Renaissance painters before Michelangelo such as Giotto, depicted God but only as a diminutive hand coming out of a cloud. With Michelangelo however, God is a mighty bearded man, flying in the sky among flowing robes and cherubs. This

 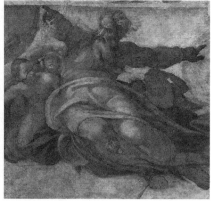

Left: Giotto portrays God in *The Legend of St. Francis* as a diminutive hand peeking out of the clouds. See white circle. Right: Michelangelo portrays God on the Sistine Chapel ceiling as a stern, mighty male with wind-blown beard.

image was so potent and has had so much transformative power that people thought God actually looked like that. Even today some Christians imagine that God is an elderly male in flowing robes floating up above the earth. They completely misunderstand that 'above the earth' is not an actual place. In art, 'above the earth' is a metaphor for 'higher consciousness'.

Awakening Psychic Energy

What gives any object, symbol or image its transformative power is "psychic energy" as Carl Jung and Joseph Campbell have described it. But they are not using the term psychic to denote some kind of paranormal mind reading; rather, they use it to denote the psychological function of the human mind. When we look at external objects, they reflect back to us like a mirror. They draw our attention to something within us. They act upon our psychic energy as it were. If that field of energy is in a dormant state—unconscious, in other words—the object or image may begin to awaken it.

Here is a personal story of the awakening of psychic energy: After graduating from art school I became depressed because the art world seemed overly intellectual and negative. The happiness I found in making art before my exposure to the art world had been completely drained away. The art that I had previously enjoyed so much I now looked upon as sentimental and unsophisticated. Naively, I bought into the ideas of the art world and in doing so I had joined the struggle. My artwork became heavy and intellectual because that is what history and the critics expected, I was told. I walked around in a dark cloud because I believed I was not being understood by the world. I was miserable. This went on for months. Then one day I walked into a museum and what I saw almost dropped me to my knees. It was an exhibition of mid-nineteenth century French art. On one wall I saw paintings of the classic academic French painters with their adherence to traditions and proper methods of the time.

They were beautiful paintings. Then I turned to view the opposite wall and—'BOOM!'—I saw a painting filled with an explosion of light and color that took my breath away. It was a painting by Claude Monet. I suddenly realized that it was okay to love beauty.

I had seen Monet's water lily paintings in posters, on calendars and in books many times before. Many of my artist friends viewed Monet's art as merely pretty, but what shot through me was the simple realization that life is beautiful! Light and color are beautiful! Nature is shimmering with wonderful energy—and it did not matter what any depressing intellectuals thought about it. The truth is: Beauty, light and color, are all right there before us.

Monet's artwork provided a tipping point for me. I realized that if this great man could love beauty without hesitation, then I could too, dammit! Something in me had snapped. I realized that what I had always loved about art had never really changed or gone away. Monet's paintings gave me permission to transcend intellectualism in art, to move to a higher plane than the intellect.

However, there was something more. As mentioned above, when art is transformative, it reflects back to us our psychic energy like a mirror. What I saw reflected back to me in Monet's water lilies was not a fanciful image of myself enjoying the beautiful colors and light on a warm afternoon in Giverny, where Monet lived. Not at all. What I saw reflected back to me was an unshaven, slovenly young man who thought he knew every-thing, who believed all the intellectual concepts and jargon he had been fed, who had bought into the struggling artist persona, and who believed that no one understood him or his artistic genius—all the typical stuff of the ego. Looking deeper I saw that I had abandoned my love of beauty. Monet's painting had triggered the psychic energy within me and provided a reflection of what was already within me. Monet's painting merely drew it

out so I could see it for myself. After this, beauty was allowed to return into my life and art

Monet, I would guess, did not intend his art to cause this specific kind of reaction in any viewer, but my story illustrates the potential transformative power of an image—of art. Had Monet not brought the brilliance of his being into his art I certainly would not have been reminded of mine. When you bring your brilliance and presence into your creativity, it reminds people of theirs. There is no greater purpose for art.

Here is another example of the transformative power of art: A woman came into my art gallery and stopped in front of a painting. It was one that she had apparently been eyeing through the window for some time. It was a landscape painting with trees and misty blue light. She wore a large hat to hide the fact that her head was shaved. She studied the painting for a long time and then turned to me and with sincere feeling said the painting was the most beautiful thing she had ever seen. We talked for a while and I told her about some of my favorite places to paint, in the Washington Arboretum and Discovery Park, in Seattle. Eventually she felt comfortable enough to reveal to me that she had been recently informed that she was soon going to die of cancer. I found no appropriate words to say in response to this, so I listened and was completely there for her. Eventually, coming back to the artwork, she said that she wanted to buy this particular painting so "I can take it home and see the beauty and peace of the world before I die". Up until that time I had received many fine compliments for my artwork but her comment was of the deepest transformative kind. The painting was providing her with a connection to beauty and peace as her physical form was about to dissolve. I was profoundly honored to participate in this small way in the transition that lay before her, the death of her human form. Months later I learned that she had indeed passed away, and the painting had been bequeathed to her daughter.

The art was able to connect the woman to beauty and peace at

a time of critical transition. What struck me most, however, was that she, like so many others, could not see for herself the beauty and peace in the world around her without the art. Although the degree to which I was able to allow beauty and peace to flow into the artwork had a lot to do with the connection, too. Nevertheless, she needed a work of art to stop her, to bring her to attention so she could see the beauty and peace that abounds in nature. As is true of many artists, all I have to do is look out any window, walk in any park, study the cooking utensils on any kitchen countertop, or look in almost any direction and I see the beauty and peace of the world. Many people do not have that ability so the transformative power of art can assist them in truly seeing the world.

The advertising industry knows quite well the transformative power of visual images, but their transformative images do not serve as portals into beauty and peace; rather, as portals into the pocket books of consumers. The advertising industry spends billions every year creating visual images for the strategic purpose of transforming the consumer's fears and desires into products and services. There are far fewer images in the world that seek to help people transcend their fears and desires.

Duchamp and The Buddha

The transformative power of art can be 'supercharged' depending on the context in which the art is presented. You may recall how artist Marcel Duchamp transformed found objects, like a shovel or bicycle wheel, into art merely by displaying it in an art museum. The setting alone transformed the meaning of the object. While it has been said that Marcel Duchamp's found objects demonstrated "Zen *without* the enlightenment"[1] it could also be said that 2,600 years ago the Buddha demonstrated a found object without the Dada, and it became Zen *with* the enlightenment.

The story goes that Buddha was giving a silent sermon, which

is a sermon communicated only by the Buddha's silent presence. During the sermon the Buddha noticed a flower nearby. He plucked it and held it in his hand for all to see. He was now exhibiting his found object. After a while one monk suddenly understood what the flower meant and in that moment became enlightened, and smiled. After that the Buddha continued the sermon with words so the others could also understand the meaning of the flower. As the legend goes, the monk who understood the meaning of the flower later became the inspiration for Zen. And, as you may recall, Monet attributed flowers as the source of inspiration for him becoming an artist.

Any found object placed at the right time in the right setting may provide the possibility of a powerful transformation. Duchamp's found objects have been placed in special places like art museums, to give them transformative meaning. The Buddha's flower was placed in his hand. These special places supercharged the transformative power of their respective found objects. A flower along a path may go unnoticed. In a different setting, however, the same flower may become a portal to enlightenment.

Mythic Power

Much of art today has lost its "mythic power", as Joseph Campbell would say. Most art is made for the market and the critics and makes no effort whatsoever at being transformative. To say that art lacks mythic power is to say that it does not direct our attention toward anything beyond, or deeper than the art itself, or the artist himself, and toward the universal. To the degree that art lacks mythic power is the degree to which it becomes ordinary and literal. It becomes a description of the artist's opinions about art, the world, or himself, and does not suggest that we go beyond them to anything deeper.

Here is the problem of using symbols and images of the past. Take for example, the popular image of Kokopelli, whose

dancing image can be found today on everything from belt buckles to mud flaps. Originally Kokopelli was believed to be a fertility deity among the Hopi. He is usually depicted as a flute player with wild hair, or a fan-shaped ornamentation protruding from his head and sometimes he is sporting an enormous phallus. Aside from impregnating women, the deity Kokopelli was capable of chasing away winter and bringing forth spring, and many other magical feats.

However, for an artist today to use the image of Kokopelli in their art, it would be nothing more than a decorative treatment, because the image has no transformative power to us. The young women of today would never become fearful of getting pregnant when confronted with the image of Kokopelli as the young Hopi women did. This is of course just one example. There is the eagle, snake, whale, dolphin, and countless other popular images that are held in reverence because of their spiritual meaning to various cultures. Those images today are echoing the mythologies of cultures of the past and do not activate the powerful transformative metaphors that would be relevant today in our society. The mythic artist of today is the artist whose art points toward the possibility of awakening.

Hopi deity Kokopelli: Women today do not fear he will impregnate them.

Chapter 10

Madness in the Art World

The art world contains as much psychic disharmony as any other facet of human society. However, compared to other facets, the art world's psychosis is relatively mild. Although some artists may have been punished for *making* certain kinds of art in cultures that forbid certain images, to my knowledge no one has ever been killed or brutalized *by* a work of art. The same cannot always be said about the world's militaries, governments, and corporations. It is for the awakening ones within those fields to shine light on the madness in them. Our task at hand, however, is to shine light on the madness in the art world, which affects not only artists, but also curators, dealers, collectors, and critics. Here we will observe how the madness that began 6,000 years ago arises today in the art world in general, and artists in particular.

The psychic disharmony, or ego, that may reside within an artist is part of the overall madness that has been shared by all human beings for thousands of years. Therefore, it is not personal to anyone. Nor is the ego bad or wrong, which are judgments about it. We simply recognize it as an unhealthy psychological condition. The basic characteristic of ego is fear and craving. It is afraid of failure and death and craves things that it believes will give it more life and happiness. It is easy to see egoic madness in others, for example a brutal dictator, a greedy corporate executive, or a politician who seems only interested in his own self-aggrandizement. From the awakening perspective, recognizing the madness in others, and especially in ourselves, is not to put others or ourselves down. If the psychic disharmony is never recognized, how could it ever be healed? Furthermore, it is important to remember that the sickness is not who the person is, it is merely a condition that almost everyone, has.

Artificially Important Art

Once, in a major museum, I took a tour of the current exhibition. The docent, who is a qualified and knowledgeable guide in a museum, informed us that the art we were looking at was very important. When someone asked why it was so important the docent replied, "If I told you why this art is important then you would only adopt my opinion. You need to come up with your own reason why this art is important." Puzzled, the tourist then said, "But it's *not* important to me; that's why I wanted to know why it is important to you". "It is important," replied the docent, "because it stimulates conversations like this. It make us think of art in new ways." In other words, the docent was saying that in order to understand why the art was important the viewer needed to come up with his or her own reason why it was important, which of course is nonsense. The tour group walked on, some still wondering why the work of art, a two-ton blob of lard on the floor, was so important. The ego within the art world thinks if it can make art appear inaccessible and important then it will feel inaccessible and important, too. From the awakening perspective, however, only awakening is important because it forms the foundation of awakening creativity.

Dissolving Superiority

The tour group continued on in tow behind the docent. We walked through another exhibition area and I noticed another docent attempting to explain a large solid-black Ad Reinhardt painting to a small group of viewers. After her explanation, she asked the group what they thought. The group could only stand there looking at the large square of solid black with furrowed brows, perplexed and silent. Visibly exasperated, the docent made eye contact with our docent. She rolled her eyes and shook her head. Her expression seemed to say: 'Lay people just don't get it.' The ego within the art world loves to feel superior when it thinks it knows something others are unable to comprehend. It

likes to raise itself up by lowering others and by diminishing them and making them feel foolish, stupid, and inferior. The fact is most people have plenty of ability to understand art. The question is, is it being presented with the intention of making it clear to any person of normal intelligence?

Awakening Art Scholarship

This book could not have been written were it not for the insights and efforts of many art world historians and scholars. For their work I am profoundly grateful. However, scholarship itself is unable to direct a person toward the possibility of awakening unless the scholar is an awakening scholar. Joseph Campbell was an example of a truly great, awakening art scholar, though he was most commonly thought of as a mythologist. He viewed humanity and its expressions in art from the context of the spiritual evolution of human consciousness, which I believe should be the premise of all art scholarship. However, that is usually not the case within the art world today.

Art scholars are among those who form the opinions and views of the art world. Some have suggested that laypeople would benefit by striving to understand artists because it would enrich their lives. How so? How would *striving* to understand art change anyone's life? Will exposure to theories of art give them spiritual enlightenment? Make them fashionable? Make them culturally suave? Make them intelligent? There is no *striving* in understanding art. A work of art either speaks to you, or it does not. There is no effort in that. Naturally, some people might be more inclined than others to explore art's history and evolution. But again, there is no inherently strenuous effort in exploring a subject that you find interesting.

The ego within an art scholar would like lay people to think that there is something very complex, mysterious, and mentally hard to grasp about art all the while claiming to help them understand it. If there was something complex or hard to grasp about art

what would it be? If you are awakening spiritually then you already know that all art is the manifestation of the infinite creative source that is beyond the artist, flows through the artist and is ultimately who the artist is. Once you get that, what theory of art could possibly be hard to grasp? The truth is there is nothing difficult to understand about art. Monet put it this way "Everyone discusses my art and pretends to understand, as if it were necessary to understand, when it is simply necessary to love."

One scholar, when referring to Van Gogh's painting *Starry Night*, suggested that the key for lay people to understanding art is for them to unravel the meaning-effects of contextual codes and formal nuances without falling prey to the assumption that good art is realistic.[1] (Huh?) Once an inspiring work such as Van Gogh's *Starry Night* is reduced to intellectual interpretation, its transformative power is completely lost. The greatest works of art are experienced, not understood. If a layperson wants to understand Van Gogh's life and the history and culture surrounding Van Gogh, fine. That may tell them a little something about the art and the artist but it will never give them the experience of *Starry Night*.

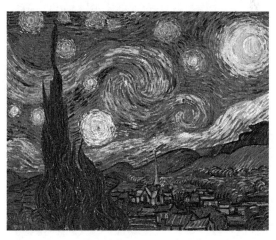

Starry Night by Vincent Van Gogh. Can you unravel the meaning-effects of contextual codes and formal nuances in this picture?

An art scholar can be considered brilliant without an ounce of original thinking of his own. All he needs is the ability to recount and have opinions about the original thoughts of other scholars. An art scholar may have a profound knowledge of a given artistic subject, and that knowledge may demonstrate that the scholar is very intelligent. But knowledge itself makes him neither original, creative, nor wise. If he possesses these higher qualities he will have had to arrive at them by other means than scholarship. He would have to arrive at them by becoming receptive to the infinite creative source beyond him that is yet within him. Then his insights about art could be nothing other than original, creative and wise.

Beyond Secret Codes

In some modern art, like conceptual art and some minimal art, there isn't all that much to see. In this case the artist is often more concerned with how the viewer thinks about the art than how the art appears. To compensate for this absence of visual content some critics, curators, and art theorists have claimed that there are hidden meanings in the art. There are secret codes to unlock, and weighty concepts and references only hinted at. The viewer has to figure it out. However, even if modern art were to have secret codes, if it has no transformative power to move us in any deeper way when the big secret is finally revealed, then why should we care? The ego within the art world loves to pretend it has special and secretive knowledge.

Related to this, here is a story about putting secret meanings into art: Many years ago, and according to my high-minded art world standards at the time, painting a picture of a puppy dog would have seemed cute, unsophisticated, even shallow. Since then a shift in my awareness has allowed me to see that dogs are amazing creatures that are completely loyal and protective of their humans. They are non-judgmental and always ready to evoke our affection and love. For this reason dogs have on

occasion appeared in my artwork. Sometimes I've been commissioned to paint pictures of pets for their owners. Painting a picture of someone's beloved pet is obviously not an intellectual and artistically weighty undertaking. Instead, if we are open to it, images of dogs may connect us to qualities of loyalty, protection, non-judgment, affection and love that they evoke.

One evening I was dining with friends and seated next to me was an artist who was well regarded in the local art scene. I asked him what he was currently working on. He said he was painting abstract works. He was taking excerpts from Chilean poet Pablo Neruda's poems and writing them, in Spanish, on the canvases and weaving the poems into and around the colors of the paintings. I thought the idea of combining poetry with abstract art in this manner was very interesting. I asked him why he was writing Neruda's excerpts in Spanish on his artwork when he knew that the vast majority of viewers would likely read only English. He said because he didn't want the painting to be a quick read. He apparently wanted the work to have layers of meaning, obscured references, contextual secrets and cultural nuances that would not be easily understood. He said he wanted viewers to really work hard to get his art. In other words, he did not want viewers to simply enjoy looking at the art, he wanted to impress upon them that his art was extremely difficult to comprehend. Apparently requiring a knowledge of Spanish just to get started. Then he asked me what I was currently working on and I told him I was painting pictures of puppies. He stared at me, as if waiting for a punch line. Slowly a sly smile grew on his face as if he were getting it. "I see", he said, "you mean in a kitschy way, as in a tongue-in-cheek commentary on society's naiveté?" "No", I said, "I'm just painting these puppies as cute as possible because they're lovable, that's all". The sly smile went away and confusion took its place, as if I had said something that was extremely difficult to comprehend. The truth is awakening art never has to rely on artificial complexity. Nor does it require

the unlocking of secret codes to be enjoyable. In fact, the only real secret is no longer a secret anymore—awakening is possible now.

Everyone Should Love Art Syndrome

Some in the art world wonder why more people do not take an interest in art. The educational system is often blamed for not teaching the importance of art. And when budgets are tight, art programs are always one of the first things to get cut. Others say that art is not appreciated because most people cannot afford it. If you ask a person on the street why they are not more interested in art they will likely tell you because they do not know anything about it. All of these reasons have validity, but there is one prevailing reason why society has little interest in art. It is the result of hundreds of years of condescending attitudes and exclusivity toward lay people by the art world. Egoic madness has manifested sometimes in the art world as condescension and exclusivity. In the humorous book *The Painted Word*, author Tom Wolfe estimated that in the '60s the art world consisted globally of only about 10,000 people out of a total world population of just over three billion. It consisted primarily of artists, collectors, critic, and curators.[2] The so-called masses were never involved. Wolfe writes that the art world bourgeois rolled their eyes whenever the non-elite didn't understand art, but they were never supposed to, according to Wolfe. The masses were merely spectators and parade watchers as the art world went by. For art to have greater social relevance it must have a relationship to the life of the society, not merely to itself as a sub-culture.

The Awakening Art Dealer

No doubt there are many wonderful and honest art dealers in the world and any artists fortunate enough to be working with one should be very grateful. However, the madness that all humans experience also affects art dealers. Many artists can tell horror stories about the deceptive and dishonest art dealers with whom

they have worked. In some cases, art dealers have damaged and stolen the artist's work. Dealers have also pilfered or hidden profits made from an artist's work. You would think that art dealers are an artist's worst enemy.

In addition, many art dealers, museum curators, collectors, and art critics have artificially pumped up the personas of their artists to feel special by association, to impress viewers and attract their business. Some art dealers like to build a mystique around their artists to tantalize prospective buyers. One mystique is that the gallery's artists have a life style ordinary people can only dream of. It would hardly be as romantic if it were learned that many outstanding artists are just regular people with regular day jobs at ordinary companies.

One time I stopped unannounced into a gallery that was carrying my artwork and the dealer introduced me to some collectors. They immediately wanted to hear about my studio in Paris and about my paintings of my travels around the world. I had no idea what they were talking about. I had never been to Paris. I told them the paintings were painted near my house, in Seattle. The art dealer quickly stepped in to explain the real story, the France story. I had no idea what he was talking about either, however I finally caught on. The art dealer had fabricated a story for the couple before I had unexpectedly walked in. He created a fantasy image of an artist. He was forming the artist (me) into an important identity in their imaginations. The message was that this artist, *his* artist, has a free and easy life style. He paints in Paris, Tahiti, and Tuscany. Museums and galleries all over the world are clamoring at his studio door. He may be temperamental, the dealer warns, but he's a genius! And you can experience his exotic lifestyle too, sort of, by buying his paintings. And by owning this important breakthrough work, you will be playing an important part in his extraordinary life and helping to shape the history of art! On the other hand, the awakening art dealer would have no interest in inventing

fanciful stories to lure in customers. All that is needed is the simple truth and some kindness.

Going Beyond the Role of the Artist

The common stereotype of the artist is that he is frustrated, obsessed, hedonistic, egotistic, temperamental, poor, struggling, anti-social, non-conformist, misunderstood, and a genius. Some genuine artists may have these experiences and challenges but for others they are merely roles they play to appear artistic to others. For these individuals there is little authenticity.

In an interview with author David Sidaris on NPR, he recalled a time in college when he was "a cliche of an artist." He dressed how he thought an artist would dress. He carried a sketchbook with him wherever he went. He was enacting what he thought an artist did. And even though he completely believed in his persona at the time, he could see later, when he was older and wiser, that it was only an act.

The awakening artist, however, embodies a fundamental contradiction: His is an artist when he is not one. He is not an artist when his whole attention is completely absorbed in visually exploring the world of thoughts, perceptions and feelings and transforming them into a work of art. He is not an artist in that moment because he does not have a voice in his head proclaiming, "I am an artist looking around at the world right now." Rather, he has disappeared in the act of observation and creation. There is no artist left; there is just the awareness of seeing and expression. In this sense, he is without an identity when he is doing everything an artist does. On the other hand, he must identify as an artist when explaining to others what he does, or when filling out a tax form or insurance policy. Those are situations in which he is not doing what an artist does and yet he must identify as an artist.

Einstein said:

The true value of a human being can be found in the degree to which he has attained liberation from the self.

This kind of artist is not a cliché—he is the real deal. Labeling oneself as an artist is only relevant when someone needs to know about a role you assume, or function you perform. And at other times you play other roles, like motorist, passenger, mother, father, pedestrian, and so forth. The role of artist is just like any other role for the most part, you play it as it is appropriate in the moment. However there is one important caveat to this statement: Even when the artist is a motorist, passenger, mother, father, pedestrian, and so forth, he or she is often viewing the world through artistic awareness. For some artists this continual observation of their daily life becomes the raw material for their creativity.

Common Stereotypes of the Artist

As mentioned above, some of the common stereotypes of the artist are that he is frustrated, egotistic, temperamental, struggling, misunderstood, and a genius. Those are some of the labels that some of us artists have worn in the past, or continue to wear. Now we will look at each label:

When an artist is frustrated he is telling himself and those around him that the frustration is interfering with his creative potential. In fact, he is not accepting the situation exactly as it is. His mind wants it to be different. The awakening artist knows that no matter the situation in one's art or life, it is always the perfect situation in which to allow the creative source to flow.

When the ego within an artist becomes boastful and full of self-importance, it wants those around to think that the artist is important and special. But it is really saying that it is afraid of becoming nothing. Fear of death is always at the root of self-importance because to not be important is it to be nobody, and to be nobody appears to be death from the point of view of the ego.

When the artist is temperamental, he is saying, 'Pay attention to me, everyone. I have strong creative feelings!' In fact he is saying that he has no stillness or peace within.

When the artist struggles, he is saying that being creative is very difficult. He is saying that the art he is working on, or the world in general, is against him. In fact, he has created resistance to the easy movement of the creative flow by insisting that his art, or life, should be in a different state than it is presently. Accepting one's situation as it is allows the creative flow to begin moving. That is not to say that you must tolerate an intolerable situation in your life. Rather, if you carry internal resistance to what is—to what the facts of a situation are, it only creates internal suffering. If a situation is intolerable then allow the creative flow to transform it, which may include removing yourself from the situation.

When an artist thinks of himself as an artistic genius, he is actually yearning to be the greatness he senses within himself. That greatness, however, is far beyond the role of genius; it is oneness with the creative intelligence of the universe.

The Art Instructor

The ego within the art instructor loves to feel important. It wants to feel special, wise, and authoritative while lording over students. Especially since naïve art students are such easy targets for the ego. Students are open, receptive, empty vessels awaiting the wisdom and knowledge of the great master. Their wide-eyed attention, clinging to his every word, furiously taking notes, makes the ego in the role of art instructor feel very special, important, and alive. The ego envisions students telling friends about the great, brilliant, artist they are so privileged to study under. If you find this happening to you as an art instructor then I would recommend that you quickly go out and find a stern Zen master who will smack you up the side of your head with a stick! An art instructor is simply there to offer the knowledge that is

required to make art. The awakening art instructor also includes a non-judgmental environment, and his or her own awakening presence in which students may discover the infinite creative source within themselves.

The Art Student

You do not have to be a prestigious artist or a member of the art world elite to suffer from egoic madness; you can also suffer as an art student. A woman came into the gallery with a large painting she had done, having seen the sign out front that said I offered painting classes. She told me she had been studying with an instructor but she was very unhappy with his teaching method. The instructor would paint on the woman's painting in order to show her how to paint. This is a common practice in art classes, but the woman felt the instructor was only ruining her painting. So she asked me to evaluate the artwork she had brought with the hope of becoming one of my students. So I looked the painting over and it was quite amateurish. But as I usually do, I first pointed out areas in the painting that I thought worked fairly well. As I was doing so I also noticed that the woman was becoming increasingly agitated and finally she interrupted me. She said she would not be able to study with me either because the parts of the painting I was pointing out to be the best were the same parts of the painting that her instructor had 'messed up'. It appeared that she had concluded that if I could not agree with her opinion as to which were the good parts and the bad parts of the painting then I was no better than her instructor. So she gathered up her painting and left. In this case, the woman was unable to accept helpful knowledge even when it was freely offered to her. The ego within some people always has to be right no matter how many experts show that it is wrong.

When an instructor points out that something is either right or wrong, or works or doesn't work, is that being judgmental?

Not at all. You cannot learn any subject without understanding the difference between the correct way and incorrect way. Being judgmental makes the *person* wrong. But a person is neither right nor wrong, a being simply is; though their method of doing something might be right or wrong.

From Frustration to Easy Flow

Frustration arises when we do not accept a situation exactly as it is. For example, when we have an expectation or a demand that the situation should be different but we are unable to change it. Artists feel frustrated when their art is not going right, when their vision of the finished work is not coming together, or their materials are not behaving as expected. Or on the scale of someone's overall life, they may feel frustrated because deep down they feel they are truly an artist but life has not allowed them to pursue it. Then that frustration spills into everything they do and onto those around them. Or they are frustrated because the world, or art galleries, do not understand them and will not give them a break, a chance. But it is all the same. Frustration is the self-inflicted suffering caused by not accepting a situation just as it is. When we do accept it, obstacles may not go away, but they no longer cause us any agony.

Here is a story about Guru Bob that relates to artistic frustration: Occasionally I meet with a group of artists who do life drawing. The job of a life drawing model would seem to be easy. After all, the model just sits there while the artists draw. But the ability to not move a muscle while you are holding a pose is challenging. You cannot daydream or space out because your limbs will start drooping, your position will shift and your torso will begin to unwind. A good model has to remain sharply focused on the muscles and joints in the body. On the other hand, there is Bob.

Delightful Bob gets modeling jobs because he is so old, and there just aren't that many old, wrinkled men out there who are

willing to take their clothes off for people. But artists enjoy drawing the human form and old ones offer their unique challenges, so Bob gets lots of modeling jobs. However, to produce a decent drawing the model needs to hold still, right? Not Bob—who likes to brag that he has been modeling for so long that he can do a twenty-minute pose in ten. Bob fidgets, scratches, adjusts, looks around the room, mumbles and laughs to himself. And when he's not trying to tell a story to the group of artists who would much rather just draw in peace, he falls asleep and starts snoring. How to actually get a good drawing out of Bob's modeling remains a mystery. This can be very frustrating to some of the artists. But I look at old Bob as a teacher, a guru. He teaches us to not demand or expect life to set up every circumstance perfectly for us.

Sleeping life drawing model "Guru" Bob teaching a lesson.

From Jealousy to Learning from Other Artists

The jealous artist has worked so hard and with such dedication to do the best he can. He believes his freshly created works of art are the best work he has ever done and he delivers his work to the art gallery for the upcoming show. But then later at the art opening he sees another artist's work in the show that looks just like his, only much, much better. So he feels jealous. The ego within an artist is incapable of acknowledging that it has anything to learn from other artists. On the other hand, the awakening artist is always open to learning something new from any artists.

When an artist feels jealousy toward another artist's work or success, he is not aware of his own creative authenticity. When you are , you are in your most natural state of creative expression. In that state, if you express what is true of you, there is nothing more you could possibly want. Then you can enjoy viewing the marvelous artwork of other artists, but you would have no desire to be them or to have what they have. Artists who are 'better' than you are your teachers. And even if you are an accomplished artist yourself you can enjoy learning valuable lessons from them.

Fear of Style Theft, or Accepting Creative Abundance

In our society there are laws in place to protect the intellectual property rights of the artist; which means, in essence, that it is illegal to copy another artist's work and then claim it to be your own. However, it is legal to create artwork that is *similar* in style and appearance to another artist's artwork. Having said that, some artists have developed a style that has become popular. Then, awhile later, the artist who developed the style sees that other artists have 'borrowed' their style in order to capitalize upon its popularity. The ego of the originator of the style may feel cheated and victimized. It will protest: "Why can't those other artists come up with their own style instead of stealing mine?" The awakening artist knows that there is no scarcity of originality within the infinite creative source and lets go of identity with any

particular style. There is a lot more where it came from.

Who is an Awakening Artist?

When speaking of the awakening artist I am often asked: How do you decide who is an awakening artist, and who is not? And how do you decide what art is awakening art, and what is not? There is no purpose served by trying to categorize what is, or is not awakening art so that we can *all agree* upon a definition, and then sit in judgment of who is in and who is not. This book is not proposing a concept of awakening art for everyone to accept. Besides being impossible, it would merely be a hypothetical approach to understanding awakening when awakening cannot be known by hypothesis. Awakening can only be known through personal experience. The important question is not who is in and who is out; the important question is: Is there space within *me* for awakening? If you aspire to be an awakening artist then let your first interest be in Being, as artist Morris Graves has taught us. And then be open to learning from art, and artists. They all have something to teach us.

The New Art World

The true potential of museums, galleries, critics, and collectors is to provide a cultural setting for the infinite creative source as it expresses through artists. That is one way that museums, galleries, critics and collectors can participate in the awakening. The world yearns for the art world and their individual and corporate partners to awaken too.

Conclusion

We have looked at the ego as it exists within the art world and in those who play roles in the art world. However, the same madness could be examined in any field of human endeavor. Madness could be examined, for example, in the fields of science, business, education, relationships, financial institutions, politics,

and so forth. What is the purpose of examining the madness and psychic disharmony wherever it shows up? When we are able to observe psychic disharmony without judgment, particularly within ourselves, we are allowing the beginning of psychic healing. To see the disharmony is to be one step removed from it. As more people begin to observe the psychic disharmony within themselves and in the world, the more they will be able to move beyond it and toward awakening.

Chapter 11

Curiosity, Chaos, and Clarity

It could be said that every creative journey begins with a problem. That was certainly true in the advertising agency world where I worked for twenty years. Every new project was another crisis heaped upon a mountain of crises that all *must* be finished a week ago or sooner, or someone would die! I watched many creative people; writers, graphic designers, photographers and art directors thrive in that kind of environment. They may have bitched and complained the whole way but in the end many of them produced outstanding work. Unfortunately I wasn't one who thrived in that kind of environment. As an art director I did outstanding work too, in my opinion, but the whole work environment was depressing. Being involved in completely avoidable mayhem day after day made my heart feel like an anvil. That's why I eventually got out of the advertising business and returned to my artwork.

Creativity is messy sometimes; however, we do not need to add fear and anxiety on top of the mess like so often happens in the corporate world. In the art studio, on the other hand, the creative process can be more harmonious if we want it to be. With this in mind I began observing how my students and other artists engaged in the creative process. I discovered that most experience three basic stages: curiosity, chaos, and clarity. Curiosity is when we are excited and inspired and we are starting out to explore new ideas. Chaos is when the work of art is in an unresolved and disorderly state and we are not sure what to do. And clarity is when it is clear and obvious to us what needs to be done.

The concepts of curiosity, chaos and clarity are not a rigid linear formula. A work of art may typically go from curiosity at

the beginning, chaos in the middle and clarity at the end, but not always. Each phase can overlap and they can go in reverse to some extent. And each phase can be repeated in a single work of art. For example, a work of art could be approaching the finished state (clarity) but then the artist suddenly gets inspired by a new idea (curiosity) and chooses to take the work back into a state of disorder (chaos) in order to explore the new idea (curiosity).

The curiosity, chaos and clarity model may not apply to those artists who believe that struggling through the whole experience is what makes good art. For them the beginning, middle and end are nothing but chaos. I would agree that disorder and confusion are sometimes a part of the creative process. However, to also bring a negative attitude into the experience is a choice, not a necessity.

Curiosity Phase of the Creative Flow

Everyone who finds an interest in creativity enters it through curiosity. It is a characteristic of the creative person. Curiosity is about exploring and discovering. As an artist, you may have explored ideas and techniques and you may have discovered that making art can be a wonderful experience. While you created, the world and all its problems faded away; time vanished and you felt a deep sense of peace as you handled your tools and mediums. Your first work of art may not have been a masterpiece, however, that really didn't matter because the experience was so enjoyable. So you wanted to explore your creativity further.

Creating is enjoyable because it allows the artist to no longer think about anything in the typical analytical way. Analytical thinking is about dissection and categorization whereas artistic thinking is about perception and integration. When an artist asserts analytical thinking, which usually includes self-judgment, into their creativity it quickly becomes a struggle. Artistic thinking, which more aptly might be called perceptual play, is always explorative.

Some people, who have never made art except in childhood, find the idea of making art very compelling. Many people have told me that they have always been curious about making art but have never tried it. Many who do discover their creativity find peace in the seeing and the making of art. They may sense the possibility of discovering something about themselves or of life.

In art making, there is also a sense of adventure, discovery and a possibility of personal healing and rejuvenation. Creating art can transform your awareness, stop time, engage the creative aspects of the mind, evoke a deeper connection with life and bring a sense of fulfillment. This is all part of what I call the 'curiosity phase' of the creative flow. Many students proclaim how wonderful a painting experience is during this phase. On the other hand, many seasoned artists lose their original curiosity because the artistic experience somehow gets reduced to a formulaic exercise. It becomes too familiar. The artist finds his groove and the initial excitement is gone. Many artists have abandoned or forgotten their original curiosity that first inspired them to become artists. It is easy to be drawn away from original curiosity by the arrival of the artistic ego, or the drive for fame and success. An artist may start getting compliments about his or her artwork, and that is encouraging for the beginner. There may be a natural pride and sense of fulfillment from of a job well done, which is all perfectly natural. However, if compliments stimulate ego in the artist this may give him a sense of self-importance or superiority. Then, shortly he may begin removing himself from the natural state of creative curiosity because now his mind has become busy trying to make something, perhaps an identity or a future, out of being creative.

Curiosity certainly drew me into creativity as a young boy. I was walking down the street with my father. We walked past a frame shop and in the window was a reproduction of Van Gogh's *Wheat Field with Crows*. I had never seen anything of such beauty and expressive energy; I was in awe. At my urging we went into

the frame shop so I could see Van Gogh's picture up close. I also saw a kit of watercolor paints and brushes on display so I begged my father to buy the kit of paints for me. He purchased the kit but only on the condition that I use up all of the colors before he would buy any more. In a few months I used up all the colors but yellow so I painted yellow paintings. When my father asked why I was painting only with yellow I reminded him of his condition for buying more paints for me, that *all* the paint in the kit had to be used up first. He, of course, did not remember saying any such thing. Regardless, we went back to the frame shop and bought more art supplies. The curiosity was continuing to build in me.

Egoic curiosity is 'nosey' and wants to meddle in other people's affairs. It wants to find out what is going on so it can formulate opinions. On the other hand, pure and innocent curiosity is like a newborn baby looking around and seeing the world for the first time. Artistic curiosity is looking at the world with openness and without assumption or preconceived ideas. As artist Keith Haring put it: "I'd like to pretend that I've never seen anything, never read anything, never heard anything... and then make something..." The creative flow always begins with curiosity. For creative people, be they visual, literary, or performing artists, curiosity always starts with a blank—a blank mind, a blank canvas, a blank page, or a moment of silence. Then the artist begins to move forth into the creation by discovering and exploring. After a while though, the whole thing begins looking like a mess, which brings us to the second phase of the creative flow, chaos.

Chaos Phase of Creative Flow

Encountering chaos is natural and appropriate in the creative flow. However, what is typically judged as chaos in creativity—what is judged to be a hopeless mess—is not really chaos at all. That is only how the mind sees it. The artwork has been developed and has reached the stage where it appears to be

unsolvable. Most seasoned artists know this phase well. They know that disorder is a natural part of the creative process. It is only when an artists struggles against it does it become painful. However, when it is accepted then it is not a problem. The chaotic stage is universal and is found in every field of human creativity. A building construction site, for example, at a certain point will appear chaotic, muddy and messy. In the process of teaching painting I tell my students about the chaos phase, and then when it arrives we are able talk about it.

The first thing for a student of any artistic discipline to understand about the chaos phase is that it is supposed to be there. It is supposed to look chaotic and it is okay. However, it is not really chaotic, the creation is merely in a temporary state that the mind cannot comprehend. In this phase the egoic mind often becomes activated and will try to convince you that all is hopeless. It will tell you that you are no good, that you are a failure, and that you should just quit! However, if failure is not allowed to be a possibility for you then success cannot be an option, for success and failure go hand-in-hand. When the fear of failure overwhelms us there is no more curiosity and there is no more enjoyment. Occasionally during a class a student will proclaim, "This is awful. I've made a terrible mess." And I will reply, "Excellent, it sounds like your painting is coming along perfectly." I tell my students that chaos is their friend. And this friend is teaching them to continue moving in the creative flow without their mind knowing what is going on or what to do. The chaos phase of the creative flow is a wonderful spiritual teacher. If you are able to observe your thoughts and feelings during the chaos phase then that is an excellent start. The next step is to not take your thoughts and feelings too seriously. Why do students, or anyone in the middle of this natural creative phase, get stressed out? They do so because the ego wants to be in control and now it is not. The ego wants to know which way to go but it does not. It wants to look good in the eyes of others but it does not.

What is really happening, however, is that the creative flow is moving through the artist at a level where the mind cannot consciously participate. So what should the artist do? I tell my students to stop thinking about it. I tell them to relax, breath, and let the eyes and brush do the work. I tell them to go slow, look, dab, be at peace, look, breathe and just keep going. Slowly but surely their painting comes out the other end of chaos and into the light where things become clear. The artist has now entered the clarity phase of the creative flow.

Clarity

The clarity phase of the creative flow is when you are able to foresee the final result before it is finished. Enough hints of line, shape, color and form have emerged through the 'fog of chaos' so that you can see in which direction the artwork needs to go and then you take it there. You enjoy applying the finishing touches, and standing back to view your creation. In the end you may or may not like the results, and either is fine. If the three phases of creativity: curiosity, chaos, and clarity have taught us about the creative flow, then the experience was well worth the effort.

Curiosity, Chaos, and Clarity also describe, in the broadest strokes, the essence of this book because curiosity, chaos, and clarity also correlate to the three stages of the flowering of human consciousness that we have been exploring. By way of analogy, curiosity relates to the innocent art of early humans that we spoke of in Chapter 4. Chaos relates to the psychic disharmony of the egoic art after the Age of Madness began and it continues today. And clarity relates to the possibility of awakening to the spiritual dimension, which transcends human suffering. As you can see, the creative flow not only relates to artistic creativity on the level of the individual, it also encompasses the entire scope of human evolution. Presently, I believe, we are at the end of the chaos phase of human consciousness and potentially entering the clarity phase.

Chapter 12

The Brain, Mind and Universal Intelligence

Your Brain on Creativity

Before we discuss the relationship between the infinite creative source and the human brain, let us consider conventional views of creativity and inspiration. Up until the eighteenth century imagination was considered entirely synonymous with higher powers. People presumed that inspiration came from somewhere else. Now days science points to the human brain as the ultimate source of human inspiration. Scientists are able to measure the flow of chemicals, blood, and electrical impulses in the brain in such a way that reveal patterns suggesting the human brain is intimately involved with creative inspiration.

In recent times scientists have begun to unravel the hidden mysteries of the brain's role in human creativity. What follows is a description of what happens in your brain during moments of inspiration or when new ideas occur to you: Prior to the moment of inspiration there is a decrease in activity in the left hemisphere of your brain, which is the part of the brain that solves problems in a linear and logical fashion. This decrease in activity reduces your brain's ability to assert linear and logical thinking. Simultaneously, the right hemisphere of the brain releases soothing alpha waves that create a calming effect. Meanwhile, the dorsolateral prefrontal cortex temporarily shuts down, which is the area of the brain related to impulse control and intellectuality. This shut down allows you to observe thoughts, feeling and perceptions without judging or analyzing them. Within this tranquil and unstructured mental environment your mind automatically begins searching its memory database for connections and relationships between ideas and experiences. It is as if the mind is randomly searching through a filing cabinet or

surfing the Internet. Eventually, the mind pushes selected thoughts, feelings and perceptions up to the level of your conscious awareness and there is a 'flash of insight' and the recognition of a good idea. According to some scientists, this process is similar to the free flow of thought in daydreaming.

Creativity and Daydreaming

Scientists make a distinction between unconscious daydreaming and conscious daydreaming. In unconscious daydreaming, when the mind is released from a specific task such as driving a car or counting change, it begins its random search of its database for problems to solve or to just have a look around to see what grabs its attention. This produces thoughts and feelings that take a person's attention away from the present and into the daydream.

The same is true in conscious daydreaming but the person, particularly a creative person remains aware of what is happening instead of being drawn away into daydreaming. The creative person is consciously watching for creative relationships between ideas that float up into awareness. Another way of saying it is that when we are in the creative mode our attention is free to observe what the mind is up to. In uncreative moments our attention is too occupied to watch our minds. In that case our minds drag us along unconsciously wherever they wander.

It should be obvious that the insights that the creative person has will relate most strongly to those experiences stored in their memory. It is unlikely that an artist, such as myself, would have any original insights about the arrangement of molecules for a new exotic metal. Nor would a molecular scientist likely dash off a beautiful painting without some prior painting experiences stored in memory.

As we noted earlier, creativity can be used for the betterment of humanity, such as inventing ways to provide water where water is scarce. Or for destructive purposes, such as inventing ways to deposit toxic chemicals into a water supply without

getting caught. However, the brain functions the same way in either case. It doesn't distinguish between good creativity and nefarious creativity. What makes the difference is whether the people using their brains are sane or insane. An insane person will come up with insane creative solutions, and a sane person will come up with sane creative solutions.

Does your Brain or the Infinite Creative Source Create Art?

I have stated that all creative expression has arisen from an innate compulsion to awaken to the infinite creative source. On the other hand, we have brain scientists telling us that artistic inspiration originates in the brain. Who is correct? The answer is that they are two separate topics, though they have a relationship.

The brain is obviously involved in creativity. MRI brain scans have shown a cauldron of electrical impulses occurring in the brain when we are being creative. By contrast, when I say that creativity arises from the infinite creative source, it is a metaphor. Literally speaking, there is no source, or place somewhere *way* out there that is beaming creativity to us, *way* over here. Through metaphor I am communicating that the same creative energy that has created all of life is the same creative energy that is the artist. This same creative essence that you are, naturally uses your brain while creating. The fact that brain researchers have observed the behavior of the brain and its participation in creativity does not make the brain the ultimate source of creativity, it makes the brain a creative instrument for the artist's use. From the awakening point of view, the human brain is participating within a larger creative whole, a larger inspiration.

The Inner Art Critic

One of the biggest obstacles to creativity is self-talk and self-

judgment, whether the talking is internal or spoken outwardly. Like most people, those new to creating art have a continual stream of self-talk going on in their heads. Self-talk and true creativity do not easily coexist. If you observe in yourself self-talk and self-judgment, notice them and let them subside. Perhaps focus your attention on your breathing for a few moments.

I have noticed that students who have the greatest difficulty with their art are the ones who cannot stop talking, either outwardly or within their own heads. The talk is usually about how difficult their experience of creating is, or about anything that will take their attention away from the task at hand. In her book *Drawing on the Right Side of the Brain* (1999), Author Betty Edwards, speaks of brain scientists who have discovered that certain parts of the human brain are dedicated to visual creativity and other parts to critical analysis and verbalization. To a large extent, verbalization and visual creativity oppose each other. From the standpoint of brain function it is difficult to be both visual and verbal simultaneously, except in a superficial way. When I tell my students to turn off the voice in the head while creating, I am not suggesting that they be good, quiet students. I am telling them that good art cannot easily be made any other way. Some manage to make their art while constantly chatting away, they struggle and the end results are rarely satisfying.

In our culture we are conditioned to be predominantly verbal, analytical, and critical. We are encouraged to have opinions and thoughts about everything. However, to be creative, or truly original, our cultural conditioning must not dominate the creative flow. It is not that analytical thinking or verbalization is never used in artistic creativity. There is an important place for it, but if that is the dominant modality then it will surely clash with one's creativity.

Bending Perception

Some artists have advocated taking hallucinogenic drugs as a

way of altering their state of mind in order to move into the creative flow and peer into the spiritual dimension. They believe that the effect of the drugs would pull back a curtain and reveal an extraordinary, magical world beyond. But an altered state of mind cannot see a world that exists beyond form; it can only see the world of form in a different way. Hallucinogens may induce an altered appearance but it is still only an appearance. The spiritual dimension is without form and no amount of hallucinogenic drugs will make it visible.

As a teenager in the late 1960s I experimented with making art under the influence of hallucinogenic drugs that were popular at the time. In one experiment I unrolled a long roll of white butcher paper across my bedroom floor and began painting. At first it began looking quite lovely with hills and trees. Then as I continued painting down the length of paper the drugs started kicking in. I began painting figures in an extraordinary manner, like nothing I had ever seen before. I believed I was accessing a cosmic energy that was expressing figurative images through my brush. I had never seen anything like it. It was truly spectacular. I knew for certain this was groundbreaking art.

I was awakened in the morning by my mother who was demanding an explanation: "What is the meaning of this?!" She was pointing at the butcher paper mural on the floor. She was already suspicious because of some of my other drug-induced art experiments. I dragged myself out of bed to look at the painting. It started out pleasantly enough with trees and rolling hills, then in the middle everything began morphing into strange forms. When you got to the other end, where I had believed the cosmic energy was expressing through me, it was just a bunch of twisted and crude, stick people. Like a child would draw, but not nearly that good.

Mind altering drugs can change the way a person perceives the world. They can twist and bend the illusion of time. They can

even create the sense of being transported into other dimensions, and give one the feeling of seeing into the past or future. That experience, however, is not an awakened experience; it is merely an alteration of perception. It is similar to the hyper-perceptual experience of the artist-shamans that we discussed in Chapter 4. Hallucinogenic drugs are also degenerative of the body and obscure inner stillness. To the awakening artist all perceptions are the same; they are all variations of the illusion of form. The awakening artist is not trying to portray what is beyond, or behind, or prior to form. Rather he or she is allowing the formless to flow through him or her to create whatever form it wishes in the realm of form in the present moment.

Overcoming Conditioned Thinking and Seeing

When graphic designer Milton Glaser first tried to draw a picture of his mother he said:

> I was just sitting in front of her one night and I thought it would be fun to sketch her face, So I got out a piece of paper and a charcoal pencil. And you know what I realized? I realized I hadn't the faintest idea what she looked like. Her image had been fixed in my mind at the age of one or two, and it really hadn't changed since. I was drawing a picture of a woman who no longer existed... That sketch taught me something interesting about the mind. We're always looking, but we never really see.[1]

Although glazer looked at his mother every single day of his life, he didn't really see her until he tried to draw her.

One of the functions of the mind is to simplify and generalize everything that it sees. That is how it aids us in understanding the world. The mind automatically seeks to condense complex ideas, perceptions, and feelings into easily categorized nuggets of information. But within this subconscious function of the mind

there are severe limits. If we are not aware of those limits then we are doomed to experience the world only through simplified and generalized thoughts, perceptions, and feelings that are created not by you, but by your mind.

This automatic function of the mind is easily observed when teaching drawing. For example, everyone knows that a typical window in a building is square, or rectangular. However, viewed in perspective, from an angle and not straight on, the window's shape becomes an irregular four-sided figure in which either only two sides are parallel (a trapezoid), or no sides are parallel (a trapezium). If you ask any untrained person to draw a window in perspective, even if they are standing on the street and physically looking at the window in perspective, their mind will attempt to override what the eye actually sees. The mind will prompt the person to draw the window as a square rather than the trapezoid, or trapezium that the eye factually sees. This is because the untrained mind does not store in its memory trapezoid and trapezium shapes to represent square windows when they are seen in perspective. Rather, the mind simplifies the shape of *all* windows into squares and rectangles no matter from what point of view, or angle, you are looking at the window.

The untrained person attempting to draw a window in perspective will feel the frustration caused by the conflict between what the eye actually sees and what the mind is trying to dictate. What should be obeyed? The person may see clearly that their attempt to draw the window in perspective is not correct. They will see with absolute certainty that the actual window does not appear as a square or rectangle when they really look at it. Yet the mind will do everything in its power to compel the person to render the window as a square. With training a person can learn to overcome their mind's generation of conditioned thoughts. In fact, that is a large part of what art schools are supposed to do. The first step to overcoming condi-

tioned thoughts and images is to recognize them when they arise.

Even very good artists can fall into conditioned seeing and thinking. In Chapter 10 I mentioned a life drawing class that I attended in which old 'guru' Bob was the model. One of the artists in the class was William. He had been drawing the figure for many years and he was considered the best. I studied William's figure drawings and they were truly beautiful. He told me, however, that even though he had been drawing the figure for many years, he doesn't think that he drew nearly as well as he used to. I studied his drawings again and this time I noticed that although William's drawing resembled old Guru Bob's approximate appearance with masterful flair and confidence, they did not really reveal old Guru Bob's beautiful spirit. William had fallen into the same trap that we all have. Rather than seeing the world as it really is, he began drawing from images that had formed in his mind from years of drawing the figure. He no longer saw what was actually there before him in the physical world. William was merely reproducing a generic figure of an old man with flair and confidence.

William teaches a spiritual lesson: The importance of not getting lazy with our attention. He teaches us to stay fully present; otherwise we may come to believe that the spiritual ideas we have, that we can express with flair and confidence, are the real thing.

However, creative thinking originates when we are able to observe conditioned thoughts as they arise. The next time a thought arises from within you ask yourself, is this merely a conditioned thought or am I looking at the matter from a deeper place, an open place? The awakening artist always questions assumptions and allows space for real thinking and real perception to arise.

Great Ideas

In high school I had a great idea to start an art movement. The

idea came to me when my girlfriend Sally and I showed her father some of my oil paintings. He seemed impressed. As he was leaving the room I heard him say something about starting a school of art. What a marvelous idea I thought. To start a school of art like Impressionism or Cubism would be fantastic. For the next few weeks the idea grew. I visualized a group of artists creating some sort of new and strange art form but I couldn't quite figure out how to actually start a school of art. I thought perhaps Sally's father would know so I told Sally that I needed to have a discussion with him. However, whenever I saw him at her house he seemed to be avoiding me; he never had time. After several weeks of my pestering, Sally's father finally said, "Ok, Patrick, what is it that you wish to say?" I said, "A few weeks ago you mentioned the idea of me starting a school of art like Impressionism or Cubism, and I thought that was a great idea. So, I wanted to ask you how I would go about starting one, exactly?" He said, "For Christ sake, Patrick, I thought you were going to ask me if you could marry Sally! You scared the dickens out if me, son. I wasn't saying you should *start* a school of art, I was saying you should *go* to art school." Anyway, that was when the idea of going to art school came to me.

How do we know when an idea is a good idea? In art-making a good idea may come in a flash of insight. It may come simply by choosing to use a different color palette than usual. Or it may come by trying a different subject matter, technique, or concept. Sometimes an artist will have a great idea that he is excited about, and so attacks his creative materials with enthusiasm. Then two days later he looks at his work of art and realizes it was not such a good idea after all. One way of knowing if an idea is worthy is to live with it for a while. Never be in a rush to manifest an idea. If it is a good idea, if it is true of the infinite creative source seeking expression through you, the idea will endure. Also check in with your feelings, your gut, about the idea. What does your intuition tell you? Your body will always

give you honest feedback about your 'great' ideas. A good idea will feel harmonious in your body, your gut. Some highly original ideas may even seem unfamiliar to your mind, yet will feel familiar to the body. As we have noted previously, images and ideas that are aligned with the body's inner universal intelligence will naturally feel harmonious.

The mind alone is incapable of inventing great ideas. To demonstrate this, here is a simple test you can do right now. Within the next 15 seconds try to come up with a great idea. (15 seconds later). Did it work? Did you come up with a great idea? You probably did not because ideas do not come from the mind alone; they also require inspiration. Or, to put it another way, when the infinite creative source expresses through the human mind, the form it takes is what we call ideas. The mind may play a part in the larger creative context but it is not the ultimate originator of inspiration.

Visualization

Astrophysicist Carl Sagan said: "Imagination will often carry us to worlds that never were. But without it we go nowhere".[2] Just because you can imagine your finished creation does not necessarily mean that you should create it. Consider all the crazy things people have made, works of art, inventions and gadgets for no apparent reason other than someone seemed to have been obsessed with thinking about it. They had to make it, they believed, because they thought about it and saw images of it so strongly in their imagination. Then in the end, the created object serves no truly meaningful purpose.

Visualization is a part of creative imagination, but just because something can be visualized with powerful emotions and perfect clarity does not necessarily mean it should be brought into form. If an artist were inspired to manifest everything he could visualize he would become a slave to an endless stream of images in his mind. It's not unlike being driven to build a house just

because you happen to have a hammer. Visualization plays an important part in creativity, but is not a reason to create. It is merely one of the mechanisms by which the invisible is made visible. If you visualize a good idea, let it simmer for a while. Take some notes and make some sketches and put them in a drawer for a few days, or week. Take them out now and then and see if they continue to speak to you. There is no hurry. One of my methods is to pin sketches to a wall. Then later when I glance at them I may get a little "ping" of inspiration.

The creative intelligence of the universe is the same intelligence that has created the human brain and mind. It produces ideas and has created our ability to visualize our world. Now let us see how the creative intelligence of the universe flows into our creativity.

Chapter 13

Moving in the Flow

The creative flow can be a torrent or a trickle. Either way when you are in the flow your sense of self disappears, curiosity emerges, time vanishes, attention is brought sharply into focus and the experience brings satisfaction and fulfillment. The flow is experienced in many kinds of activities, not just in the artistic disciplines. It is experienced in sports, bird watching, mountain climbing, sailing or any activity that fully engages our complete focused attention.

For most people the flow is experienced only in certain limited activities and in special conditions. It is usually experienced in an activity the person prefers and that requires skills and talents the person has. The creative flow is less likely to be experienced when a person has to do something they do not enjoy or do not have the necessary skills and talents to do. The book *Flow*, by Mihaly Csikszentmihalyi, analyzes the flow in detail. The book examines the optimal conditions needed in order to experience the flow and the pleasing effect that the flow has on the human psyche. However, from the standpoint of awakening, the flow is not determined by ideal external conditions as Csikszentmihalyi views it. Instead, the flow is seen as originating from within. Let's put it this way, if you imagine there are only a few special activities that activate the flow in your life, like making art, then you are experiencing flow only occasionally and in special circumstances. If you imagine your life to be miserable then you are not experiencing flow at all. However, if you live at the very source of the flow then the flow will naturally be found in everything you do. There is no expectation that only special circumstances, skills, or talents can give you happiness or the feeling of aliveness. At the source of flow any and every circumstance is

perfectly adequate to experience the flow. Eckhart Tolle has referred to the source from which the flow emerges as the Now. When we are in the Now we *are* the portals for the flow. And the flow, of course, is the infinite creative source that is beyond us, that flows through us, and ultimately is who we are. There is no easier way of entering the flow than coming fully into the present moment, the Now. From there, time dissolves, curiosity arises, awareness sharpens, the mind-made self disappears, and manifesting artistic forms comes naturally and enjoyably.

The artistic creative flow is rhythmic in nature, like a beating heart. The beat is your creative action; the space between beats is inaction. A beat or pulse is a characteristic of all forms of creativity. Music is the most obvious. Dance, which is usually set to music, requires a beat, too. In poetry, even when poems are arrhythmic they usually have a cadence. The same is true in the way words, sentences, paragraphs and chapters are woven together in literature. In theater a good performance will have a pulse to the actors' movements and delivery of lines; speaking and gesturing just at the right moment. In visual art the pulse is found in the physical motions that are required to make the art. Whatever the medium and process, the artist will exert an action, pause to consider it and then exert another action forming a continual rhythm.

Moreover, artistic ideas and concepts are also contained within the pulse of the creative flow. From a place of inner stillness ideas naturally arise and subside. Creative thinking is rarely continuous because ideas and realizations usually come in waves. Each wave of usable thought is added to other related thoughts worthy of keeping and in this manner an overall concept eventually emerges. Between each thought is no thought—nothing. The creative flow that pulses through the artist's creativity is the same pulse that beats the artist's heart, that brings day and night and the four seasons. It is the same pulse that gives birth to stars and galaxies. It is in this one,

universal creative flow that the artist is participating. It is from this foundation that we will now look at the creative flow specifically as it relates to artistic creativity. And as we have already noted, the difference between the creative *process* and the creative *flow* is this: The creative process relates to the tools, techniques, and mediums an artist uses, whereas the creative flow relates to the artist's experience while creating. There already exists an enormous amount of information about the creative process available in books and online; however, our task presently is to explore the creative flow while creating.

Preparing to Create

The early Japanese Zen Sumi-e painters would meditate before they painted. In this way they would prepare a space within themselves for the creative flow. Meditation may or may not be the method for you; however, some kind of transitional preparation is usually necessary for artists before they begin creating. Before virtuoso cellist Yo Yo Ma goes on stage, he sits quietly in a room for about a half an hour. When he emerges he is known to be jovial, kidding, and playful with the people backstage just before walking out to greet his audience. With this technique he centers himself in stillness in his room, then loosens up by being playful so that his music is spontaneous and alive.

Not many visual artists can walk into their studio and immediately start creating. A transitional phase is usually needed to move from one's daily routines and into the creative mode of being. Some of my students come into my evening classes after a long day of work and they have driven across town during rush hour. They circled the neighborhood looking for a parking space and when they finally get to the studio there is a big exhalation. Finally they have found a place apart from their hectic world. They have entered the transitional phase, between the high-energy activity of a workday and the solitary quietude of making art. If this describes you, be aware that this transitional phase is

natural and needs to be honored. The duration of the transitional phase is different for each person. For some it is only a few minutes, for others it may take a half-hour, or more.

I prepare by spending time doing small tasks like organizing my brushes or sweeping the floor. I find the rhythmic 'swooshing' sound of a broom against a floor to be very enjoyable; it is similar to the sound of a paintbrush stroking canvas. Then I may review my sketches, look at the canvas whether it is blank or in progress. I will sit in stillness for a while, look at my sketches again, and select the colors I intend to use, drink some water and look at the canvas some more. Eventually I will find a single place on the canvas that is wanting something, perhaps a daub of color, a new line, a change of shape, or a refinement or loosening. I will listen with my eyes to see what the painting is asking for. Then I will pick up a brush and be on my way. This transitional phase is a very important part of entering the creative flow and needs to be respected and enjoyed; it sets the tone for what is to come. If your creative time is limited and you feel rushed, then already you are out of sync with the creative flow. But even in these situations it is vital to come into the place of stillness first and to be anchored there, before turning on the afterburners.

Comfortable Working Environment

George Inness' studio was sparse. Before he became famous he painted in his barn for many years. His barn-studio was unadorned unlike photos of art studios of that era with fashionable Asian rugs, European antiques and prints of the old masters paintings... In his barn-studio there were only his easel, a chair, and a small table for his painting supplies. It was as if he had walked into his barn, set up his gear, started painting and never gave a thought to his working environment, although he did provide a bale of hay to sit on for visitors who came to visit him. Inness was so driven by his creativity that the environment

he worked in simply did not matter. Unless you are a dynamo like Inness you will probably want to pay attention to your working environment.

Being creative is challenging enough without the addition of neck pains, backaches, or repetitive motions that bring about carpal tunnel syndrome. For this reason you want to make sure your creative space is always set up comfortably and ergonomically, so no physical discomforts distract your attention. Some artists play music while they work. Slow tempo music can put you to sleep and high-energy music can sometimes be too stimulating. I work mostly in silence, but occasionally with whatever music fits my mood. Find what is right for you, pay attention to how the music feels, how it complements your inner state.

If you have a large, well-lit studio in which you can spread things out, that is wonderful. Some artist studios even have a kitchenette, couch and coffee table area to sit, relax and socialize with friends. It would be wonderful to have such a studio but if you do not then know that the creative flow can be experienced just as easily in a small studio.

As a child, I was quite content to paint on my bedroom floor. In adulthood my first art studio was 5 ft. by 7 ft. (1.5 m x 2 m) and I shared it with a washer and dryer. I placed a drawing board between the two and that became my worktable. If anyone left the house by way of the back door I would have to pick up my stool and leave the room in order for the person to pass through. The washer would wobble during the spin cycle causing all my supplies to bounce around on my drawing board. Nevertheless, I recall the studio with fond memories, and I remember producing many paintings that I was quite proud of there.

My first studio was large compared to a friend's. His studio is only 36 inches by 48 inches. (1 m x 1.2 m) Furthermore his studio is in constant motion, rocking back and forth. His studio is on a sailing yacht that he and his wife use to travel the world's oceans. On a sailboat there is very little surplus space. His paintings are

stored under their mattress, and his painting supplies are wedged into any nooks and crannies he can find. Remarkably, this limited art studio condition has not prevented him from producing outstanding works.

The size of your workspace is not all that important, other than the fact that it will affect the size of the art you create. Clearly, if you only have a corner of a kitchen table to work on, you will most likely not be creating very large works. Most important, however, is that a small workspace cannot diminish the creative flow, nor can a large studio increase it. What counts is the attention you bring to your art regardless of its size.

Boredom

When artists get bored while creating they sometimes project an internal state onto their creation. They think the art is not going well and has lost its appeal. More often it is because their attention span has been overextended. If a work of art ever seems boring, the first step is to not blame it for your experience. A work of art cannot stimulate boredom in a human. Then check to see if you have been taking breaks, which provide relief from excessive concentration.

Closely related to boredom is impatience. Some of my new students say they do not have the patience to work for long periods of time to do a complex work of art. To others, however, taking on a complex project is an exciting challenge. Patience implies tolerating time. In other words, asking someone to be patient is asking them to be tolerant of time. It is trying to maintain a good attitude while wanting to be somewhere else. The hungry mind is always eager to move on to the next thing. But the awakening artist knows that creating any work of art, simple or complex, never requires patience because time does not exist in the creative flow, there is just creating. If you ever feel impatient, the first thing is to always notice the feeling. Observe the feeling of wanting to move on, wanting to get away. To the

extent possible let go of impatience and simply observe your artwork in the state that it is in without wanting to go anywhere. Let the moment be okay just as it is.

Boredom and impatience also relate to the fact the student has not yet learned how to hold his or her attention for any length of time, so looking at the piece for more than a few minutes becomes unbearable. In this case it would be good to learn the art of concentration.

The Art of Concentration

A short attention span is a disease our society has cultivated through TV, advertising, and other media, especially in the formative years of childhood. The media industry knows that excitement, novelty and rapid-fire images draw in our attention. However, they do not require our concentration. Popular TV watching, for example, invites *passive* involvement with its content, whereas artistic concentration invites *active* involvement.

One way to increase your ability to concentrate is to practice contour drawing. It is to the artist what meditation is to the meditator, or at least they are cousins. A contour drawing uses a line to define the edge of a form. Contour drawing helps you to develop sustained singular-minded attention. The skill of concentration can later be applied to anything requiring your active awareness.

In art school it was common for a drawing instructor to set up a complex still life for students to draw. It might contain deer antlers, chains, empty egg cartons, an anchor, half of a soccer ball, bicycle wheel, toy robot, pitcher, stool, hub cap, plastic fruit, Japanese fan, a wooden "R", old telephone, a shoe, pipe valve, auger bit, and dozens of other random objects. All painted white and thrown into a large pile. They were all painted white so the student would focus of the form of the objects without getting distracted by their color. The instructor would say, "Ok, start drawing." For me, in addition to learning how to draw, the

exercise became a personal challenge to increase my skills of concentration. It is normal for an artist to draw thirty minutes to an hour or so, and then take a break. However, I imposed upon myself the goal of not taking any breaks for two or three hours at a time—not even to look away from the white pile of stuff. If my attention started to wander, I caught it and forced it back to the pile. If my drawing started getting lazy, I would redouble my effort to draw perfectly. If my eyes started glossing over details, I required them to focus in tighter to see every nuance. If I started to yawn I would suppress it and look even harder at the pile through watery eyes. I did this many times. It must have worked because after that I could attend the most boring, pedantic lectures in the world and easily sit there for hours, bright-eyed and attentive long after others had fallen asleep or given up and gone home. (That's not to say that I understood the lectures any better than others, it just means I could look at the lecturer longer). I would not recommend that you go to the extremes that I did in order to develop your concentration. However, a less austere approach to contour drawing is very helpful in developing this important ability.

Never Hold Back, Always Come Fully Forward

Coming fully forward means showing up. It means being completely open, receptive, focused and alert. It means putting in the time it takes to develop skills and abilities.

We must come fully forward in every creative act and never hold back. Allow the power, beauty and fullness of who you truly are to pour forth with absolute assurance into your creation. If you do sloppy, or merely adequate work, thinking that nobody will notice, you will be wrong. If you think that attention to detail is not important, you will be mistaken. You may be handling a brush, a torch, duct tape, rocks, thread, gold, a spray can, a computer keyboard but know that the quality of your presence will show through in your work of art in the end.

In contemporary art it is common that tools and materials are sometimes handled without much regard because it is believed that the overall concept of the final work is more important than the manner of its creation. As mentioned earlier with the Impressionists, they loosened their painting technique because they were fed up with the fussy and exacting methods of the classical painting tradition, with its stifling overemphasis on proper technique. The Impressionists were one group of artists who broke loose of that suffocating tradition. They wanted to feel and express the life they saw, the beautiful effervescence of light and color that can only be expressed with a more spontaneous painting technique. Eighty years later, in the 1950s, the Abstract Expressionists were throwing and dripping their paint because to them it represented the spontaneity of the unconscious and expressed their existential struggle. Even here there was a deliberate intention in how they handled their materials. It was wild for a reason. Handling your materials with attention is not necessarily saying they must be handled preciously, though that might be the case sometimes. Whatever you do, remember that there is never anything you do that is irrelevant. Everything you do to, in, or with your creation matters. Your presence, or the absence of your presence, will be evident in the final work of art.

Manifesting Original Creations

Woody Allen once said: "If you're not failing now and then, it's a sign that you are not doing anything very innovative." When I began painting in watercolors I wanted to capture the essence of a bell pepper in only a few brisk brushstrokes. I finally accomplished this but it took hundreds of attempts. However, there was no struggle or frustration involved, each try was accepted for what it was, until finally one bell pepper arrived that resembled, or was better than, the one in my imagination.

Some artists have a peculiar relationship with struggle. Normal struggle is when we fight against a situation that is not

cooperating with us. Artistic struggle is a belief that the artist *must* fight against something whether that be his tools, mediums or concepts. For these artists, struggle is believed to be an essential ingredient in their creative process. They believe they are able to overcome self-limitations and bring forth truly authentic works of art through their struggle, and sometimes they do. However, it could be debated whether struggle was really necessary. Perhaps what they interpret as struggle is really the natural experience of creative intensity. When I speak about enjoying the experience of making art some artists have no idea what I'm talking about. To them I would pose this question, does your struggle contain negativity toward your process? Or is your struggle a welcomed strenuous challenge? If there is negativity then you are only causing suffering for yourself and it is not contributing to your creativity. I would suggest that negativity only gets in the way. However, if your struggle is a welcomed strenuous challenge then all of the chaos and obstacles that come with it can be welcomed as part of the process and not fought against. And let us be honest, the misery and suffering that artists experience could be viewed as somewhat mild compared to the sever suffering that can be found in the world today.

When we are working with an original idea, trial and error is natural because we are attempting to do something that is as yet unknown. Originality requires that we be comfortable with the unknown. In this regard, errors are not mistakes. A mistake is having done something incorrectly, but we can only do something incorrectly if we know what correct is in the first place. For this reason each adjustment, reversal of direction, or erasure, can be a fascinating exploration for the truly creative person.

It would be wonderful to be able to step up to the plate the first time you ever played baseball and on your very first swing, rocket the first pitch out of the ballpark. But it doesn't happen. Some art students have an expectation of instant mastery too.

They want to create a masterpiece—now! But it is simply not possible. An essential part of mastery is making thousands of mistakes along the way. Each mistake teaches us something new and our mastery grows slowly and inevitably. Problems and obstacles are what enable us to grow. If nothing ever pushes against us then we never build strength, knowledge, and experience. At the height of Beethoven's mastery his scores were still scratched, reworked and altered many times over before they were finished. Da Vinci made hundreds of sketches before painting one of his masterworks, *The Last Supper*. Mistakes, false starts, and redirections are normal, even for geniuses.

The Assembly Line Artist

You have sold a few of your works and have suddenly realized that you could make money by doing something you love. You plan to get into several art galleries, do art fairs, sell your art online, and license images of your art to publishing companies. You believe it would give you an income and provide enjoyment to others. The problem arises when making money becomes the dominant motivation for being creative. Making your art can quickly turn into an assembly line. You soon find yourself creating works that you have no personal interest in but you know will sell. The original magic of creativity is gone and the situation you have created is just like any assembly line job. Some artists thrive in that type of environment. The question is: Are you happy doing so? Is it joyful and fulfilling? Many career artists understand very well that the world of commerce is not always compatible with artistic creativity. Artistic creativity operates without regard to time, without a schedule, and without pandering to the tastes of the market. Nevertheless many career artists have succeeded financially and have gained art world status under those conditions. However, commerce today only knows the bottom line and does not recognize, understand, or appreciate the natural and easy creative flow of life. If you intend

to make a career out of your passion for art, know what you are getting into.

Creative Blocks

If you temporarily lose your direction in your artwork and it looks messy, unresolved, or confused, know that this is a normal experience in creativity. The same applies to creative blocks. A creative block is when an artist gets stuck in their direction as an artist. In other words, they do not know which way to go with their art, or how to get started. A creative block is the same as the chaos phase and the way to move beyond it is the same. A creative block has no real existence; it is only an opinion about your situation. The opinion says, "I am stuck, I am confused." Whenever that happens consider that life's creative intelligence is taking a moment to breathe and you are being invited to stop and breathe with it. Books are full of suggestions for overcoming creative blocks and many are helpful; for example, taking walks, journaling, doing other non-art related activities such as listening to music, playing with your dog, walking or hiking. These are useful activities to help you clear your head so you can return to your studio fresh. However, keep in mind that any effort to overcome a creative block can also strengthen it. As the saying goes "What you resist persists." The block is telling you to stop, to be still. The mind only wants to go forward and produce and produce because that is considered admirable in our world today.

Consider this: Can it be okay to not know what to do? Can it be okay to not do anything? Can it be okay to never make another work of art again? Art making is enjoyable but if it does not bring you happiness or a deepening experience of life then why bother? It is okay to let it go. There are many other enjoyable things to do in life. There are many artists who would actually be far happier doing something else, but they have a rigid notion that they must be an artist no matter how much pain

and suffering it causes them. On the other hand, there are probably many people who would discover a field of wonderful self-expression if they would only follow their inner urge to explore their creativity. Remember, the creative flow is happening everywhere all the time. It is, after all, the endless expression of Life and there is no limited supply.

Burnout

Burnout can also come from the feeling that no matter how hard you try you just can't get anywhere. Once, I was showing my artwork at an art fair and another exhibitor came over to talk. She was an artist whose beautiful watercolor paintings I had always admired and she was trying to make a living as a professional artist. She told me how hard it was to make it and how burned out she felt from always pushing but never being able to quite succeed.

This is the story of many artists, even if their artwork is outstanding. They pour their hearts out but get nowhere. Galleries alone never seem to be able to sell enough for an artist to survive on. Doing art fairs offers no guarantees of profit and requires extraordinary stamina to haul artwork and a display booth all over the country. It is not surprising that so many artists who attempt to make a living from their art finally hit a wall and are forced to acknowledge that it is just too difficult.

It is important for an artist to recognize if the desire to become a professional artist has arisen naturally. Ask yourself: Is it a clear and obvious direction that life seems already to be moving in? Is being a professional artist a fantasy that you are leaping for, like trying to grasp a shooting star.

You are fortunate if you do not have to earn a living from the sale of your artwork because it allows you to explore creativity without the added pressures and preferences of the marketplace. By functioning in the market place a professional artist is choosing to be involved in a commercial business. If you want to

be a professional artist then ask yourself if you also want to be a commercial retailer, wholesaler, bookkeeper, advertising manager, sales manager, employee manager, office manger, errand boy or girl, and janitor. As a professional artist you will have to perform all the myriad duties that any business has to perform in order to survive in the marketplace. If operating a business is not your passion, and you are unable to have others do it for you, then all that work, in addition to making art, makes burnout inevitable.

Additionally, burnout usually occurs because the artist has pushed him or herself beyond their physical, emotional and mental limits. The artist has knuckled under and pushed on by ignoring the dread their body feels from working late into the night when their eyes just want to sleep. They do not hear their body crying for rest. They do this all because the goal of being a successful artist in the future appears more important. But the worst thing is, after going through all the sacrifice and suffering they discover that nobody, or very few people, want to buy their art. It seems hopeless, so what does one do? Burnout comes from using the creative flow as a means to an end, rather than as an end in itself. The creative flow is being used merely as a way of obtaining success in the future. It has been forgotten that participating in the creative flow is itself the fulfillment of creativity.

Once you are burned out, though, there is no way around it; your body's natural intelligence has said enough is enough. If that means you must stop forcing yourself to make art for a month, a year, or ten years then that is what you must do because you can never reenter the creative flow based on will power.

Stopping Time to See the World

Artists see the world a little differently than most other people. They see the world through 'artists' eyes'. The first step in seeing the world as an artist does is to 'stop'. Whenever we see something that moves us deeply, whether we are aware of it or

not, we stop thinking for a moment. We become still. For some the experience is brief; for others it lasts longer. Either way, when our attention is stopped and we are in stillness, the world appears differently than when our minds are constantly in motion. Most people are not aware of it but when they look out upon the world they are actually seeing a blurry image compared to the way a perceptive artist sees. The world may not seem blurry to most people and they may swear that it appears normal and clear. From the place of inner stillness, however, the old normal way of seeing could only be described as blurry.

Consider this metaphorical story about seeing: God created the world but in order to see the world for Himself He created eyes. But when He put them on and looked into the world through them He saw a smeared, blurry image of fast moving shapes and vague impressions. He knew (from lots of experience) that He did not intend to create the world as a blur so something was clearly wrong. He went back and checked his world-making manual and confirmed that, yes, He had indeed created the world correctly and it was not supposed to be blurry. It was supposed to be beautiful, a garden of paradise. Then it became apparent that the mind He had created through which to perceive the world was out of control. It was under severe stress due to the extraordinary pressures of its manufacture. Because of the resulting malfunction the mind's attention moved constantly from one thing to another. Its endless compulsive thinking caused the human eyes to dart around spasmodically and so violently that they created the illusion that the world was blurry. To fix this God created, among other individuals, artists who would make images of the world so that through them He could see what the world truly looked like; the garden of paradise that He had intended.

Related to this, Einstein was so slow at learning that he was considered mentally challenged. However, later in life he claimed that going slow simply allowed him to see things that others

glossed over. The point is that the first step in true artistic seeing is to stop. Just as the first step in really looking at a work of art is to stop in front of it. So, too, the mind and emotions have to stop, if only for a moment, in order to see the world as it really is. In fact, one of the few common characteristics of all art throughout the ages is that it stops time in the awareness of the viewer. First, the artist must stop to see the world as it really is, and then the viewer must stop to see what the artist saw through the art. One of the characteristics of human madness is the inability to stop thinking, doing, and fidgeting. But when we stop, true seeing occurs naturally and the creative flow can begin to move.

Is Being Prolific a Good Thing?

Producing volumes of art has never produced better art or artistic greatness. For Picasso, for example, the creative flow was a torrent and he produced well over 20,000 works of art in his lifetime. However, no respectable art historian would ever suggest that the quantity of his output was what made him great. It was his bursts of inventiveness that made him great. On the other hand, for Vermeer the creative flow was like a gentle stream and he produced only about 35 paintings in his lifetime. However, the small number of paintings did not prevent him from becoming one of the world's truly great artists.

Afterword

The Problem with You Being God

I have stated that the artist and the infinite creative source are ultimately one. I have also stated that works of art are expressions of that creative source. Sometimes the artist has been transparent to the creative source flowing through him, or her. Other times the egoic insanity within an artist has conditioned the artist's creativity.

The idea that the artist has a relationship to that creative source, or to God may be difficult to grasp. Picasso spoke of this:

> We ought to be able to say that word, or something like it, but people would take it the wrong way, and give it a meaning that it doesn't have. We ought to be able to say that such and such a painting is as it is, with its capacity of power, because it is "touched by God". But people would put a wrong interpretation on it. And yet it is the nearest thing we can get to the truth.[1]

Picasso recognized the difficulty in using the word God when discussing creativity. In previous chapters we have explored the limitations of the word God. I have sometimes used other phrasing such as the Tao, the creative intelligence of the universe, the impulse to evolve, the infinite creative source, and Being. Ralph Waldo Emerson called it the "Oversoul". These are metaphors that point ultimately to the reality of your creative being.

One reason that the reality of your creative being cannot be communicated easily in words is because language is inherently contradictory. Which means that everything that is said infers its opposite. This infers that, here infers there, black infers white, up

infers down. This applies equally to the concept of you. The concept of you infers all that is not you. Your concept of you could not exist without the concept of that which is not you. The duality of language is also evident when we think. Scientists have shown that our thoughts are formed by language therefore thoughts are dualistic too. Of course, if one felt the need to do away with language-duality one could choose to not use language; simply enjoy quietness.

This brings us to the problem of trying to explain to someone that they are one with the infinite creative source. If I were to say, "You are one with the infinite creative source." that thought would automatically create the opposite thought that you and the infinite creative source are separate. Because the phrase makes it appear as though you are here and the infinite creative source that you are supposedly one with, is over there. The phrase "you are one with the infinite creative source" expresses the idea of oneness and separation simultaneously. Furthermore, the phrase presumes that you know who you are in the deepest sense, and what the phrase infinite creative source signifies. Moreover, when we compare our concepts of ourselves to our concepts of the infinite creative source we may find they have little in common. In such a case, suggesting that a person is in any way a divine being would seem silly if not sacrilegious. However, the problem is not that our concepts about the infinite creative source and ourselves differ. The problem is that we believe in our concepts. If we do not hold a concept of ourselves or of the infinite creative source then the two cannot be separate because there are no concepts distinguishing them. If that is the case, then you and the infinite creative source are one. The way to begin knowing this is to practice holding that non-conceptualized knowing within your awareness without clothing it in words or thoughts. Then you may begin to sense that you and the infinite creative source are one.

Does Size Count?

Some people wonder, if there was a God, why would He, She or It care about insignificant human beings who are virtually nothing relative to the scale of the universe? I would agree that humans are virtually nothing. They are not only tiny relative to the scale of the universe; they are also made mostly of the empty space between atoms. My question is, however, how did we come to the conclusion that God, whatever that word signifies, is impressed with large dense objects? To say that God is big and mighty and humans are small and insignificant is not really a statement about God and humans, it is about the human concept of scale. The notion of scale exists only in human thinking. A sparrow does not perceive itself as small relative to the universe. A whale does not think of itself as large relative to a sparrow. I doubt that whatever the word God signifies would perceive large as important and small as insignificant. However, what is significant about humans has nothing to do with their scale and everything to do with consciousness. As Carl Sagan suggested, the universe is becoming conscious through humans. However, it is not because we are special that the universe seeks consciousness through us, it is because we happen to be evolutionarily available.

From Awakening to Awakened

Many artists have sought to bring universal consciousness into their art, some have been more sharply aware of this than others. However, there has not been a singe art movement that I am aware of, in which universal consciousness, or Being has been the core message of the movement. As more people awaken it seems inevitable that their art will begin to reflect, brighter than ever, an awakening culture.

It would be naive to attempt to create an ultimate definition of awakening art that we can all agree on. To do so would only reduce a vast universal expression into a limited mental

construct, which this book has sought to overcome. However, I feel comfortable offering my view of awakening art knowing fully well that it is only my personal observation and other artists may come along with ways of looking at it that I have never considered. That's the beauty of it.

To me, awakening art is inspired by curiosity and wonder. It is explorative and playful. It may be enjoyable, even if challenging. It demonstrates focused attention. It is concerned with perception, beauty, truth, and the 'isness' of the present moment. It does not try to fit into or please the old egoic consciousness of the art world. Though it might use styles and trends of past eras, the awakening light will always shine through the art and artist. It is never merely a product. It expresses the artist's inner depth. It may confront our assumptions and jolt us out of our slumber. It acknowledges the aliveness of every subject and demonstrates love and respect for the environment, all of life, and for oneself. And ultimately, awakening art is transparent to its origin. That origin is the same creative source from which all life springs. These are a few ideas and pointers for the awakening artist to ponder. What awakening art may look like to you is for you to enjoy exploring. However, more important than defining awakening art, is to explore the depths of Being for yourself. And out of that depth, creative forms that reflect Being will naturally arise.

The Awakened Artist

When we use the word 'awakening' in the spiritual sense, we are referring to a gradual process toward spiritual wakefulness. The strength of the word awakening is that many readers are already experiencing spiritual awakening so they may relate easily to what the word means. From another point of view, however, the belief that we are in a gradual awakening process will, sooner or later, separate us from the actual awakened state. As long as we believe that we are traveling a long road toward an awakened

state we will never arrive there because we are imagining it to be in the future. We imagine it to be where we are not. Therefore, true awakening can only happen in the here and now, where there is no process or time.

The word 'awakened', on the other hand, describes your true state of being. There is no process or gradual movement toward anything. The awakened state is here and now. However, when the ego in us hears that, it will seek to block the beauty and simplicity of that truth. The ego will insist that the awakened state, if it exists at all, is one of sublime perfection that only a few rare individuals are capable of. This view can make the awakened state seem unobtainable. The egoic mind likes awakening to be unobtainable because it deflects the inevitability of its own dissolution. And what is left when the ego, the madness, finally dissolves here and now? What is left is only you, the infinite creative source—the awakened Artist.

Notes

Introduction

1 Robert Henry, *The Art Spirit* (New York: J.B. Lippincott Company, 1923) p.19.

Chapter 1: The Awakening Artist

1 David Sheff, *Keith Haring, An Intimate Conversation*, Rolling Stone, August 10, 1989: http://www.haring.com/archives /interviews/index.html (site last accessed by P. Howe, September 20, 2012).

2 Lewis Hyde, *The Gift: Creativity and the Artist in the Modern World* (New York: Vintage Books, 2007) p. 186.

3 William C. Seitz, *Mark Tobey* (New York: The Museum of Modern Art,1962) p. 22.

4 Wulf Herzogenrath and Andrea Kruell, Eds., *Sounds of the Inner Eye* (Seattle: University of Washington Press, 2002) p. 38.

5 Roger Lipsey, *An Art of Our Own* (Boston: Shambhala,1988) p. 355.

6 Ibid., pp. 18-19.

7 Joseph Campbell, *The Inner Reaches of Outer Space* (Novato: New World Library, 1986) p. 89.

8 George Rowely, *Principles of Chinese Painting* (Princeton: Princeton University Press,1970) p. 77.

9 Stephen Nachmanovitch, *Free Play: Improvisation in Life and Art* (New York: Tarcher, 1971) p. 30.

10 Conrad P. Pritscher, *Einstein and Zen* (Bern: Lang Publishing, 2009) p. 11.

11 Lipsey, *An Art,* pp. 415-416.

12 *Cosmos: A Personal Voyage, Episode 1: The Shores of the Cosmic Ocean,* creat. Carl Sagan, et al., perf. Carl Sagan, VHS, PBS affiliate KCET, 1980.

13 Joseph Campbell, *Thou Art That: Transforming Religious Metaphor* (Novato: New World Library, 2001) p. 36.

Chapter 2: Seeing Beauty and Telling the Truth
1 Herzogenrath, Kruell, Eds., *Sounds,* p. 38.
2 Roger Lipsey, *An Art of Our Own* (Boston: Shambhala,1988) p. 17
3 Ronald Parkinson, *John Constable: The Man and His Art* (London: Victoria and Albert Museum, 1998) p. 15.
4 Andy Karr and Michael Wood, *The Practice of Contemplative Photography: Seeing the World with Fresh Eyes* (Boston: Shambhala, 2011) p. 6.

Chapter 3: The One Art Movement
1 Eckhart Tolle, *A New Earth, Awakening to Your Life's Purpose* (New York: Penguin, 2008) p. 1.
2 Steve Taylor, *The Fall: The Evidence of a Golden Age, 6,000 Years of Insanity, and The Dawning of a New Era* (New Alresford: John Hunt Publishing, 2005) p. 32.
3 Ibid., p. 5.
4 Ibid., p. 104.

Chapter 4: Learning from the Art of Innocent Humans
1 Taylor, *The Fall,* [page #?]
2 Ibid, p. 132.
3 Ibid., p. 47.

Chapter 5: Egoic Art of Ancient Civilizations
1 Eugene Strouhal, *Life of the Ancient Egyptians* (Norman: University of Oklahoma Press, 1992) p. 166.
2 Taylor, *The Fall,* p. 81.
3 Ibid., pp. 106-7.
4 Phillip Ball, *Bright Earth: Art and the Invention of Color* (Chicago: University of Chicago Press) p. 200.

Chapter 6: From the Renaissance to the Hudson River School

1 Ross King, *Michaelangelo and the Pope's Ceiling* (New York: Penguin Books, 2003), p. 59.

2 Genesis 2:7, King James Version

3 George Rowely, *Principles of Chinese Painting* (Princeton, Princeton University Press, 1970) p. 36.

4 Michael Sullivan, *Symbols of Eternity* (Standford: Stanford University Press, 1979) p. 2.

5 Jack Weatherford, *The History of Money* (New York: Three Rivers Press, 1997) p. 105.

6 Howard Zinn, *A People's History of The United States, 1492- Present* (New York: Harper Perennial, 1995) p. 3.

7 Ibid., pp. 123-124.

8 Coleman Barks, *The Essential Rumi* (San Francisco: Harper San Francisco, 1995) p. 122.

9 Thomas Cole, "Essay on American Scenery," *American Monthly Magazine,* n.s.1, January 1836, 1-12

10 Ibid., 1-12

11 Adrienne Baxter Bell, *George Inness: Writings and Reflections on Art and Philosophy* (New York: George Braziller, 2007) p. 152.

12 Ibid., p. 39.

13 Ibid., p. 79.

14 Ibid., p. 67.

15 Ibid., p. 91.

16 Adrienne Baxter Bell, *George Inness and the Visionary Landscape* (New York: George Braziller, 2003) p. 43.

Chapter 7: Modern Art

1 *National Gallery of Art,* September 2008, http://www. nga.gov/exhibitions/2006/dada/cities/index.shtm (site last accessed by P. Howe, September 20, 2012).

2 "Dada," *Wikipedia,* http://en.wikipedia.org/wiki/Dada (site

last accessed by P. Howe, September 20, 2012), reference: Fred S. Kleiner, *Gardner's Art Through the Ages* (Beverly, MA, Wadsworth Publishing, 2006) p. 754.

3 Tolle, *A New Earth*, p. 194.

4 "Abstract Art," *Wikipedia*, http://en.wikipedia.org/wiki/Abs tract_art#cite_ref-14 (site last accessed by P. Howe, September 20, 2012), Reference: Anna Moszynska, *Abstract Art* (London: Thames and Hudson, 1990)

5 Wassily Kandinsky, *Concerning the Spiritual in Art* (New York: Empire Books, 2011) p. 25.

Chapter 8: Abstract Art in America

1 Tom Wolfe, *The Painted Word* (New York: Bantam Book, 1975) p. 74.

2 Harold Rosenberg, *The Tradition of the New* (New York: Da Capo Press, 1994) p. 30.

3 Seitz, *Tobey*, p. 40.

4 Ibid., p. 10.

5 Ibid., p. 27.

6 Ibid., p. 45.

7 Ibid., p. 45.

8 Ibid., p. 47.

9 Deloris Tarzan Ament, "Graves, Morris (1910-2001)," *HistoryLink.org*, 2003: http://www.historylink.org/index.cfm?DisplayPage=output. cfm&File_Id=5205, (site last accessed by P. Howe, September 2 0, 2012).

10 Ibid.

11 Herzogenrath and Kruell, Eds., *Sounds*, p. 38.

12 Lipsey, *An Art*, p. 330.

Chapter 9: The Transformative Power of Art

1 Lipsey, *An Art*, p. 115.

Chapter 10: Madness in the Art World

1 Dr. Mike O'Mahony and Karen Fitzpatrick, *World Art, The Essential Illustrated History* (London: Flame Tree Publishing, 2007) p. 13.

2 Tom Wolfe, *The Painted Word* (New York : Bantam, 1999) p. 57.

Chapter 12: Moving in the Flow

1 Jonah Lehrer, *Imagine: How Creativity Works* (Boston: Houghton Mifflin Harcourt, 2012) pp. 68-69.

2 Carl Sagan, *Cosmos* (New York: Ballantine Books,1985) p. 2.

Afterword

1 Lipsey, *An Art*, p. 19.

BOOKS

O is a symbol of the world, of oneness and unity. In different cultures it also means the "eye," symbolizing knowledge and insight. We aim to publish books that are accessible, constructive and that challenge accepted opinion, both that of academia and the "moral majority."

Our books are available in all good English language bookstores worldwide. If you don't see the book on the shelves ask the bookstore to order it for you, quoting the ISBN number and title. Alternatively you can order online (all major online retail sites carry our titles) or contact the distributor in the relevant country, listed on the copyright page.

See our website **www.o-books.net** for a full list of over 500 titles, growing by 100 a year.

And tune in to myspiritradio.com for our book review radio show, hosted by June-Elleni Laine, where you can listen to the authors discussing their books.

MySpiritRadio